KEN SPRAGUE – PEOPLE'S ARTIST

JOHN GREEN

Hawthorn Press in partnership with Artery Publications

Ken Sprague – People's Artist © 2002 John Green

Published by Hawthorn Press in partnership with Artery Publications.
Hawthorn House, 1 Lansdown Lane, Stroud, Gloucestershire, GL5 1BJ, UK.
Tel: 01453 757040; Fax: 01453 751138.
Orders: www.hawthornpress.com
E-mail: hawthornpress@hawthornpress.com

Book design by Michal Bończa of Artloud
Back cover photograph by John Green
Illustrations by Ken Sprague
Typeset by Artloud
Printed by Lithosphere

ISBN 1 903458 34 X
A catalogue record of this book is available
from the British Library Cataloguing in Publication Data.

ken sprague

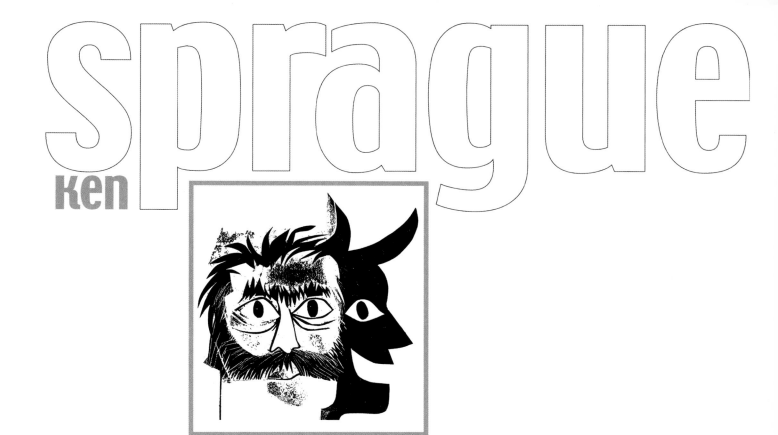

KEN SPRAGUE – PEOPLE'S ARTIST

JOHN GREEN

Hawthorn Press in partnership with Artery Publications

Thanks

This book is the result of a collaboration between a number of committed individuals and generous donors. The author wishes to thank the following for their help and support in its production:

The **Barry Amiel and Norman Melburn Trust**, **The Lipman-Miliband Trust** and **Tony Farsky** for their generous grants which made publication possible.

Sid Brown for giving me full access to his invaluable archive of Sprague's work and for his own reminiscences, Brunhild de la Motte and Richard Murgatroyd for their enthusiastic encouragement of the project, Michal Boñcza for his expert advice in terms of design and layout and Carolyn Jones, Norma Bramley and Ken Gill, Ray Watkinson, Jack Jones, Geri Morgan, Norman Saunders-White, Jim Pennington, Anita and Ron Gray and Martin Large of Hawthorn Press for their advice and assistance.

But above all, the artist Ken Sprague, without whose energy, co-operation and generous giving of his time, even during some of the most trying periods of his life, the whole project would not have got off the ground.

Also thanks to the following who kindly made donations towards publication costs: Diane Adderley, Mike Baldry, Chris and Betty Birch, Sid Brown, Gladys Coleman, Prof. David Craig, Sally Dennis, Alex Dohurty, Rosie Eagleson, Jim Fisher, Shiela Fisher, Stanley & Hilda Forman, Mike Gray, Anita and Ron Gray, John Hendy QC, Barbara Jermyn, Jack Jones, Carolyn Jones, R Kaufman, Bill Maitland, Tony Maughan, G&S Mercer, Ludi Simpson, Charlie Try, Ron Wiener, Liz Willis, Nick Wright.

FOREWORD

Ken Sprague's life has been extraordinarily wide-ranging in activity and experience, but always with the keen eye and sharpness of the outstanding artist. I first got to know him when I was seeking help in developing publicity and organising a campaign for the TGWU. It was very clear to me that we had to break out from stodgy ideas and limited perspectives.

Some printing and poster work Ken's company, Mountain and Molehill, had done for us led to my first contact with him. He immediately impressed me by the range of his ideas and examples of his work, but he excelled in a rip-roaring fashion when he took charge of the union's journal, *The Record*.

His imaginative approach and drive transformed it from a humdrum 'house' journal into a lively, dynamic newspaper. It attracted interest together with action and the circulation started to climb rapidly.

The need to popularise successes in local actions and encourage emulation was stimulated by Ken's drive and expertise. He has indeed been a wizard of good public relations and campaigning publicity. These qualities reached their peak in the great battles against the Heath government's notorious *Industrial Relations Act*. Ken's slogan "Kill the Bill" swept through the trade union movement and the workplaces like a bush fire.

Through his art he has articulated the fight against injustice at work and in society and not least an opposition to racism and unjust wars.

This book reflects the varied life and interests of a splendid character, racy, determined, invariably smiling with people and at life.

This is a book to cherish and return to from time to time, if only to stir the memory and arouse the need for action to achieve a more peaceful world of justice and equality.

Jack Jones CH
(former General Secretary TGWU)

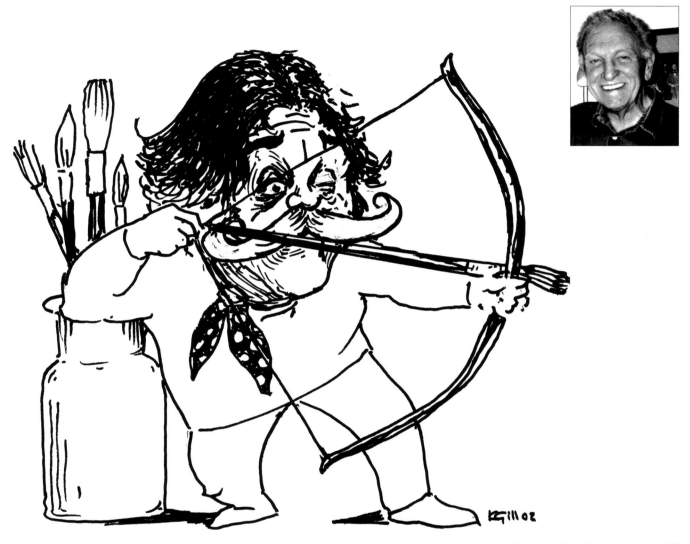

Cartoon of Ken Sprague by Ken Gill

How do you know Ken Sprague – as a painter, sculptor, poster artist, film-maker, psychotherapist or campaigning socialist? You will find facets of all these reflected in this book.

I have known him from the early days as the frenetic small one in the Mountain & Molehill partnership – purveyors of proletarian publicity for the labour movement over many years. Today he is still using his craft to expose injustice, political pomposity and dangerous state brutality.

His work is in dramatic contrast to the fashionable world of elite art, which only makes contact with people through publicity stunts flaunted in the sensational press as contemporary art.

Ken communicates with us by drawing and painting subjects close to us, about life at work, out of work and of the day-to-day struggles.

His radical observations are publicly displayed to his fellow citizens to agree with or oppose as they feel fit. He cannot and will not be ignored. His work for the trade unions and as a political cartoonist have warmed my heart – as one who has dabbled and worked in both. Ken Sprague is the consummate craftsman with a conscience.

Ken Gill
(former General Secretary of TASS and past President of the TUC)

The Omnibus programme, Posterman, on Ken Sprague was one of those TV programmes that (along with Jacob Bronowski's "The Ascent of Man" and a very few others) had a profound effect on me. By which I mean that it had the power and strength - or, rather, Ken's art has had the power and strength - to stay very firmly in my mind both aesthetically and as an inspiration. Apart from the Union Law poison bottle, my vividest memory is of Ken's wallpaper, which he described as what William Morris was aspiring towards. Well, that's the encomium: Ken Sprague is the true heir, as a socialist artist, of William Morris, and achieved what Morris could only dream of.

Martin Rowson, cartoonist for *Guardian* and *Red Pepper*

Ken Sprague is a man of great courage, generosity, humanity. He is an extraordinary story teller, a philosopher of action, a compassionate friend, a man of peace and a tireless campaigner against oppression. He is kind, humorous, playful, thoughtful, skilled, inspirational, spontaneous and creative.

John Casson in a laudation on awarding Ken Sprague a lifetime achievement award on behalf of the British Psychodrama Association

Ken Sprague, the most practised and efficient image maker of them all, shows a school of fish organising themselves to devour a big predator and, in a couple of watercolours, reveals himself to be something of a humane Burra.

William Feaver, *Sunday Times* art critic, reviewing the *Art for Society* exhibition at the Whitechapel Gallery

Ken Sprague is a dreamer, but a practical one, and his work helps to bring his dream a little closer.

Radio Times on the BBC Omnibus film, *Posterman*

I would not lift my finger to produce a work of art if I thought there was nothing more than that in it.

Bernard Shaw in a letter to Tolstoy

INTRODUCTION

Ken Sprague – people's artist. Why this title? The term "people's artist" makes a bold, if not pretentious claim – an artist for, and of, the people. It is not synonymous, though, with "popular artist" and the latter's connotations of pandering to the lowest common denominator and enjoying widespread popularity. It should not be confused either with the somewhat tarnished version bequeathed us by the Soviet Union. There the title "people's artist" was a prestigious award usually given to those artists who most loyally reflected the party line. Sprague would be the first to eschew such a "title", but it was felt the term captures most closely his unique position as a visual artist in Britain, alongside similar figures like John McGrath in the theatre, Adrian Mitchell in poetry and Ewan McColl in song. His art has always been intimately interwoven with his community activism and its language is one that is accessible to, and connects with, ordinary people without patronising or losing its artistic and aesthetic qualities.

Most artist monographs focus on famous figures from the art world who have belonged to influential movements or been particularly innovative or iconoclastic. Sprague does not really slot into either of these categories, yet he is a rare phenomenon. He is one of Britain's few overtly "political" artists. No British artist has worked so long and continuously for the Labour Movement, an association that is probably unique in British art history. He refuses to divorce his art from his political convictions. He is, therefore, not the sort of artist the British critical establishment knows how to accommodate and thus finds it easier to ignore or to consign such artists condescendingly to the bottom drawer as mere "functional artists" or propagandists. This situation is very different from that which pertained in Latin America or continental Europe, which produced artists like Diego Rivera and Alfaro Siquieros in Mexico, Fernand Leger in France, Frans Masereel in Belgium, John Heartfield and Käthe Kollwitz in Germany, Alfred Hrdliczka in Austria and Renato Guttuso in Italy, to name but a few who expressed their politics overtly through their art.

Sprague's work dovetails into the struggles, upheavals and wars throughout the greater part of the

twentieth century and into this one. His art cannot be considered or fully appreciated without reference to this context. He would undoubtedly be more widely recognised if he had been willing to jettison his strongly held socialist beliefs and his outspoken hatred of injustice and the abuse of wealth and power, but this was, for him, never a consideration. However, he never ceases to bemoan the fact that his chief "patrons", the Labour and Trade Union Movements, have, in general, been more than tawdry in their treatment of artists and visual imagery.

Sprague is an all-rounder and straddles the artistic disciplines. He is a painter, cartoonist, print maker, poster designer, graphic artist, sculptor, banner designer, muralist and sometime TV presenter. He is, though, first and foremost a print-maker and cartoonist. It is in this area that the greater body of his work has been produced. This lack of a clear specialisation in his work and his sheer prolific output have perhaps not helped cement his artistic reputation, as most critics like to be able to pigeonhole artists clearly as one thing or the other. There is also the belief that one cannot excel in more than one or at most two disciplines.

His art is defiantly out of synchronicity with the times. His approach is invariably a moralistic one, he believes in strong ethical values in an era characterised more by cynicism and negativity, and where egocentricity is de rigueur. He espouses socialist and humanist ideals and adamantly refuses to abdicate realist positions in his work at a time when these are deemed old-fashioned. In this sense Sprague is swimming consciously against the tide and represents a counterforce to the elitist world of "high" art.

He is a contradictory figure — at the same time rebellious and on occasions anarchic, but also conscientious and disciplined in his work. He is a mélange of Celtic spontaneity and passion, with an underlying streak of very English tolerance and pragmatism. In his youth he no doubt cut quite a dashing figure with his shock of jet black hair, Mexican moustache and strong physical presence. Even now, in his seventies, he still draws attention with his curling Victorian whiskers and Sancho Panza ebullience. He is a larger than life character, a consummate self-publicist and compelling communicator. His personal life has not been without its tribulations.

In his first marriage he had three children, two of whom were severely disabled and died at a young age. Sam, the surviving son, is a successful industrial designer. They also had two adopted daughters, Mandy and Maureen, the former an award-winning television producer and the latter a social worker, who both remain in close touch. With his second wife, Marcia, an American psychodrama therapist, he had another two children, Jackson, an art student, and Poppy, who is doing a Masters in psychology.

His first wife wife Sheila, a notable potter, died of cancer when in her prime and he later had to fight his own life-and-death battle against cancer.

Despite the fact that his dreams of a socialist society have been shattered by the demise of the Communist world, calling into question his years of sacrifice for the Labour Movement and Communist Party, Sprague, at 75, remains an unrepentant socialist and optimist, with an amazing zest for life. His belief in solidarity and friendship, in tolerance, the vital struggle for world peace and, above all, in the social function of art remains undimmed. Sprague, though, doesn't like being called a "political artist", because, as he says: 'Political to most people means political parties, corruption, insincere rhetoric, and sloganising, but to me it is more about human relationships. Whether I am producing posters for the trade unions, Save the Children Fund, Christian Action or the local Quaker group, that is, for me, politics.'

Ken Sprague was never the kind of artist to flaunt his art like a peacock's tail. He's not a precious prima donna and that's largely why he is able to communicate so well with ordinary people. I'd been convinced for some time, as had a number of other people who knew the man and his work, that his life and his art should be more widely known and were worth recording in book form for posterity. Not only are the works themselves of more than topical interest, but the lessons of Ken Sprague's life, and the experiences he went through offer valuable insights into the cross-over period into the new Millennium. His life in terms of his qualities as a citizen-artist could be, in many ways, an example for others, particularly young artists confused about their function in a society that sees art chiefly as a commodity. His recalcitrant questioning and belief in other human beings, his strong sense of solidarity and vision of the artist as a responsible and privileged member of the community harks back to early socialists like William Morris. His life also reflects the ongoing contradictory relationship between the artist and his society.

Sprague has an urgent, irrepressible need to communicate through his pen or brush. He is not in the slightest bit interested in sensationalism, to shock for shock's sake or in the sort of ego trips which establish many of today's most well-known artists as performers, who are then invariably better known than their work. Ours is a solipsistic era.

14

His reminiscences are history seen through a personal optic. They represent the memories of an artist, coloured strongly by his political beliefs, and are often related, consciously or unconsciously, as moral tales graphically projected in sharp focus. His pictorial images reflect this attitude too and often remain etched in one's mind; they unsettle, provoke, discomfort.

Much of his art, outside the publicity area, has a narrative base; his paintings and prints often find their origins in incidents witnessed, stories or dreams. Because of this they gain if the viewer knows something of their genesis or is able to hear the accompanying story. On the other hand, this strong association with a narrative can also endanger the work's aesthetic self-justification.

So where does Sprague's work fit in alongside the other art of the twentieth and twenty-first centuries? John Berger said, "I have come to see that the arranging of artists in a hierarchy of merit is an idle and essentially dilettante process. What matters are the needs which art answers."

However, the acquisition in 2000 by the Victoria and Albert Museum of one of his largest and most powerful prints, *The Killing Machines*, together with his anti-Vietnam War print *Return to America*, is perhaps a significant, if belated, vindication of his work.

In this book I make no attempt to mount a competitive claim for the importance of Sprague's art, but simply to assert that it merits wider recognition and appreciation because it poses uncomfortable questions in a way that few other artists are doing.

Ken Sprague is vitally concerned about how politics with a capital "P" impact on the ordinary person. In essence the leitmotif of his work is about power and the abuse of power as well as the resilience of ordinary working people to this abuse. He depicts the world as ameliorable and changeable. His work is imbued with unfashionable optimism, depicting a world where values are still important. It is the antithesis of post-modern fragmentation with its disdain of value systems. It is an art of engagement – engagement for change.

Sprague sums up his life's work thus: 'What I've been trying to do, and this is perhaps impossible, is to create a picture road to socialism, an illustrated pathway to the Golden City or Jerusalem, to use Blake's imagery. My aim is to build bridges by talking Jerusalem to hill farmers, factory and office workers, to give them a glimpse of an alternative world.' In his work Sprague has always demonstrated an ability to construct those bridges — that's been the key to his life.

John Green

The question of the relation of the individual to collective society of which he is a member is the fundamental issue, in art as well as in politics.

Herbert Read

THE BEGINNINGS

In 1927, on New Year's Day, only one year after the General Strike and a mere ten years after the Bolshevik Revolution, Ken Sprague was born in Bournemouth. Not the place that immediately springs to mind as a revolutionary cradle or a place of young children. Bournemouth, even today, probably has a minimal birth rate. It is a retirement town, where the post-reproductive aged with money retire to enjoy their remaining few years in genteel tranquillity and then expire. It is also traditionally the town with the highest concentration of Tory voters in Britain. Old army officers with ramrod backs would take the air along the cliff top, from where they could survey the beaches on which the sun-starved lower classes cavorted. Their blue-rinse wives dawdle

behind, with their well-groomed toy poodles and Scotch terriers in tow. So for someone to become a Communist in such an environment, as Sprague did, is on the face of it, a small wonder!

He seemed, though, destined to become a rebel, particularly after undergoing a Dickensian schooling and being confronted daily with a wealthy, privileged middle class and his own family's relative poverty in a town where the contrasts were some of the crassest in the country. Although the town conjures up images of white-washed villas and hotels, sandy beaches and deck chairs, there was another side to it. The margins of Bournemouth – Winton, Moordown and Parkstone – were the so-called rougher, working class areas. People who lived there had contact with the "other" Bournemouth only in their capacity as servants, cleaners, cooks and delivery men. Sprague was born in Winton, "on the wrong side of the tracks", as the North Americans would say. It is significant that when recalling his childhood in Bournemouth he doesn't mention swimming or sunbathing on the beaches; he could have been born a million miles from the sea.

His first stirrings of artistic interest were generated by seaside picture postcards and watching his father draw from the newspaper each day when he came home from work. In Sprague's cartoons with their

directness and spare use of line you can still feel the resonance of those postcards which remain imprinted on his mind. Interestingly, Sprague returns to this childhood memory for one of the Channel 4 television programmes he made in 1978 as part of the series, *Everyone a special kind of artist. A wee bit cheeky*, was the title given to his portrayal of probably Britain's most prolific and accomplished seaside postcard artist, Arnold Taylor.

George Grosz, in his autobiography – *A Small Yes and A Big No*, comments perceptively: "Postcards represent the genuine art for the masses, art that could dispense with the high-flown rantings of art historians or bombast of the critics." He, like Sprague, came from a working class background in Pomerania and also found early inspiration by watching his father, a caretaker, draw on scraps of card on the dining-room table. The only "art" Grosz could find to imitate in his environment were illustrations in cheap magazines and the gory fairground panoramas of his childhood. These were reflected in his garish caricatures of bourgeois decadence in twenties Germany.

Orwell, too, discusses the role of comic postcards in his essay *The Art of Donald McGill*, written in 1941. He says: "What you are really looking at is something as traditional as Greek tragedy, a sort of sub-world of smacked bottoms and scrawny mothers-in-law which is part of Western European consciousness," and, he goes on to say, "what they are doing is giving expression to the Sancho Panza view of life...Like the music halls, they are a sort of saturnalia, a harmless rebellion against virtue." This recognition of the social role such postcards played in working class consciousness is significant. Orwell, with his public school sensibilities, was repelled by the vulgarity of these cards, but recognised that they gave expression to human frailties and behaviour. They were in a very basic way a form of rebellion against the "upper" classes in the same way that Greek comedy was. This humour cocks a snook at the morality of polite society. As Sprague rightly says, they were then, for many working class people, probably their only real contact with the visual arts.

Sprague recalls: 'The earliest drawing I can remember doing was when I was about four years old and I drew a covered wagon drawn by four horses. It wasn't a cowboy scene, but must have been triggered by a visit to the Barnstaple horse fair. I just managed to draw the wagon and two horses on the page, but couldn't fit in the other two, so drew them up the side of the page. Years later I was looking at the Bayeux tapestry and blow me down if the weavers hadn't done the same

thing. They'd run out of horizontal space and taken the horses up the edge. I feel that was my first introduction to political thinking – that you could change things and make them the way you want.'

The family, too, encouraged him: 'There was actually an enormous artistic stimulation. First my mother was very supportive in terms of my drawing and making things, even though she didn't do it herself. She'd been a fancy cardboard box maker in a factory in Clapham, making gift boxes for shops. When I was young, I remember on wash days noticing her fingers split all over, like a chopping board, lacerated by the paper's sharp edges. Then with the hot water and the soap the wounds would open up – I've never seen fingers like it.

My father used to come home from work, wash, have his meal and then take an exercise book and draw. I've actually watched him while he was drawing and his head would slump on to the table, he was so tired. He'd fall asleep in the middle of drawing. He always drew with a soft black lead pencil. He would make a drawing from a newspaper or sometimes he'd copy photos. They were good drawings. By the time I was ten, on a Friday night after being paid, he started to bring home a pencil for me called Black Beauty, so, with his encouragement, I started to draw. The sad thing was that soon after

I'd started, he thought I could draw better than he could and he gave up and never drew again. My mother would praise everything I did, but Dad would say, "That's very good Ken but his hand looks like a bunch of bananas." So there was encouragement but also constructive criticism. Now I'd say that was quite unusual in a working class family.

The family had its roots in Devon. My grandfather had been a potter there and was described as an "art potter" on my Dad's birth certificate, so he was probably a design potter. His father had been a violin and clock-maker. So there was an artistic tradition in the family, but in a craftsmanship sense, not a fine art one.

There was, though, little outside encouragement apart from my primary school headmaster. My aunts would say, "It's a gift of God. He makes lovely photos." Working class people were confused about what art really was because art had already left them. I'm sure people never thought that way when they were building the gothic cathedrals – there must have been thousands of sculptors and masons at the time and I can imagine the baker, after work, saying to his wife: "Let's go to the site and see what Harry's done with that gargoyle." Then there was a connection that is now totally severed.

Outside there were two attitudes: I was given a box of chalks as a boy and my mates would ask me to draw a cowboy or a Busby (the Queen's hussars with their large bearskin hats) for them on the pavement – those were the heroes of the day. I liked doing this because it gave me a certain kind of power – I was creating something my mates wanted. But it was also quite hurtful at times because I could see things they couldn't and it wasn't always wonderful, it could also be very disturbing when I felt I was being treated as a different species.

One day a man came along, paused, admired the drawings on the pavement and then gave me a penny. I was knocked out by this because it represented a new sort of power that this art racket commanded. But it also raised a contradiction that I've never been able to reconcile, and perhaps it can't be reconciled – that between money and art. They don't go together.'

Bournemouth's Dotheboys Hall

Pre-war there were no comprehensive schools and there was a big class division in education. The "cream" was selected by the scholarship system (later Eleven Plus) to go to the grammar schools and the opportunity to sit their Matric (the equivalent of today's GCSE and 'A' levels) and then proceed to college or university if they wished. The rest were sent to Central or Secondary Modern schools, where they received a modicum of education, sufficient to equip them for their destinies as manual workers in shops and factories. Those who went to such schools sat no final exam and invariably left school at 15. Sprague was able to escape this dead-end by transferring to art college at the age of 13$\frac{1}{2}$. The majority of his contemporaries, however, were consigned to a Central School, where intellectual and artistic stimulation was minimal and anyone with an artistic temperament would often be mercilessly tormented as a softy. For the teachers it was more a question of keeping their pubescent charges under control, until they could be passed on to their workplaces, rather than actually imparting knowledge.

He gives a vivid thumbnail sketch of his schooling: 'I went to Alma Road Elementary School until I was thirteen and a half. When the school was bombed by Hitler during the war – the best thing he ever did, I thought at the time – I transferred to Porchester Road Secondary School before going on to art college.

I was known at school as "sandpaper balls" because I regularly had holes in the seat of my pants. There was nothing shameful about this, because most kids had holes and patches in their trousers. One lad came to school one day in pyjama bottoms with the fly sewn up because there were no trousers at home for him to wear. The teacher stood him on a desk in front of the class and ridiculed him, so the whole class erupted in anger. Other kids, girls and boys, came to school without shoes. Bournemouth, despite its patina of affluence, had a lot of seasonal unemployment, being a largely summer holiday resort.

I was a natural left-hander, but in those days this was not tolerated – everyone had to learn to write with their right hand. The idea of possible psychological damage being caused by forcing children to conform was not considered. So very early on at school the teacher actually tied my left hand to my belt behind my back to stop me using it. I went through hell for months on end. I couldn't think straight, couldn't write a sentence or do sums. It was impossible to go home and complain – only sissies did that. But I had a girlfriend, Dorothy Tollhurst, who told her mother what a hard time I was having at school and her mother told mine. She was too wise to go down to the school while all the kids were there, so chose to go after we'd all gone home but the teachers were still there, clearing up. The school entrance had a yellow line drawn in the road, across the gate and under this line it said: Parents must not cross this line without an official appointment with the headmaster. I took a photo of it years later and used it in an exhibition for the

National Union of Teachers, to commemorate 100 years of public education.

Mum waited until the teacher came out and asked him if he knew that Michelangelo was left-handed. "No I didn't," he replied. "Well he was," said my Mum, "and if it was good enough for Michelangelo it's good enough for my Ken." After that I became the first boy at Alma Road to be allowed to write with my left hand. Years later, I asked my mother, who had had little education, how she knew Michelangelo was left-handed. "I didn't," she replied, "but I jolly well knew that that teacher wouldn't know!"

I was dyslexic at school, but this wasn't recognised as a genuine disability at the time. It may have been associated with my not being allowed to use my left hand and the mental confusion that caused. I was made to stand up in class and read aloud. When I reached the word "donkey" for instance and couldn't read it, the teacher would say: "It's elephant Sprague, you fool." and I'd innocently repeat "elephant" and the class would burst into laughter – mind you I gave those that laughed loudest what for afterwards. That's how I learned to fight and defend myself. I still couldn't read properly when I left school.

School was awful, a bloody nightmare, and with few exceptions the teachers were a pretty poor lot. Joey Whelan, one teacher I remember well, was a real bastard. I actually plotted against him and one day stole his cane, broke it into little pieces and buried it in the allotment. That caused a furore. The headmaster took me for an honest boy and actually selected me to try and find out who had stolen the cane! I already had a pretty low opinion of my teachers, but when they then chose the culprit to find the culprit it really confirmed their stupidity in my eyes. I only found out much later that this "bastard" Whelan, an ex-public school boy, had been an officer in the First World War and suffered shell-shock and they put him to teach in our elementary school, whereas he should have been in hospital having treatment.

One day he called a lad out, Bob Tanner, who we called "one and six" (a Bob and a Tanner were slang for one shilling and six pence) and lashed him with the cane. Bob retaliated by kicking him in the shins with his hobnailed boots and Whelan went down, howling with pain. The entire class then jumped on him – he was off work for three months. He was also the only one I can remember ever setting us a piece of homework. We were asked to draw a picture. I drew a cowboy on a rearing horse and Mr. Whelan said I'd traced it. "I damn well haven't", I retorted. He was furious and told me I was lying and not to swear at him. I was sent to the head-

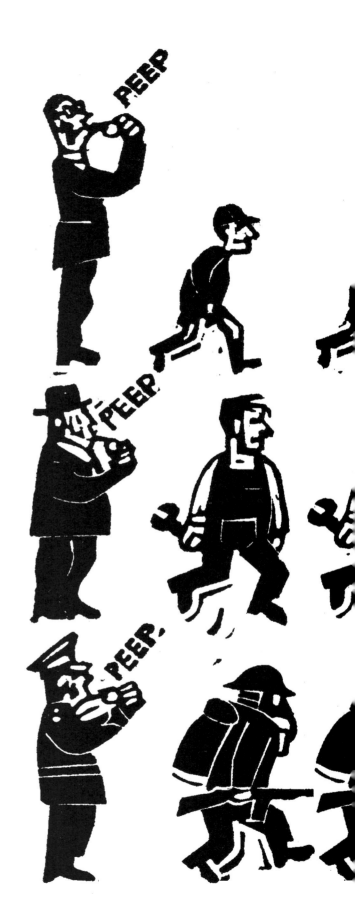

master who listened to my story and said: "Well, Sprague, if you said you drew it, you drew it, so that's the end of the matter." The headmaster did encourage me and it was he who advised my parents to let me apply for an art school scholarship.

Empire Days were special. One I recall distinctly. Two hundred of us were lined up for assembly and an outside speaker addressed us and his words went something like this: "This is Empire Day. Remember you are British, which means you have won first prize in the lottery of life." And when you think about it, we had – we were English working class lads, not Indian or African workers barely eking out a living, the poor sods. On the backs of those colonial subjects we had a somewhat better standard of living.

Then there was the other side of the coin. I remember once the headmaster telling us: "You will become the drawers of water and hewers of wood and you should do this to the best of your ability." Now I was about ten years old but even then I remember distinctly thinking, not for you I wouldn't! I may draw water for old Mrs. Sykes next door, but not for you. We were designated as factory fodder. So there was an inchoate political understanding even at that age, devoid of all the political rhetoric, which I've never had any time for anyway. I had a definite understanding of where I was and where I came from.' In a less resilient child, such schooling would have destroyed any sense of creativity and determination, but not so in Ken Sprague.

Then came politics in a more direct sense. Sprague explains: 'This was the thirties, and the rise of fascism. I can remember Mosley's Blackshirts regularly standing outside the school gates, dishing out literature. At that age we were not really aware of politics with a big "P" and the fascists were clever, they would play on our boyhood fantasies by emphasising the marching, the smart uniforms and flag carrying which Mosley's party afforded. The Jews in Bournemouth were also an easy target. Most working class people in those days wore sombre, dark grey or charcoal-coloured clothing. I remember my aunt wearing a red scarf once and being told to cover it up because she "looked like a floosie". Many of the Jews who lived in Bournemouth were business people and they would often flaunt their new-found wealth in the form of gaudy costume jewelry and fur coats. That was noticed and engendered envy and even hatred. Of course, parallel with the rise of fascism was also a consolidation of the socialist and communist movements. Young people would have had daily contact of some sort with these political movements and loyalties would be formed.

On leaving school you were faced with basic choices as to what you did afterwards. If you were ambitious', Sprague explains, 'you could become a craftsman or a bosses' man, or try to escape by becoming a boxer or footballer (similar to the situation today for black kids), or you could become a Communist. This may sound strange today, but in the context of the polarised politics of the thirties, such choices were forced upon you. I chose boxing and Communism,' he says, mischievously, 'but after a few years I gave up the boxing, figuring that it was a rather stupid and painful way of making a living. I stayed with Communism. It was personally less harmful. There was also another choice of course: you could become a small time gangster, which a lot of boys did. That way you could make a living somewhat easier than in more mainstream ways. You didn't hold it against them, either, unless they started stealing from you – it was merely another means of survival. We also knew by the age of ten who in the class would become coppers – invariably the snitches and tell-tales.'

Family influences

'Like most working class folk at the time, we rented a flat or small house. I remember my room had a small narrow little grate and I can only recall it being lit once by my mother when I brought my first girlfriend home – we couldn't afford the coal normally. The house was a small terraced one, but we moved every couple of years. As my father earned more we'd move to a slightly better place and even one with a garden where he could grow vegetables, but he also grew flowers for my mother. They were all rented places except the last which my father bought with a mortgage – he actually finished paying for it only a fortnight before he died. I know the house cost £600 to build, so he must have paid for it several times over.

My father, as an engine driver, was considered to be a member of the working class elite – he had a regular job. He would polish his boots every day and put on a white shirt to go to work, but that didn't stop him feeling very much part of the working class. Both my parents were political but never members of any political party. My father was an active member of ASLEF (Associated Society of Locomotive Engineers and Firemen), the train drivers' union. He went as a delegate to the conference every year. He never joined the Labour Party because he felt they'd invariably "sell out," which they did, although he voted loyally for them to the end. My mother was very active in the Co-operative Guild, so there were strong connections to

working class organisations. There was a deep suspicion of political parties as such – they were viewed as the equivalent of organised religion and thus to be avoided. They'd see themselves as socialists but not of the organised variety.

That's where I got my political grounding, in the family. My decision to join the Communist Party did not come from theory, from reading Marx or anything like that. I couldn't read until I was 15. My father had read two books: *The Seven Pillars of Wisdom* by T.E. Lawrence and *The Origin of Species* by Charles Darwin. The only other books I saw in the house were on railway engineering. I think my father was a born anarchist, but despite this he was chosen to be one of the Queen's engine drivers and would drive her to Plymouth on Navy Days. I suspect something like that could only happen in England. I was outraged, though, that my father was forced to take a day's unpaid leave to ensure that he was fit and alert before driving the Queen.'

Sprague had a strong affinity and love for his father, which endured until the latter's death in 1988. He bequeathed Sprague his life-long commitment to working people and pride in craftsmanship together with a dogged determination to fight for dignity, as well as a keen sense of class hurt.

'The politics certainly also came from hearing about the Spanish Civil War, from experience rather than reading or study. I grew up in the thirties with all the poverty and unemployment. and that must have had its influence. I remember one day at the local market a man and woman, obviously hard up, fighting over whether they should buy a conger eel head for a penny – they

were literally hitting each other over whether they could afford it or not. I felt desperately hurt that my people would fight over a penny. Later, when I went to work in the mines – I was already a Communist by then – I saw men fighting over who should be allowed to work at the face for an extra shilling a day. That's how I learned my politics.'

Politics could hardly be avoided in the thirties, and it hadn't yet acquired that soiled image it has today. Of course there was careerism, graft and corruption but in general the public still believed that there were political solutions to social problems and cynicism was rare. For Sprague, political immersion came relatively early. While his parents were not activists in any political party and there were no heated political discussions each evening over tea, they were politically aware and interested. This must have provided young Sprague with a political framework for his own future development.

'My first conscious political experience was in 1937, on 27th April. I came home from school and there at the gate was my mother with a group of women, all crying. I'd never seen anything like that. There are times when you cry, like at a funeral, but not without apparent reason, publicly on the street. I thought perhaps my dad had died or something dreadful like that. Mum just said: "Go inside, Pat (his sister) is there and your tea's on the table." It turned out that Guernica had been bombed by Nazi war planes the day before. It was the first example of air raid terrorism on cities. It's perhaps unbelievable today, where it's become almost an acceptable form of war, that people were actually crying about it. My father came home in a real rage over what had been done to Guernica. They both got involved in helping Republican Spain. The fact that my mother had a resemblance to La Passionara, the Spanish Republican heroine, no doubt reinforced my identification with the Republican cause. She became involved in the "Milk for Spain" campaign, collecting tins of condensed milk to send to the children in Spain. A local woman used to come around collecting the tins in a big bag. Her bag was bulging after she'd been down our street. Sometime later, I met her in one of the posher streets and saw she only had a few tins in her bag and I asked her why. "Ah," she said, "that's something you'll learn about later in life – it's all about class."

As a ten-year old I wondered what I could do to help the campaign, so one day I went into the kitchen, moved the mangle and cut out a square of lino to make my first linocut and printed it using Mum's mangle. My father then had it properly printed up on a collecting sheet for Spain and a few years later Nan Green (a nurse in republican Spain and later Secretary of the International Brigades Association in Britain) published it in *Spain Today*. That showed me that I could give expression to what I felt and see it used to some purpose. That planted the seeds of my love of printing and led me, later, to discover the work of Thomas Bewick, the great English wood-engraver and Posada, the Mexican engraver.

I was only 12 when the war broke out in 1939. I remember one clear day a year later, in 1940, I was with a crowd of friends, and we were watching a dogfight between Nazi and British planes over Bournemouth during the Battle of Britain. We saw one of the fighter planes dive steeply and burst into flame, and like Icarus, the pilot fell out of his plane and plunged to earth – his parachute didn't open. We all cheered, thinking a Nazi airman had been shot down. Only a few days later did we learn it was one of ours – a Spitfire pilot and he'd actually been to the same art college I was shortly to attend.'

These early political experiences would hardly have prepared Sprague for the shock of the war, but it would have helped him understand why it happened and what it was about. Despite his rather laconic memories of those early days and his gung-ho decision later to join the Royal Marines, it must, nevertheless, have been traumatic to realise that a major war had broken out before you have been able to embark on your own independent life.

Learning about ethics

'My Mum took a cleaning job so that I could go to art school. Although I had won a scholarship, and tuition fees were covered, there were still materials to be paid for. She worked in what at the time was a sort of palace to me, in Fitzharris Avenue. I've been back since and it's a pretty ordinary upper middle class home, but with a big gate and tradesmen's entrance – it even had a sign, saying: "tradesmen's entrance". Some days I'd run from school to meet her there. I wasn't allowed to go in or stand at the main gate, so I would wait at the tradesmen's entrance till I heard her steps on the gravel path as she left. One such day, I heard the door slam and saw her coming down the path, but then I heard the voice of the owner, a Jewish nouveau-riche woman, calling after her – Bournemouth had a number of such people at the time. She accused my mother of stealing a loaf of bread. My father was on strike at the time and we were having a very hard time but I knew my mother would never

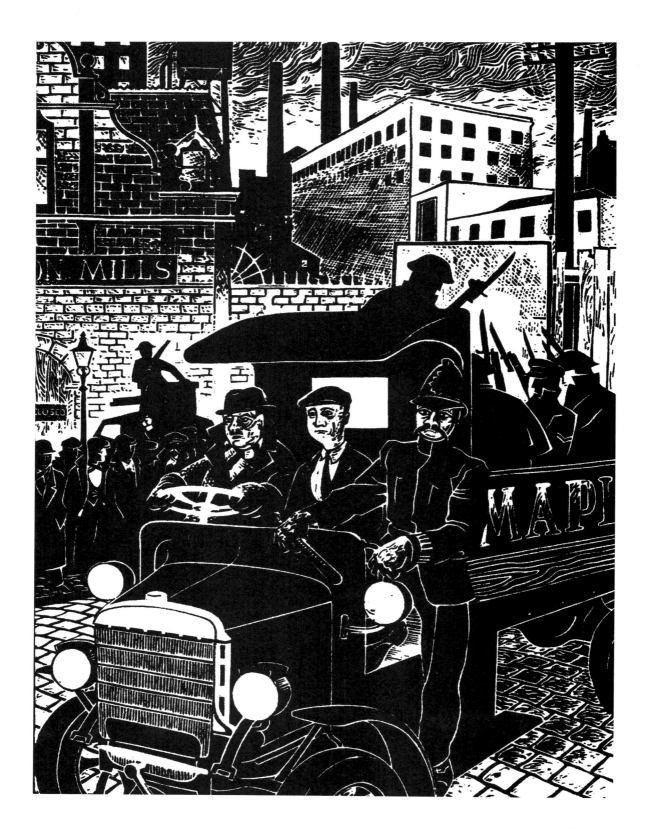

steal anything. She didn't say a word, just stood where she was, put down her wicker basket which was covered in a gingham cloth and contained her cleaning materials – just imagine, you had to buy your own cleaning stuff – and slowly took them out one by one and laid them on the gravel path. The basket was empty. The owner saw this, turned on her heel without a word and went back indoors. As she disappeared, I said to my mother: "The dirty Jew." Quite clearly the superficial contact with the Blackshirts and fascist ideology had had its effect. I'd grown up with anti-semitism and although I hated it, it's amazing how these things become automatically incorporated in your sub-conscious. Mum put her things back in the basket and then belted me around the ear. My ear was ringing. Now Mum had never hit me, so this came as a real shock. It wasn't the blow that hurt – I'd been in enough scraps at school not to let that worry me – it was the fact that she'd actually hit me. As we walked down the road, she said, "It's nothing to do with being a Jew, a Moslem, a Christian or a Confucian." That really confused me, I'd never heard of Confucian before – and of course you can't be a Confucian – but she didn't know that. "It's got nothing to do with being a Jew," she said, "it's all about being rich and the rich always think the poor are stealing from them," then she paused and added, "and sometimes they're right!" My god, that was a lesson for me, although at the time I wasn't at all sure what she meant. When we got home she said, "Go out and play." Now she never said that, so I knew something was up. I went out but hid behind the door and spied through the gap between the door jamb and the door. She emptied her basket then removed the gingham lining and took out slices of bread which had been laid around the inside of the basket under the lining! I never said a word until years later when she was having a go at me for lying. I said, "hold on Mum, what about the time you stole that loaf of bread?" "That wasn't lying," she said. "Come on," I replied, "you said you hadn't stolen it." But she hadn't actually said a word of denial although it was still deception. She said to me, "It's got nothing to do with morality, it's got to do with ethics – she had too much and we had nothing. Ethics see!" Now that's real wisdom, manipulated wisdom of course because it says working people come first, everyone joins the queue, mate. Ethics for her meant taking care of your own. That's where my politics really began.

I remember, as a small boy, being taken by my grandfather on a visit to London's East End. We rounded a corner and suddenly came up against an enormous crowd of cloth-capped workers surrounding a small, dark-skinned man dressed in what looked to me like a white sheet. They were listening in rapt attention as he spoke to them about India. Years later I realised it had been Mahatma Gandhi. As an adult, not far from this spot I also heard Ben Bradley, a communist expert on India who'd lived in that country for many years, calling for Indian independence. The streets were surrounded with police vehicles, which soon disgorged their truncheon-wielding bobbies who proceeded to break up the meeting. One forgets today that it was the Communist Party and a few individuals like Fenner Brockway who led the calls for colonial liberation when no one else dared contemplate it. The Party also provided educational opportunities, training and support for a whole number of colonial leaders who later became leaders of their independent countries, people like Nehru, Krishna Menon, Nkrumah, Cheddi Jagan, Ho Chi Minh and Maurice Bishop to name some of them. Such experiences sowed the seeds of my learning about history.

School didn't provide any really worthwhile life tools. Most of what you learned was picked up from school friends and neighbours in the day-to-day practice of surviving – what happened to you, what you heard or what you saw. The same went for sex. The concept of sex education didn't exist in those days. You had to pick it up in the school playground or by spying on couples in the park. As I was now a teenager, my mother obviously felt my father should explain things to me to stop me getting a girl "into trouble." So one day he took me for a walk along the promenade and onto the pier. We're walking over the boards – they are laid to leave wide gaps between them to allow the sea water to flush away. He stops suddenly and says to me: "See that down there?" Below us on the beach is a sailor lying on top of his girlfriend. So I look, and he says: "Well that's how you do it lad." And that was it! Ever since I've always wished I'd answered: What, from up here Dad?'

Funny thing wind!

'My uncle Alf and Aunt Lil lived in Clapham with my Grandma and we often spent our holidays there or visited them on Sunday afternoons. My father, as a Railway employee, was allocated cheap or even free trips on the railway and this enabled us to go up to London to see the relatives. Uncle Alf had been gassed on the Somme in the First World War and he wheezed his way through my boyhood. We would sit down at the table with Uncle Alf and my aunts, eating cucumber sandwiches

with the crusts cut off, aping what was seen as middle class etiquette. So uncle Alf would wheeze his way through the meal, while we ate and sluiced the sandy Madeira cake down with strong tea. Then one Sunday, in the middle of the afternoon, he suddenly fell sideways out of his chair and I remember he did so in a sort of slow motion and then hit the floor. Everyone was rooted to the spot. We knew he was dead.

Many families in those days had a single woman lodging with them, either a member of the family or friend, women who had had lost their men folk in the war and had become mentally disturbed. They were often deeply embittered and it was etched in their faces – my father said they had razor blade mouths. In our family it was Auntie Vi. She used to help around the house. She giggled all the time and acted child-like. She got up and took Uncle Alf's head on her lap and cried – she knew far better than we did what had happened. That had a tremendous effect on me as a small boy. Some years later I said to Aunt Lil: "Poor old Uncle Alf, the Germans got him in the end." She replied, "It wasn't German gas Ken. It was English gas." Earl Haig had ordered gas shelling of the German lines, but the wind changed and it was wafted back over the British trenches. It must have been mustard gas and killed and maimed many of our soldiers. This was a shock to me,

because I'd automatically assumed that his suffering was due to the enemy. When Earl Haig was told about it, he is reputed to have replied: "Ah yes, funny thing wind."

About 50 years went by and I had this wonderful dream: I am nearing the end of my life and am walking down Whitehall on a sunny Sunday morning, as an old man, with a stick. No one is about. The bronze statue of Earl Haig, astride his horse, stands imposingly in Whitehall and across the road is parked a big yellow bulldozer. I walk over to it and I remember in the dream putting my stick on the seat and pulling myself up with some effort. I drive this big machine very slowly and push the bucket against the statue and Haig topples sideways in slow motion to the ground, as I remember Uncle Alf falling, but Haig makes more noise when he hits the ground than Uncle Alf did. I back the machine away, take my stick, climb down and walk off down the road. There is still no one around. But by the time I reach the bottom of Whitehall, people begin to gather and police cars arrive and one of the policemen says to me: "Did you see anything? What happened?" And I reply, "Well, constable, there was a gust of wind which came up Whitehall – funny thing wind! I felt very happy, knowing my friends would read about it after I'd gone. Wouldn't that be a terrific way to go?'

A feeling for things as such is far more important than a sense of the painterly.

Vincent Van Gogh

ART SCHOOL

'I was just thirteen and a half when I started college. The headmaster at Alma Road school had encouraged my parents to enter me for a scholarship to the Bournemouth Municipal College to study art, which I did. Although I'd won a scholarship, I still had to buy my own materials and had to look decent – I couldn't go in patched trousers anymore.

While still at secondary school, I already had a job at the Co-op bakery. I started work at 6.00am and had to be at school by 9.00am. When people hear this, they think it must have been terrible – child exploitation. But I didn't see it that way. I'd get to work, have a steaming mug of chocolate and a hot bun. It was great, and certainly better than sitting in a dingy classroom. I kept this job to help out while I was at college. I used to finish working at twenty to nine and would then have to run the two miles to college and was always late, but Lesley Ward, the class tutor, would mark me in for nine, even though he'd have been in hot water if anyone had found out.

One of the places to which I had to deliver bread and cakes was an apartment on the fifth floor of a block of flats. The lady who lived there was always dressed in lace and she had an obnoxious little daughter called Gloria. I would stand at the door with my bread basket and she would say, "What cake would you like Gloria?" I could guarantee that she'd ask for the one I hadn't brought up, so I'd have to run down all five flights and back up again with the requested cake. Once I'd realised what was happening, I would stop at the fourth floor and leave a selection of cakes on the windowsill and then continue up. When Gloria asked for the one I hadn't got, I then only had to go down one flight, wait a few minutes looking out of the window, then trot back up again.

Years later, when I was with Mountain & Molehill (Sprague's publicity company – see chapter on trade unions), I advertised for a secretary. Who should turn up for the interview but Gloria! I told her the story – she was only a small girl at the time and said she had no recollection of what had happened – and she was deeply embarrassed. I said, "Now if I were a real bastard, I could really make your life hell". She turned out to be a very good secretary.

At that time the class system in Britain was still very strong and was reflected in the college. The generally held view was that if you studied there, you either had a private income or you were a "poofter" with a sugar daddy who paid for you!'

Geri Morgan, a contemporary of Sprague and also a Communist and artist, recalls that it was probably easier to be accepted at art school at that time, in the early forties, because most young men over 18 had been called up and "only those with weak hearts, one leg, or foreigners could be encountered there."

Sprague found his first few months at college tedious: 'They were taken up with learning the basics – lettering together with a study of Greek and Roman antiquity. That drove me mad, day after day drawing plaster busts and copying letters, but it taught me how to draw and to understand how to use typefaces.

I was already labelled as the working class kid who'd have to make a living later, so was placed in the commercial class to study design and printing. I wasn't admitted to the fine art classes until I muscled my own way into life classes. This was unheard of for a kid of my age with nude models! There was a wonderful teacher in charge of anatomy and he gave me a lot of encouragement. He used to do all the lettering for the sculptor, Jacob Epstein. With him we also visited the local hospital where we learned about anatomy from the corpses.

The class system was really appalling. I was very much looked down on as a scholarship boy, but most of the students didn't know one end of a brush from the other. The boys were waiting to become officers in the army because the war had already been going for two years, and the girls were debutantes just filling in their time before becoming engaged. There were a few who were real artists and they worked in the corridor – that was their studio. So there was this paradox of being looked down on as a working class scholarship boy, but rebelling against that, determined to prove that I could draw better – and I often could, that was my strength. There was also the stimulus of watching the older students who were good – the ones in the corridor, not in the classrooms.

Lesley Ward RA, who was my mentor, was a real old English liberal who believed in the values of education and in fostering talent. He had a very principled attitude to life and relationships. There was a mature student in his class at the college, the son of a grocer, who continually used the expression "self-made man". I could never understand what he meant by it, so I asked Mr. Ward. "It's someone who's forgotten all those who helped him get where he is," he answered. I've never forgotten that.

He taught us about Daumier and showed us draw-

ings of Don Quixote – he's still one of my favourite literary characters along with Sancho Panza. Sancho is an ordinary peasant who thinks his master is a fool but loves him. When the mob burn the Don's books it is Sancho Panza who saves them from the flames and gets burnt in the process – and he can't even read! But the most wonderful episode I remember is when the Don sees the windmills and tilts at them, is caught in the vanes, carried aloft to be pitched back down in the mud, his armour all bent. Sancho runs up and says, "You're crazy to tilt at a windmill – look at you, all battered and bloody." Don Quixote replies: "Ah yes, but it lifted me to the stars!" Oscar Wilde reiterated the same idea centuries later, when he said: "We may all be in the gutter but some of us are looking at the stars."

Lesley Ward was encouraging right from the start. Having something to fight against was worthwhile and I used to fight Mr. Ward something terrible. I'd say, why do I have to do it that way? Exasperated, he'd reply, "I've given you enough reasons, Sprague, but here's another, because I say so and you'll do it that way until you've got a better idea and then you'll be an artist." One day, towards the end of the course, he came over and tugged me by my sideburns and said: "Sprague, now you're an artist". That was one of my proudest moments.

We had an Italian lettering assistant at the school and he would bawl at us and make us do the letters time and time again. I used to grind the litho stones to earn a few shillings after classes, once the other students had gone home. The Italian assistant was still there one evening and he called me over and told me to get him a cup of tea. I brought it, but he rebuked me, saying it was only half full and told me to bring a full cup. So I went again and filled it to the brim this time. He carefully took the cup and poured it into his own. "See, it fits exactly into this one," he said. "It's a similar principle with letters. You need exactly the same volume between the letters. Look at letter A next to the letter I or the letter O next to L. You need to bring one letter a little closer or place it farther apart to create the same volume of space between them." This was like being given a key. But as soon as I started thinking about proportion with the help of this old boy, I realised that it

wasn't just about lettering, it was about life. How things are related to each other. And in politics: if I do it the bosses' way, he's got disproportionate power. He puts a letter H right up against a letter I because he's squeezing the workers for all he can get. It would make more sense, certainly for the workers, if their share of the spoils was more proportionately related. So when I joined the Party and started to read Marx, I found confirmed what I'd already experienced. That was the important thing, the Eureka phenomenon – so that's what it's all about! It was a revelation.

Day after day we'd draw the letters of the Roman alphabet and I'd begin to realise why the letters are that shape. The Greeks and Romans had to get a chisel into stone and that's how the serifs came about. All those hours doing lettering suddenly clicked and I realised that in these letters you have a history of Western civilisation. It started with the stylus in Egypt, writing in wet clay, then came the Greeks and Romans with their chisels and the development of the serif, then Gutenberg with his printing press and then later, as the presses became more sophisticated and faster, the development of non-serif letters, because the serifs would break off the wooden blocks under the pressure of the press. No one thinks, when they pick up a newspaper, wow, I'm looking at history here!'

War intervenes

'While I was at college in 1943 the war reached its height and my father was desperate to keep me out of the army – he knew he might never see me again if I joined up, but I did. I was only 16, but I wanted to do my bit, so I quit college and went to join the Marines which was a real snub to my father and I've always regretted making the decision. He was doing the best he could for me, but I took no notice. Once I'd told him he called me a bloody fool and swore at me for the first time in my life. I'm going to be the toughest of the fighters, I thought. There was also peer group pressure to go and help kill Germans. Several of my family had been killed in the Nazi air raids and that was also a spur to go out and be more bloodthirsty than the enemy.

I completed my basic training, but was then transferred to a secret research establishment – Vickers Armstrong Super Marine that built the Spitfire plane. My workplace, in the design department, was in the village of Hersley near Winchester. I was a technical artist attached to a team whose job was to design an ejector seat for the Spitfire. Britain was losing too many pilots. When a Spitfire went into a nose dive it could reach speeds of 600 mph and the pilots were unable to remove the cockpit cover to eject.

Sir George Cooper, the director, tested me by showing me a drawing for the new ejector seat, saying: "What do you think of this, young Sprague?" I replied that I was not sure, but there was something wrong with it. The opening looked the same length as the seat, but what about the pilot's legs, I thought. Cooper had someone check the drawing's measurements again and it was clear that the opening was in fact designed two inches shorter than the average pilot's legs – if he'd ejected, he would have had his knees taken off! I could see things others couldn't, but wasn't able to do even simple maths to save my life. All the drawings I made were done without the technical equipment available, they were more intuitive.

As part of my work on the design of a new ejector seat, I was sent to Yugoslavia. The Germans had already solved the ejector seat problem, but we were still grappling with it. During the war Yugoslav partisans had captured a German plane with a complete ejector seat and it was way ahead of anything we'd produced. So we were sent to Yugoslavia to bring it back, offering the partisans weapons in exchange. Now it was a total betrayal because the guns were sten guns which didn't work properly – they jammed every third time you fired them. A lot of weaponry at the time was made by all sorts of factories, inexperienced in war work, but had been obliged to undertake it, like the Triang toy company. These guns, though, were made by Woolworths.

I went there as a Super Marine artist and my job was also to produce water colour illustrations of burnt out planes. This sounds ludicrous, but apparently the boffins could work out from the discolouration what fuel the Germans had been using. There were all sorts of crazy things like that being done during the war. Although I was in fact a sergeant, I didn't even wear a uniform while I was out there, I wore a red bandana around my head like a bloody irregular. It was madness, if I'd been caught they'd have done me in right away.

My moustache dates from my time in Yugoslavia. People think it comes from working in the circus, but it's nothing to do with that, it's a Serbian tradition. It was working with the Serbs that made me a man, because I was only a boy when I arrived there, but I was a bloody man when I came away. My experiences there made me yearn to return after the war and that was where the real learning took place. I went back in 1947 to work on building a road and that was a remarkable experience – politically, emotionally and culturally.'

Return to college

'It was now towards the end of 1945 and the war was drawing to a close. As ex-service men, we were told we could apply for grants to go to college. I applied, because I was keen to return to complete my course, but it would be several months before the grant came through.

It was no use my staying in the Marines, because with the end of the war and the rapid cooling of British-Soviet relations, Communists were being weeded out. But I had to earn some money in the meantime and there wasn't a lot of choice. On top of that, I was now blacklisted and the few jobs I managed to get would only last a few weeks because I'd end up hitting the boss or walking out. And that wasn't exactly the way to get on in the world.

In the winter, I eventually found a job with a circus, painting the fairground stalls and backdrops in preparation for the new season. My first backdrop was a big 62 feet long one of a concubine and I painted her with the most enormous tits you've ever seen. It soon got around in Winchester and people came from miles around to

touch these tits. Summers' Circus it was called, run by George Summers, a real gypsy. After the backdrops, I'd be employed doing any of the other jobs that needed doing. I rode an elephant, kitted out with turban and loin cloth, but most of the time I spent shovelling elephant shit, and do they produce mountains of the stuff! In the Spring, when we opened, I joined a team of lads in the boxing booth and, in the local boxing club, at one time or another, had as my sparring partners boxers like Vince Hawkins, Freddie Mills, Ted Lambert and the Turpin brothers. That's how I gained the experience I needed. You'd box anyone who wanted a go and if they lasted three rounds they won £3. We had all sorts of tricks to ensure they didn't. A pretty girl would be placed strategically among the onlookers and at a crucial moment she'd call out, "Ooh, you're lovely lad" and the guy would look round and you'd hit him. We'd also put sand on our gloves to bloody the face of the contender.

When my grant eventually came through, I finished with the circus and returned to college. The course had already been going for several months, so I had to complete the three-year diploma course in design and illustration in only 18 months'.

Like many other demobbed soldiers returning to college, Sprague was now a changed individual. He might not have seen frontline fighting, but he'd experienced enough of war to see how brutal it could be and, at any moment, how easily life could be curtailed. So these students brought into the colleges a maturity, a combativeness and eagerness to learn, very different from the attitudes of pre-war students.

In 1946, he was taken on as an assistant by Anna Zinkeisen (a self-portrait by Anna Zinkeisen hangs in the National Portrait Gallery), one of two sisters, both of whom were exceptional artists, and had been commissioned to paint a mural on the ceiling of the Russell Cotes Gallery in Bournemouth. The Zinkeisens were decorative painters and should have had more recognition, but at the time, being women, they didn't receive the recognition they deserved.

Sprague has fond memories of working with her: 'Anna received this commission and employed me as her assistant. The curator at the gallery, a man by the name of Sylvester, was an absolute pain. He didn't want any women painting the gallery, and would have preferred a big name male artist. So he made himself as obnoxious and as awkward as possible. I managed to keep him at bay and earned the moniker "my bulldog" from Anna. She was a very upper-middle class lady, like one of the Bloomsbury set.

One day Sylvester came into the gallery while we were working, dressed as he always was in an expensive silk suit. Anna says to me, "Kenneth, my boy, would you pass me the white paint." I wonder what she wants the white paint for, we're using colours at the moment? She takes it from me, mixes a quantity in a tin and then pours it from the scaffold all over the unfortunate Sylvester, standing below. I've never been so surprised in all my life. This genteel, well-bred lady doing something so outrageous, but it wasn't malice, it was an impulsive impishness.

Before the mural was complete I had fallen in love with my first wife, Sheila Kaye, and I surreptitiously painted K.S. loves S.K in what I remembered to be a small corner, hidden from view. 54 years later, my son Sam received a commission to supply some exhibition materials to the gallery and I told him this story. He and the curator searched all the corners of the ceiling but couldn't find my message. I thought it might have been painted over in the intervening period. But he was tenacious and kept looking. Eventually he rang me up to say he'd found it. But it wasn't where I'd said, "it is right in the middle where everyone can see it. But you've been clever, you painted a leaf in the shape of a heart and put your love message inside that. In the mass of leaves painted by Anna, it's so well camouflaged that no one spotted it!"

The ceiling panel is not a significant work of art. It is painted in a late-Victorian, mock-oriental style to meld with the rest of the décor and commensurate with the taste of a wealthy merchant collector of the time.

'When I was leaving college,' Sprague concludes, 'I was given the chance of a job by the Director of the college, working for the jam manufacturers Tiptree in Manchester. A very well paid job at the time – around £1500 a year. "What do you think Ken?" he asked, and I replied that it sounded like a hell of a lot of jam labels to me. Did I want to design jam labels for the rest of my life? So I don't regret that I turned it down, although I could have done with the money to buy a few things for my mother – things she could never afford – and I owed it to her. But the idea of endless jam labels! It was similar when I started playing Rugger for the Marines. The first team we played was the No.1 Commandos and they smashed us, but on the basis of my performance I was invited to join the Royal Marines Rugby team. That was a great honour, but the idea of every Saturday afternoon into the misty distance taken up with Rugby, the drinking and bawdy songs – I couldn't face it. The idea of a planned future was not for me. This attitude has forged my life. I don't want it to sound

heroic, because I never saw it that way, it was just that there were things you did and things you didn't – ethics, my mother would call it. It's what you've imbibed, it's become part of you.

Before I left college, the Director gave me a reference saying that "when Ken has had a little more life experience, I'd like him to come back and join my staff." I think I could have been a good teacher, but I wanted to be an artist, and the only artist I knew who became a teacher stopped painting. Teachers invariably become Sunday artists. If you're talking about art all day, you have no creative energy left afterwards to go and paint. I would have had financial stability as a teacher, but not a better life.'

This road awaited him, stretched in front of him, luring him on with its mysterious curves and the stern responsibility it imposed

Vladimir Dudintsev

JOINING THE PARTY

Ken Sprague's childhood in Bournemouth conspired to bring out the rebel in him. How far this rebelliousness is due to nature or nurture is impossible to unravel and is in any case immaterial here. The adverse environment in his primary school and his need to defend himself toughened him for a life that was to become a continual challenge, requiring cunning, tenacity and sometimes force to come through it successfully. But Sprague did-

n't just view it as a challenge to himself alone, but identified with working people and the less fortunate. At that time though his attitudes and ideas could be more accurately described as visceral than intellectual, a spontaneous reaction to experienced injustice.

When the war started Sprague's father was determined to get his son a job on the railways because he knew it was a "reserved occupation" and would save him from being called up. But for Sprague the choice was not that simple: 'The fact that Dad was risking his life every day driving bloody munitions trains never seemed to occur to him. But he worked very hard to keep me out of the army. My mother wanted me to work in a bank because it was a secure, white-collar job – a job for life, which it certainly isn't anymore. I can remember Dad saying to my mother: "Flo, leave off, the only thing he'll ever do is rob it." And he was probably right. I still have dreams of robbing a bank and I picture myself riding up on a white horse to hold up the cashier.

I joined the Marines in the morning and in the after-

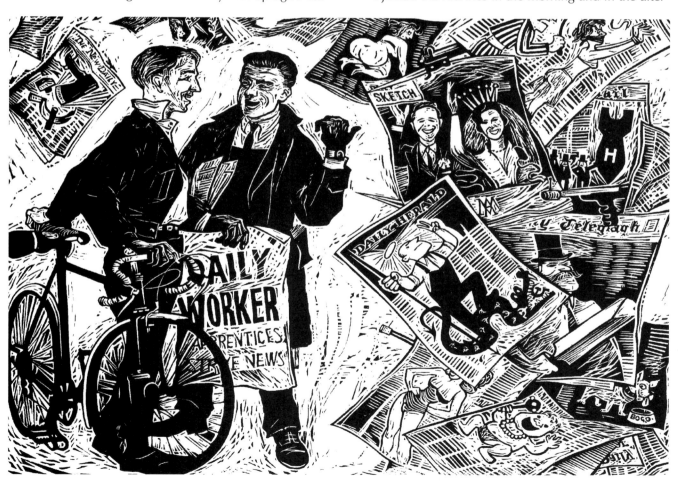

noon I went to the People's Bookshop, 133 St. Mary's Street, Southampton, which was the district headquarters, to join the Communist Party. That was in 1944. People today may think that's ridiculous, a total contradiction, but it wasn't then. The Marines had the reputation of killing more Nazis than anyone else and the Communists were seen as the only real political force opposing the Nazis, and at that time the two went together, so my decision has to be seen in that context.

The room where my party branch held its meetings was called the Unity Club in Eastleigh and this is where they sent me to join. I knocked and a bloke opened the door and asked me what I wanted. "I want to join the Communist Party," I reply. "Wait a minute," he responds, and closes the door again. I hear a drone of voices inside, then the door reopens an inch – "What's your name?" I tell him my name and the door closes once more. I think I'm applying to join a secret society – which of course it pretty well was in those days. The door opens to a slit again. "Are you related to Reggie Sprague, the train driver?" "Yes I'm his son." "Oh come on in then lad you're welcome." If my father hadn't been on the railways I'd probably never have been allowed to join. Being the son of a member of the working class was considered the best credential.'

Sprague's description here of joining the Party is probably quite unique even at this time and the attitude of suspicion may have had something to do with the fact that Joe O'Farrell, the District Secretary, was an ex-IRA man. In the thirties the Party had emerged from its early conspiratorial beginnings and was recruiting openly and widely in its attempt to build a mass party.

The thirties saw the outbreak of the Spanish Civil War, which was the opening salvo of World War Two. The outrage at the butchery of the young Republic and the indifference of the other European governments brought many intellectuals, artists and workers into the Communist Party. In the forties the Soviet Union became our ally and the dictator Stalin became transformed for the duration of the war into "Uncle Joe." For a politically aware, working class teenager like Sprague, joining the Communist Party was a logical step.

On top of this, the Communist Party conferred on those joining a new dignity and sense of worth. It considered the working class to be the motor of history, the workers became active historical subjects, not mere passive objects on the historical stage. There was also the intellectual stimulation and a place where Sprague's skills as an artist and draughtsman were wanted and valued.

The immediate post-war period, too, was a time of strongly held beliefs and optimism, perhaps difficult to

imagine today. Many really thought socialism was around the corner. Despite Churchill's enormous standing after his heroic conduct of the war, the people wanted a change and swept Attlee's Labour Party to power. This was, on the part of many, a genuine vote for socialism, but their hopes were soon dashed by the onset of the Cold War. Those who were in the Communist Party still believed that revolution was imminent and that every little effort counted. It wasn't a party you joined to become a passive card-carrying member – everyone was expected to be an activist. Sprague immediately plunged into work on behalf of the Party, and one of his first tasks was to help local people fighting evictions.

'While most working class families accepted their lot with stoicism,' Sprague says, 'some attempted to elevate themselves to the middle class. Opposite our house, there lived a Labour councillor who, as a sta-

tionmaster, actually wore a top hat and thought of himself as a cut above us lower mortals. His ambition was to become mayor. He owned the house next door and once tried to evict the family that lived there for rent arrears. I supported them and actually won the case against the landlord. That helped politicise me too. Afterwards I fought a lot of eviction cases and became known locally as the "Eviction King". That Labour councillor never became mayor and his wife never ceased bemoaning the fact that now she'd never become Lady Mayoress.

His son and I were the only two in our street, of those who joined up, to return alive from the war but his son had lost a leg. He did manage to get a job as, of all things, a window cleaner but fell off a ladder and was hospitalised for a long time. So fate treated that family really badly. They were only ordinary working

class people who had ambitions to better themselves, but to achieve that they sold out, although they wouldn't see it that way. They'd see it as rising above the rough necks, of moving up in the world and sod everyone else.

I was involved in fighting about 15 eviction cases and I soon picked up the essential elements of the law. I also adopted a bulldog approach, which usually intimidated the opposition and avoided the necessity of going to court. One eviction case I took up concerned a very poor family with a mentally-handicapped daughter. They lived in a company property – the same company for which the daughter worked. It was one of those post-war, fly-by-night companies that bought up sub-standard blankets, largely from the army, and used cheap labour to repair them, and then sold them on. I fought the company and we won. The family remained in the house, but as a result the daughter was sacked. Now for her, this was a paid job, which was not easy to come by with her disability and the income, small as it was, represented a vital supplement for the family. I was very concerned about what had happened,

So I went to see Joe O'Farrell, the district secretary and Harry Pollitt. I told them that I felt guilty over what had happened, but Harry said brusquely: "Don't come to me with your guilt, go out there and take responsibility for what has happened." Now that shocked me, but he then softened his tone and added: "and when you've done it, let me know what the outcome is." So I went back and managed to find the girl another job. When I told Harry, he wrote to me and said: "Well done lad!" That was an important lesson for me. As a political leader, you have to be prepared to take decisions which may be wrong and may even lead to disastrous consequences, but you have to be able to take responsibility for your own decisions otherwise you'd never make any.

I went to my first party education class in the village of Fair Oak, outside Winchester. This introduction to Marxism opened a door onto a whole new world I never dreamed existed. The Communist Party was my university, without a doubt. The classes were led by an armchair Marxist called Bill Allen, and he really did sit in a big armchair and propound about Marxism. But such classes were an ideal way to learn. I used to walk home afterwards as if on air.

Even the simple things that Marxism teaches you, like the connectedness of all things, as simple as it sounds, provided me with a key to understanding how my art and I related to the world. It helped make sense of my life and gave me a methodology for approach-

ing what at first sight appear to be complex problems. Marxism helps demystify them. Such tools can be applied in all areas of life – art, psychology and education. What the Communist Party didn't fully accept, however, was that there were other people thinking creatively apart from Marx and Lenin, people like Freud, Russell, de Chardin and many others, who recognised that connections can work in different ways. Human behaviour is not just about whether you are being paid well or organised in the union, it's also about more complex matters. The Communist Party when I first came into contact with it in the thirties was an incredibly creative organisation, but with the increasing domination of Stalinism and the slavish following of the Soviet line, it became increasingly narrow and intolerant.

After I'd obtained my degree, or national diploma as it was called then, in design-illustration, I started looking for a job, where I could use my artistic skills, but it was a futile effort. Being already in the Bournemouth branch of the Party, I started a peace movement at the art college. The local paper, the *Bournemouth Echo*, carried a front-page story castigating me as a dangerous college revolutionary, and after that I stood no chance of finding a job in the area. It was an outrageous article, accusing my mother of being a leading Communist and misleading her son. My mother had never been in the Party. We could have taken out a writ for libel, but we didn't know how. After that, my name was known throughout the town and I found myself blacklisted.'

The train to Jericho

Sprague, the idealistic young Communist, was determined to do his bit for the international working class movement. He'd been too young to fight in Spain, so he decided to return to help war-devastated Yugoslavia, joining a group of volunteers in 1948.

After Tito's partisans had driven the Germans out of Yugoslavia, he became a hero for the Left. The western allies mistrusted him, as a Communist, and tried to reimpose a monarchist regime on the country, but this was unsuccessful. Yugoslavia was given no Marshall Aid by the West at this time despite the fact that the country had been totally devastated by the war, so volunteers went out to help rebuild the rail and road infrastructures. E.P. Thompson, the historian, was one of those who went,

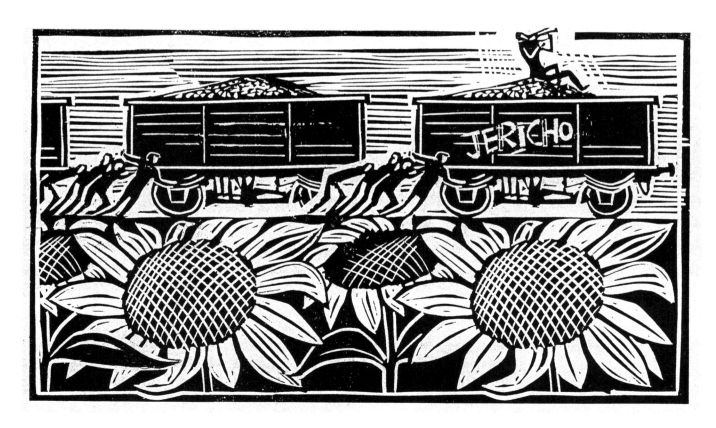

along with many other Communists and Socialists. This was before Tito's break with Stalin and his being cast as a pariah within the Communist movement.

'We were detailed to work on road building and after we'd completed the hardcore base,' Sprague relates, 'we reached the point where we desperately needed gravel for the last surface before the concrete went on. We had no proper tools, only homemade wheelbarrows and a few shovels. We were told there were wagonloads of gravel about five miles away but no engine to pull them. We set off and walked to the place and there they were. I had only 16 people in my brigade and there was no way 16 of us could move the wagons, so we were confronted with an apparently insurmountable problem.

I'd become leader of the group superseding an awful character who worked for the *Observer* newspaper and, it later turned out, also for the secret service, spying on all those young kids who'd volunteered to come out here and help. He wrote some vitriolic things about Yugoslavia in the paper on his return.

One day a New Zealander in the brigade, Brian Moore, became very ill with dysentery and was taken to hospital. A Glaswegian bricklayer and I took the day off and walked fourteeen miles along the railway track to the hospital to bring him back. He was being looked after by young peasant girls with no shoes on their feet, little experience and no medical equipment. We had to "kidnap" him and bring him back to camp because we were all on a group visa and wouldn't be allowed back home with one of the group missing.

It was pitch dark when we arrived back and it was raining like hell, so we were soaked through. This guy hadn't kept any food for us and we were starving, so four of us took him outside and dropped him in the mud and pushed his face in it. After that I became the group leader.

We had 16 in the brigade and there are 16 compass points, so I drew a compass in the sand and, early in the morning, I sent everyone off in the 16 directions. Get back here by one o'clock, I told them, with as many people as you can find. By midday one old lady had arrived, together with a mentally retarded boy carrying a bugle. They pushed a wheelbarrow full of rotting lard – you've never smelt anything like it in your life. There were no men left, they'd been slaughtered by the Nazis and the Ustashi – their own homegrown fascists.

The wagons had been standing there for years, and were rusted solid. There were even vines twining up through the wheels. We took the rotten lard and smeared all the wheel bearings. The smell of it on our hands was horrifying. Every few minutes the boy blew this damned German bugle and I could've killed him, but he was the only male left in that village. One o'clock comes and there's nobody, two o'clock comes, still nobody, and I think it is another Ken Sprague cockup. But a few minutes later I'm able to discern a small black line moving over the horizon, just like in a cowboy film where the Indians appear over the brow of a hill and are about to massacre the settlers in their wagon train.

Finally we had a circle of people approaching all around. There must have been hundreds, men, women and children, even babies. So I got them to stand on either side of the trucks and they began to take care of their own organisation, putting the women with babies in such positions that they could drop out if and when the thing started moving. My Yugoslav was virtually non-existent, even though they could understand the rough import of my shouting at them. I made a little speech, which was translated, and said, when I drop my handkerchief you all push and we'll keep pushing the five miles. Well it was laughable, we all pushed and nothing happened of course. Then I suddenly had an idea. I went to the far end where the bugle boy was and grabbed him by the ears and stood him on top of the first wagon. He was frightened, but realised, despite his mental deficiency, that this was his moment, all eyes were on him. I dragged him along, shouting his head off and the peasants were all laughing – they could be pretty heartless. There were probably about 20 trucks in all – a lot of weight. So I told him, when I tell you to blow, you blow that bloody bugle like you've never blown it before. He loved it because all eyes were on him. When he blew it sounded like the trumpets at Jericho. And everyone gave a final heave and do you know, the trucks actually moved and the momentum kept them going. So we had them rolling and people gradually dropped off, the women with babies, the old and kids first. If you start ordering them about you won't get much response, but help them create their own organisation and it works. That's the mistake the trade unions sometimes make and the Communist Party did too – telling people what to do, rather than letting people organise things their own way.

I wrote about this experience in the *British Psychodrama Journal* and called the article, "The train to Jericho," because I reckon it wasn't the trumpets that brought Jericho's walls down, it was the inspiration the trumpet sound gave to the besiegers to make that final push that did it – art in the service of an idea!'

The Bournemouth branch

Sprague returned from Yugoslavia to his hometown of Bournemouth, where he continued his work for the Communist Party.

'It was a good Communist Party branch in Bournemouth, and during the thirties quite a number of Jewish people joined, because they saw the danger of Fascism taking power in Britain too. Mosley's Union of Fascists was growing considerably and had the backing of the national press in the form of Lord Rothermere's *Daily Mail*. Jewish people recognised that the only force that would stand up and fight the Fascists was the Communist Party. Two of the members of my branch at the time were the Forte brothers. They owned an ice cream parlour and would always donate a tub of ice cream for Party events. One of them went on to become Sir Charles Forte, the hotel tycoon, but I don't know what happened to his brother. In the late forties the Bournemouth branch had about 30 activists, maybe more members, but its real strength lay in the influence it had in the local trade unions and Labour Party, far beyond its numerical strength.

Joe O'Farrell, Hampshire and Dorset Communist Party District Secretary, felt the British Communist Party was somewhat lacking in revolutionary fervour and often referred to it scathingly as: "His Majesty's Communist Party." I left school without being able to read and he was the man who actually taught me how to. He used the simple ruse of telling me to see words as pictures. "Not like the ones you do," he said, "but pictures nevertheless. Once you can read, you can communicate with the dead, authors who died hundreds of years ago." The first book I read was *Voyage of the Beagle* and reading opened up a whole new universe to me. Joe was a very sensitive man and was one of the first to be interested in my drawings, asking questions about why I'd used a thick line here or thin lines there.

Joe O'Farrell only had one eye – he lost the other while defending the Post Office in Dublin in 1916, while a member of the Citizen Army, alongside James Connolly and Padraig Pearse. He had a pure Irish sense of humour. He returned from the war where he had been a sergeant in the infantry. How he pulled that off with only one eye, I don't know.'

"No pasarán" – how we stopped Mosley

'The war was hardly over before Mosley began reorganising his British Union of Fascists again. In 1946 he'd called a meeting in Bournemouth. The town had been his biggest recruiting ground in the thirties with all its retired army officers, and, of course, their servants. Many of the servants became blackshirt footsoldiers because their boss told them to, and the old army officers became the staff. This constellation was beautifully reflected in Ishiguro's novel *Remains of the Day*. Bournemouth had a 36,000 Tory majority in those days, the biggest in the country. Perfect recruiting ground for Mosley.

Although the war in Europe was over, Sprague was still working at the Vickers Marine research establishment, and on this particular day he was at Southampton Docks unloading coffins containing the corpses of British soldiers. They were still finding bodies under rubble and in unmarked graves.

'Out of the blue, I got a phone call from Joe saying, "Mosley's coming." (Mosley had been interned on the Isle of Man during the war under paragraph 18b. He was released at the end of 1943 from Brixton, the prison

to which he'd been transferred, on grounds of ill-health.) Joe tells me to come immediately to the Party bookshop in Southampton. I now have a serious problem. I am in a secret research establishment and I get a call from the Party district secretary! I have a word with the lads who agree to clock me out. I go round to the back and climb over the barbed wire fence, walk to the village and get the bus to Southampton. I enter the bookshop, down a narrow, dingy corridor, stacked with pamphlets, into a tiny room at the end, wreathed in smoke and packed with big Irish dockers. Joe sat at the far end of the table. He says, "Sit down Ken, Mosley's coming and he's going to Bournemouth tonight for a meeting to rekindle the organisation. Well, we're going to capture him." Joe had an informant in Mosley's organisation and that's how he knew the whole itinerary. I said, "that's great, but what do you want me for, you've got enough muscle here to do whatever you

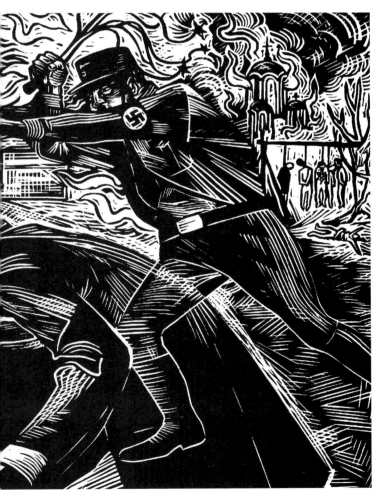

want?" "Ah!" Joe said, "but a job like this needs an artist." I think he meant it, maybe there could be paintings and drawings about it, but I also knew that having done basic training in how to use a sten-gun and the fact that he had a sten-gun, there were perhaps other reasons for wanting me there! I thought, Jesus Christ, I'm still officially a Royal Marine. I'll be sent to jail for the rest of my life. The aim was to capture him near Lyndhurst in the New Forest. He was supposed to come through at 6.30 that evening. I wasn't against it, I supported it – I'd have done anything Joe wanted, but I was apprehensive.

So we clamber into two little, ramshackle vans. I sit next to Joe who's driving one of them. All the heavies get in the back. I'm the artist, I don't go in the back. I have a seat in the front with the driver. As I get in, I look around and see there are picks and shovels on the floor and think, hell, they're going to bury him!

We lay by the side of the road and waited. In a side road there was a farm cart ready to be pulled out into the road and further down, a coal lorry to block him in. He usually had four cars with his officers and staff. I had a watch, my first one, and I noticed it was already past 6.00 and the meeting was due to start at 7.30. Mosley always started 15 minutes late, it was part of the build up, then he would march on stage to a fanfare of cheering and banner-carrying blackshirts – a Hitler tactic. But at 7.00. I said, Joe, he's not coming. "Bejeebers," says Joe, "I hope nothing has happened to the poor fella." We pissed ourselves laughing. Mosley never did come. He packed his bags and went to France, where he bought a small villa and lived there to the end of his life. I reckon, maybe deliberately on Joe's part, he'd let him know what was going to happen and he realised if he stayed in the country Joe would get him, without a doubt. Was I thankful that nothing happened!'

Mosley hardly ever set foot in Britain again. He did try unsuccessfully in 1958 to resurrect his fascist movement on the back of the race riots in Notting Hill, calling for a ban on mixed marriages and for the repatriation of black immigrants, but he was quickly rebuffed.

Questioning infallibility
'Harry Pollitt, the well respected first Communist Party General Secretary, came to Southampton in the late forties to address a meeting in the civic centre. It was the first time I heard him speak. I had designed the stage decorations – a huge red star, and as you went out, hanging from the balcony, were two huge ten foot banner replicas of his pamphlet, *The Way Forward*.

I was behind the stage after putting up the decorations before the meeting and I saw this powerful little fellow pacing up and down, terribly nervous and I remember someone was in his way and he just pushed them aside. It was well known that Harry was very tense and nervy before a meeting.

He made his speech and the meeting finished at ten in the evening. It had been packed – they were big meetings in those days, often 600 to 1000 people. In the post the very next morning I got a little card, saying thank you for the decorations, they were outstanding! Now Harry had written this and put it in the post after the meeting. So I always retained a warm spot for Harry. But when he spoke about art he didn't know what he was talking about and I thought, wait a minute, if he doesn't know what he's talking about on a subject I do know, what about those things I don't know, who knows if they are correct?

At the time of the Yangtse incident in China, the Communist Party called another meeting in Southampton, to be addressed by Pollitt, and I was asked to chair it. When I turned up, Harry said to me: "You're not chairing my meeting looking like that. Enough people already think we're mad without you confirming that we're scruffy as well. Go home and put a suit and tie on." I didn't have a suit or a white shirt, so borrowed one of my father's shirts. I got up to address the meeting and suddenly a tomato came flying through the air and hit me right on the chest, splattering all over the shirt. I carried on speaking, introduced Harry and then went down onto the auditorium floor and clobbered the bloke who'd thrown the missile. The next morning I had a call from Joe and Harry to come to the party offices immediately. I was given a dressing down by Joe and told in no uncertain terms: "In future wait until the meeting is finished before hitting the customers." Harry didn't say a word. As I left and closed the door behind me I heard the two of them laughing their heads off.

Some months later I heard Pollitt talking about the 'Russian Brides'. (This was a much-discussed diplomatic issue at the time. 200 Russian women had married British soldiers, airmen mainly, who'd been stationed in Russia during the war and the Soviet Union was refusing to let them leave to join their husbands.) He spoke about how the Soviet Union couldn't let these girls leave their motherland and be at the mercy of the capitalist world. It was total rubbish. They were doubtless in love, crazy about one another – 200 of them. Was the Soviet Union going to fall apart because they let these girls go? Half of them would probably have returned after a time anyway. I thought, bloody good speech, Harry, but it's complete baloney.

Years later I heard Johnny Gollan, who became General Secretary after Pollitt's death, talking about things I did know about and he was wrong too. And again, I thought, what about all the things I don't know about? How do I know he's right? So I began to question much more from then on. It didn't weaken my resolve to remain in the Party; in fact it strengthened it in many ways. I believed in loyalty and staying to fight on from within and change it into what it could be. I formed the opinion, a rather heretical one, that the history of the world is the history of creative men and women coming up with fantastic ideas which are distorted or corrupted by their followers as quickly as they're able! But that doesn't mean that you kick the ideas out. I've since read the Koran and the Hindu Bha'gavad-gita and there are good ideas there too, but then the followers of these religions start killing each other,

because each thinks only they have the key to truth.

I loved Harry Pollitt, he was a great man. He once told me the working class "needs artists." Interestingly he didn't say "the Party," but the working class. He was enormously encouraging to me. He would say: "A picture is worth a thousand words" (a variation, interestingly, on William Hogarth's "Ocular demonstration will convince...sooner than ten thousand volumes."). However, although the Communist Party and the trade union movement paid lip service to this, they preferred 2000 bloody words rather than a picture anytime, and that's where they fell down.

My reasons for battling on with my art, working for the Labour Movement, were to no small extent because I believed Harry's words. I must have turned out more drawings for the Communist Party than for anyone else – the title "Communist Artist" certainly applies to me. There were lots of artists in the Party in those days, but they did paintings of country scenes and still lives, spending their time at party meetings talking about art, but I don't remember too many of them doing much for the Party.'

Our boy in the North

'It was 1948 and I now had a girlfriend, Sheila, whose parents were very much opposed to me and certainly anti-Communist. They were pillars of the local Methodist church, and they managed to find their daughter a job in Carlisle, as far as you could get from Bournemouth without leaving England. It was a job teaching in a girls' preparatory school. She was already 19, but in those days, like most girls, she had to do what her parents told her and had to be in by ten at night, that sort of thing.

So Sheila leaves for Carlisle and I manage to land a

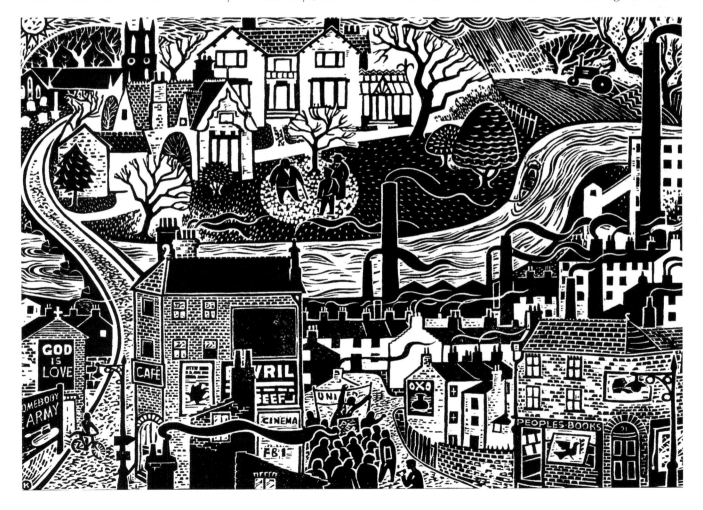

job with the Boy Scout Movement. The Editor of the Scout newspaper, *The Scouter*, who had already published some of my drawings, asked me to go to a scout convention in Scarborough and do some sketches of the main speakers for *The Scouter*. He paid my fare and I got about £3 a drawing – a good payment in those days. My father was only earning little more than £3 a week. I thought I'd hit the big time.

One of the speakers was Baden Powell, but the main speaker was the Duke of Edinburgh. He sauntered in, took his jacket off and sat on the edge of the table, like one of the boys. It was all part of the act. And he talked utter rubbish. I did a series of not very complimentary drawings, but they still published them! After the convention was over I hitchhiked to Carlisle, and Sheila told me that there was a small mining company where I might be able to find a job.

I am interviewed by the company director of the company which produces coal-washing machinery. "Your cards show you haven't worked for nine months," he remarks. He no doubt thinks I've been in jail because everyone was in work in the immediate post war period. So I decide to tell him the truth because I think it will come out anyway. I'm very sorry Sir, I said, but I haven't worked because I've been blacklisted, I'm a Communist. "Well, we won't bother about that," he says laconically, "you can start tomorrow, but you'll have to get some experience down the pit."

Two weeks later I contacted the local Party branch, which met above a book shop in the city. I went to the meeting and as the secretary called it to order I realised it was Walter Wallace, the company director, who'd just given me the job!

From 1950 onwards, I spent four years in Carlisle, although I also lived for a time at the centre of the Yorkshire coalfield, in Barnsley. I worked in pits at Whitehaven and at Gresford, where the seams went under the sea – years before there had been a disaster in a pit just like this and 37 miners were drowned when the sea flooded it – and then Cortonwood, which sparked the '84 strike.

After doing a stint underground, I was transferred to the drawing office. They were still sorting the coal by hand at this time. During the war women had done this work, but now the older miners were doing it. They already had silicosis, but in the sorting sheds you've never seen such dust in your life, despite continuous spraying with water. I went to see Walter and said, "look I know there is no money for development, but it wouldn't take much to lift the roof – take it up 15 ft." It was only a corrugated tin roof and I reckoned it would make a difference, because the dust rose. They did what I suggested and it cut the dust by around 40%, just by allowing it to rise. The miners themselves used to take pickaxes and smash the windows, to let the air in and the dust out. Then it was chillingly cold with the wind coming in. Later Walter had extractor fans put in. He became the leading authority on cleaning coal.'

While living in Cumberland, Sprague became a

member of the Party's district committee and also stood as a candidate in the local elections, his first such experience. He was also working as a cartoonist for the two Carlisle papers – one a Conservative and the other Liberal-inclined. He managed to get away with this by using totally different styles and pseudonyms and neither knew that he was working for the other, until he was inevitably rumbled.

His drawings at the time were all political, as were his prints, very much imbued with the Communist philosophy he'd taken so much to heart. He also had a job teaching an adult art class one evening a week at the local college. He had to rush home from work for a quick clean-up before going to the art class.

'I'd finish my shift and jump on a bus, desperate to get the coal dust out of my nails before I arrived at the college, trying to look like a teacher, rather than a miner. My pupils were mainly middle class ladies from the area, solicitors' and doctors' wives. We couldn't afford proper models, so I shocked them one day by bringing in a tramp to model for us. They were all a bit embarrassed, so I broke the ice by asking this woman to tell us something about her life, which she proceeded to do. I said, you've had a hard life and she replied: "Ah yes but when I was young it was all trout and butter." Now there is real poetry in those few words.

While I was in the North about six of us formed a group of progressive artists. We were all working in a similar way, we were realists and we all had a basic working class consciousness – we wanted our art to be relevant to working people. Norman Alford was one of them, along with Bob Forrester, Theodor Major and several others whose names I have forgotten. Norman was one of the first British officers to enter Belsen concentration camp at the end of the war, Bob was a factory worker and a naturally-gifted painter. To launch the group we organised an exhibition in Carlisle Art Gallery. We asked a number of leading artists to donate paintings for the exhibition to hang alongside our own. Victor Passmore sent one and L.S. Lowry offered one too. It was winter and I had to cross Shap Fell on my bicycle to fetch it. I got to his house, stiff with cold. I was amazed to find the place stuffed with clocks all ticking away, like some gigantic time machine. What's all this? I said. "Them's clocks me lad," he replied, "I likes clocks." We didn't have much more of an exchange, he was a man of few words. I took the painting, wrapped it in brown paper and oil-cloth, tied it with string and took it on my bike back over the Fells. Much later that same picture was stolen from the Kaplan Gallery in South Kensington and it was valued at £120,000 and I thought, yes and it's been over Shap Fell

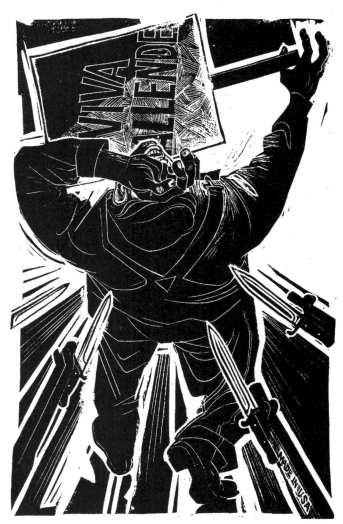

on my bike. He was a good old boy was Lowry. It was wonderful to have two father figures of British art exhibiting alongside us. For several years after I'd left Carlisle, I returned to give an annual lecture at the Art Gallery on Thomas Bewick, who had lived and worked nearby in Newcastle, and was one of my artistic heroes.'

The Artists International Association

It is scarcely credible today to imagine the artistic ferment there was in the twenties and thirties in response to the Russian revolution. It galvanised artists from every branch who threw themselves into the struggle to build a better society. They put their art at the service of the "common good", becoming involved in a whole variety of popular events. There were workers' theatrical groups, particularly Unity Theatre in London, pageants and musical performances were organised for which enormous backdrops were designed and banners painted, posters produced, books and magazines were pub-

lished. Composers like Benjamin Britten worked with Communist librettists, Barbara Hepworth and Henry Moore contributed works to Communist-organised exhibitions, and poets like Stephen Spender wrote paeans in praise of socialism. For a short time artists became again connected to the society in which they lived. The Cold War destroyed that link through the worldwide ideological polarisation that resulted from it.

Cliffe Rowe, a young Communist artist, went to the Soviet Union on holiday in 1932 and managed to get a job as a graphic artist in Moscow. On his return in 1933, and on the urgings of his Soviet friends, he founded the British nucleus of the Artists International (AI). The aim of the AI was to be a forum for progressive artists and offer them a channel for political and social expression. It was not intended to be a Communist artists group, although it was Communists who set it up and for a long time played a leading role. The Communist Artists Group, which was formed later, was for Communist Party artists only. Most of its members would also be in the AI, but its role was different. It grew out of what used to be the Hogarth Club, a grouping of radical artists, mainly Communists, which was formed in the twenties and took Hogarth as an example of a socially critical great British artist. The Party, from the thirties onwards, had around seven different cultural groups, from writers to actors and film-makers and they had an enormous influence on British cultural life during that period. The organisation of the AI was loose and although it had around a hundred Communist Party members, it was never a Communist Party organisation and was thus not constrained by Party policies on art.

Cliffe Rowe was a modest, but very talented man who could have been a renowned artist if he'd had the time to devote to it instead of having to earn a living. Geri Morgan, one of the early members of the AI along with Rowe, recalls walking with him up Primrose Hill. They were discussing the merits of Picasso's work and Rowe said: "What Picasso achieved was like an Olympic champion diving from the top board. He dived, though, without being certain that there was any water to dive into. I have no head for heights and wouldn't have had the nerve to do it anyway and, on top of that, I had to earn a living."

One of the early members of the AI was the painter William Coldstream, former head of the Slade School of Fine Art, who said: "The 1930 slump affected us all considerably. Through making money much harder to come by it caused an immense change in our general outlook. ...Two very talented painters, who had been at the Slade with me, gave up painting altogether, one to work for

the ILP, the other for the Communist Party. It was no longer the thing to be an artist delighting in isolation." This comment sets the framework of those times.

The founding members of the AI had grown up in the twenties and had responded to the deepening economic and political crisis by acting collectively to form the organisation. There had been many occasions in the past where artists had collaborated around particular artistic programmes, but there had never been a group of artists brought together solely by their sense of social responsibility.

The founding meeting of the Artists International took place during the autumn of 1933 in Misha Black's studio and among its founding members were James Boswell, a New Zealander, James Holland and James Fitton – known collectively as the three Jameses – and several others, about six people in all. Francis Klingender (the author of *Art and the Industrial Revolution*) was also involved, as was Millicent Rose, his partner. Black later became the first professor of Industrial Design in Britain, at the RCA.

In the AI's first manifesto published in the Artists' International Bulletin in 1934 it stated as its aims:
1. The uniting of all artists in Britain sympathetic to these aims, into working units, ready to execute posters, illustrations, cartoons, book jackets, banners, tableaux, stage decorations etc.
2. The spreading of propaganda by means of exhibitions, the press, lectures and meetings.
3. The maintaining of contacts with similar groups already existing in 16 countries.

It goes on to record in more detail how this programme was to be implemented.

Writers International, a parallel writers organisation was founded in April and the two organisations worked closely together. One of its members was Virginia Woolf who, in 1937, wrote an article for the *Daily Worker* arguing the case for artists to be politically active.

By 1935, responding to the calls for a Popular Front, a new policy had been adopted and it now became known as the Artists International Association and its new rallying call was: 'For the unity of artists against fascism and war and the suppression of culture'. There was widespread and growing support at the time amongst all democrats for a broad coalition to defeat fascism and this became known as a Popular Front. The AIA organised regular discussions on Socialist Realism, about content and form, abstract art, Russian art and experiments for a new socialist art. It worked together with the Marx Memorial Library and the Workers' School in organising lectures and exhibitions. The AIA

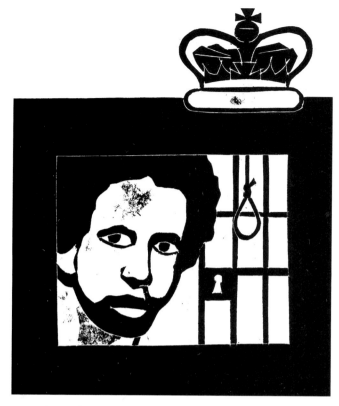

was also a forerunner in its attempts to break down traditional barriers between commercial art and fine art and in placing art at the service of working people. It had its own regular newsletter which was edited first by James Boswell, then Paul Hogarth and later by Ray Watkinson. It had premises in Compton Street in Soho, which were also used as a gallery. A commemorative 50th anniversary exhibition on the AIA was mounted in Oxford in 1983 and later came to London.

The AIA received a real boost during the Spanish Civil War, which gave it a focus and purpose as an "international" organisation. It attracted many leading artists to its cause, among them, Eric Gill, Laura Knight, Henry Moore, Augustus John, Barbara Hepworth, Ben Nicholson, John Piper and Herbert Reid, the anarchist art critic – the cream of the British art world. At this time it could boast almost 1,000 members.

The AIA organised a number of very successful anti-fascist art exhibitions in aid of campaigns such as help for the Basque children who had been made refugees by the Civil War. In 1939 they also launched the "Everyman Prints" scheme – cheap art posters which ordinary people could buy – the art equivalent of the paperback. The artists forming the AIA were a mixed bag and, as with any group of artists, there were huge differences of approach, much individualism and self-promotion but, despite this, it did still function and made its mark.

Artists for Peace was also a non-party radical artists grouping which grew out of the AIA in the early fifties and campaigned on an anti-war platform. A committee was set up by artists like Stan Young, Geri Morgan and Peter de Francia. The latter invariably supported the Party Artists Group and their initiatives but was never a member of the Party. It was supported by John Berger, another "fellow traveller", and artists like Josef Herman, Stanley Spencer and Tom Kinsey.

With the end of hostilities with Germany and Japan, and the hardening of the new Cold War divisions, the AIA became a victim of these divisions. Those forces which had brought about the expansion of the AIA in the pre-war period were also the ones which brought about its demise in the post-war period. The rapid escalation of the Cold War, the rise in anti-Communism and Stalin's autocracy produced a steady drift of intellectuals and artists from the Party. The CIA was also increasingly active in Europe after the end of the war and targeted what it perceived as Communist-front organisations. Any progressive artist or cultural organisation which showed sympathy with socialist ideas or with the Soviet Union was deemed suspect.

The AIA also became internally polarised as a result and was subject to an attack by a right wing faction. This group attempted to take out the militant politics from the AIA's constitution. A ballot was held and the right wing lost, but ballot boxes went missing and this caused a minor furore, also contributing to the organisation's demise. Its political objectives were eventually abandoned in 1953 and, with the drifting away of many of its leading lights, it lost its raison d'être.

The 1953 demise of the AIA took place after it had organised an exhibition *The mirror and the square* in 1952. The exhibition attempted to show the range of art practice at the time, but the arguments over formalism and realism at the height of the Cold War, which were reflected in the exhibition, in the end tore the AIA apart. It did though continue to function, albeit in an emasculated form, until 1971. Abstract art became synchronous with freedom; realism and social commitment were tarred with the brush of Communism and oppression. During the Cold War artists were, irresistibly, consciously or unconsciously, co-opted into the armies of the Cold War – abstract artists were drafted onto the side of capitalist freedom, and figurative ones were placed on the side of Communist dogma.

An exhibition, *Art for Society*, was organised in 1978 at the Whitechapel Gallery forty years after the big AIA exhibition to demonstrate the "Unity of Artists for Peace, Democracy and Cultural Progress", and as a sort of homage to politically committed artists. It was organised by Nicholas Serota and Martin Rewcastle and was

one of the very few post-war attempts to take "political art" at all seriously. Ken Sprague was among the artists exhibited and the *Sunday Times* art critic, William Feaver, in his review of the exhibition, said of his work: "Ken Sprague, the most practised and efficient image maker of them all, shows a school of fish organising themselves to devour a big predator and, in a couple of water colours, reveals himself to be something of a humane Burra."

Sprague, being of a slightly younger generation than most of the artists who set up the AIA, became involved in the mid-fifties when it was already in decline and then joined, together with some of those who remained loyal to the politics of the AIA, the Communist Party Artists Group. He was, though, clearly influenced by this tradition.

'We used to meet at the Garibaldi Restaurant once a week when I came to London in 1954,' Sprague relates. 'Cliffe Rowe, one of the founding members of the AIA, was the leading figure of the group. Rowe was a good artist who also produced a lot of work for the labour movement and was commissioned by the Electrical Trades Union to paint five murals for the union's college. His finished panels are a celebration of labour movement history and a classic example of realist mural painting.'

Even among the Party artists, however, there were divisions. The group was characterised very much by a divide between the "fine artists" or "easel painters" and the graphic designers. Artists like Harry Baines and Ern Brooks, who came from an industrial, printing background, as well as Ken Sprague, had different aspirations to the others. They were more practically minded and more in touch with working people and were more prepared to do the banner and poster work. Sprague never really felt comfortable with the "easel artists" and, as he saw it, their often precious individualism. He never conceived of himself in this mould and was of course influenced strongly by his own social background.

Sprague became active in the group, but by the time he joined most of its energy had been expended. Some artists had already been expelled, others had left. But even up to the end of the fifties and into the sixties many artists were still donating paintings to the annual art exhibition and later to art shows in support of progressive causes, like the Campaign for Medical Aid to Vietnam, organised largely by the Party Artists Group. The exhibitions were supported and opened by people like John Berger. 'But,' Sprague relates, 'apart from Cliffe Rowe and myself, hardly anyone was prepared to hang the paintings.'

The Communist Party Artists' Group never actually

formulated policy on the arts or produced manifestos, but was a loose discussion group. In practical terms its main contribution was the production of banners, posters and designs for Party publications. In its early days this involved an enormous amount of work, as demonstrations, pageants and meetings were organised on a regular basis. There were also book covers and leaflets to design. A number of local Party artists' groups also existed, some of which were very active.

Despite the espousal of the working classes by progressive intellectuals during the thirties, these feelings were, in the main, not reciprocated by working people and their organisations – the trade unions – remained largely indifferent. This, no doubt, had something to do with the fact that many of these intellectuals came from middle class or even upper class backgrounds making it often difficult to develop a proper two-way dialogue. There were of course exceptions. In 1945 the

We ended up going back to his place on his powerful Harley-Davidson and had a long conversation about art and the working class movement. The friendship established lasted over a number of years and he would send me a copy of his latest publication and I'd send him examples of my latest prints. Our relationship soured after he'd led a television discussion programme and we'd arranged beforehand that I'd get a large group of local people to watch the programme, then gather at my house for a bite to eat and some drinks. John agreed to come over after the programme and he would be able to continue the discussion with ordinary, but interested people. About 50-80 people packed into my house, keen to talk about art with a leading Marxist critic, but he didn't turn up. Only a week or so later did I receive a letter from him, which began: "Sorry Ken, I'm a real bastard but..." I never forgave him for that. But it was really more his loss because he missed an opportunity to discuss his ideas with ordinary people.'

Unity theatre and stage design

Unity Theatre, set up in London in the thirties, was established as a working class theatre and as a counter to what was seen as West End froth. Its aim was to put on plays of relevance to working class audiences and to provide an opportunity for Left-wing playwrights and aspiring working class actors to express themselves on stage. It was a school for many who went on to fame, and sometimes fortune, in the West End and television, people like Bill Owen, Lionel Bart, Alfie Bass and Ewan McColl. For the set designs, Unity drew on the talents of the Party Artists Group and Sprague was one of them.

He recalls: 'For a time, during the late fifties and early sixties, I worked with Unity Theatre designing scenery and backdrops. I did the stage sets for several of Shaw's plays, including *The Apple Cart*, and Chekhov's *The Cherry Orchard*. But the production I most vividly remember working on was Arthur Miller's *The Crucible*. I used cheese-cloth screens to divide up the stage and each area where the action took place was spotlighted. I felt it worked very effectively. I designed the set purely intuitively at the time, and only later, after reading Brecht, did I realise why I'd been doing it. I don't think such minimal and non-realistic designs had been used much on the British stage at the time. An Irishman, Joe McCullum, was the director. He was also the Advertising Manager at the *Daily Worker*, a gifted man who later went out to Australia to work full-time in the theatre and became a leading director there. The play was put on at the height of the Cold War, and McCarthyism, albeit in a

Amalgamated Engineering Union was the first ever union to sponsor an art exhibition in Britain, to commemorate its silver jubilee, titled: *The Engineer in British Life*. The exhibition was organised by Francis Klingender, a member of the AIA, who used it as a basis for his classic work, *Art and the Industrial Revolution*.

John Berger was closely associated with the Communist Party artists' group, and Sprague got to know him quite well. 'Although he was never a member of the Party as far as I know,' says Sprague, 'he was always supportive. I first met John at an exhibition and sale of paintings to raise money for the Party. It was held in an architect's premises in central London. A Bond Street gallery owner, who was a Party supporter, was giving a running commentary on the paintings. It was so tedious that I crept quietly out by a side door at the back of the hall. Unbeknown to me John had done exactly the same and we met on the stairs and had a laugh about it together.

slightly milder form, was being imported from the United States to Britain. I think that Attlee used it to control the strong left wing in the Labour Party, but also as part of some sort of deal with America, probably for security reasons.

Miller had written the play as a historical allegory set in the 17th century in order to facilitate its being staged in America. It was a great statement about witch-hunting and what that can lead to. Joe wanted to produce a play that was an impassioned outcry against the witch-hunting of McCarthyism – he wanted to make it contemporary. I could see his reasoning, but didn't feel comfortable with it. When I voiced my reservations about his interpretation, I was surprised to find half the group agreed with me, but Joe knew what he wanted, which put him at an advantage, because I only knew what I didn't want. The other half of the group supported him. The arguments became very heated and there was an impasse while we spent all our time talking and arguing. Everyone was involved, because Unity was run on very democratic lines and everyone from the ticket seller to the leading actor had a say. John Oxenbold, who played the judge in the play and was a born peacemaker, suggested, as a way out, that we telegraph Arthur Miller. (Sprague later worked with Oxenbold when he was editing *The Record* for the T&GWU) So that's what was done there and then, during the rehearsal. It was agreed that we would abide by what Miller replied. He wrote back, "If you produce this play as a great shout against McCarthyism, you will at best achieve cheap propaganda; if you produce it as a play about human integrity and personal courage you will have a fine anti-McCarthyite play but also one which will challenge bigotry and intolerance of any kind, in any historical period and in any society." That's the way we did it in the end without any more arguments and it was a great success. On the opening night many leading lights from the British stage were in the audience. Michael Redgrave was there, sitting next to my mother, and next to her on the other side sat Herbert Lom, the Hollywood actor. It was the first British production of what is now recognised as one of the most powerful plays of the 20th century.

Persuading the capitalist to pay for Nemesis!

As a labour movement artist Sprague was rarely paid much and often not at all for his work and so there was a constant shortage of money. Now with a growing family to feed, he needed to come up with ideas which paid and this was one that did!

'I'd done a series of ten prints called the *Arrogance*

of Power about the role of the US covert forces in Vietnam – this was before the war really started in earnest – and had secured a Bond Street gallery to exhibit them. Jack Jones, the general secretary of the Transport and General Workers' Union, opened the show. The printing bill for the ten prints came to around £735, but I didn't even have 7p. I wasn't going to recoup the money on them, so I was in deep trouble. My little printer, as poor as I am, is waiting to be paid.

I had heard that Thomsons, the travel company, had just bought up several small travel companies and now owned a string of hotels on the Spanish coast. So I had a bright idea: I took a Petanque ball and glued sticks of balsa all around it like sun rays and sprayed it gold and mounted it on a white marble base. I also did the same with a small silver deck chair and mounted it on a black marble column – that was the better of the two.

In the morning I went up to Thomson's headquarters. I'd been told Lord Thomson, the boss, would be in the office at 8.00am and no one else would be in the building. I drove up in my little van, but found the doorman was already there. I lied that I had an appointment with Lord Thomson. He said, "He's in the penthouse." "Thank you very much, I'll go up," I replied. He never asked me when my appointment was nor offered to ring first, so I went up in the lift to his office. He is at his desk, looks up and says, "who the hell are you?" He was a gruff character. "I've got an idea that will make you money", I said. With that, he hesitated. "Sit down, and tell me what it is." I told him: "Look, you've got a chain of 32 hotels in Spain, there are mum and dad

who've saved up all year to go abroad and they often get a crappy holiday." He never batted an eyelid. So I went on, "Look here's an award. You train your chefs to cook food to suit their English guests, but good food, fish and chips by all means, but nicely cooked. Then you give an award to the best hotel." He loved the idea. "What will it cost?" he asked. As I'd just been to Henry Moore's foundry in Fulham and confirmed that they could cast them for me for £382, that's the figure I gave him – quite a lot of money in those days. He was quiet for a moment and I thought I'd ruined it all by being greedy. But, went on to say, "if you want it done in bronze it will cost £735" – that's exactly the sum of money I owed the printer. So, Thomson said: "Right, I'll have 32." 'What do you mean, 32?' I asked him. 'You give one only to the best hotel.' "No, I want to give one to every hotel," he said. I sat there, stunned, and tried to calculate what 32 times £735 was, and I've never been good at maths. I was still trying to work it out as I took the lift back down and began to panic – did he really say it? Can I go to the foundry and give them the order? Well I did and they cast them all in about four weeks, which was amazing. So I drove back to Thomson's office with these things. They were heavy, so I could only carry them up two at a time. I went up and down that lift over and over again and when I got into his office, he just said, peremptorily: "Put them there against the wall." So I do as I'm told and stack them against the wall, but there is one still left in the van and I think, damn it, I'll keep it. And I've still got it at home. He didn't even notice!

I came out with a cheque for more money than I'd ever had in my life. I put it in the bank and rushed around to pay the printer. I then drove to Kensington in my old Ford and there in a posh car dealer's window was a beautiful Citroen safari. It cost £3,500, which was a hell of a lot of money. I drove it straight out of the dealer's show-room onto Kensington High Street. I put my foot down as I was used to doing on the old Ford and suddenly found myself doing 90 down the High Street! I came back and said, I'll take it. I asked what they'd give me for the old Ford. The salesman nearly dropped dead to see my old van parked outside his front window. He sent a minion out to drive it around the back quickly. He got in and turned the ignition and after an initial "grrh, grrh", there was an almighty crash and we went outside and, I couldn't believe it, the starter motor had actually fallen out and lay in the gutter. So we ended up pushing it round the back. I drove the Citroen home, parked it outside the house and showed Sheila, my wife. She told me to take it back at once. She thought I was off my head. But I never did.'

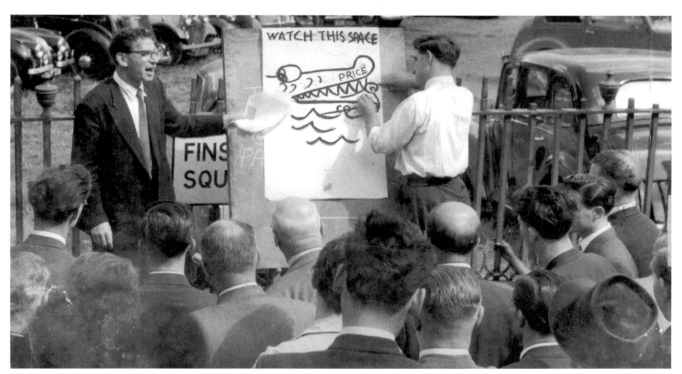

The art of economics

Up until the late sixties, public and factory gate meetings were still a feature of political life at the grassroots. There were still large factories and office blocks in Britain where hundreds or even thousands of people worked, and they would be willing to listen to speakers at the factory gate or out on the street during their lunch breaks.

'Every Friday, Solly Kaye or alternatively Sam Aaronovitch, both very bright and articulate comrades, would do regular meetings in Finsbury Square or at Tower Hill in the City of London. Thousands of office staff worked within the square mile, in the banks, insurance companies and the Stock Exchange. Solly Kaye was one of the Party's most renowned East End councillors and Sam Aaronovitch was an economist.

When Sam couldn't do the meeting, Solly would do it. They were both very good on economics. They would lecture on, for instance, the national cake and how it is divided up. I stood next to them with a big blackboard and would illustrate the points they were making, e.g. the relative sizes of the pieces of cake for each group of the population, with cartoon figures. The audiences loved it. Both speakers knew how to work with an illustrator and we became a practised team. They would pause and say: "Look, Ken's illustrated that point." We were there most weekends and would get up to about 600 people coming in their lunch hour. They brought their sandwiches and enjoyed the time in the sun while listening to the lecture. They're office workers, but working for big financial institutions so they're interested in what we've got to say because it's to do with their jobs. We invariably had hecklers, but most people were there to listen and the hecklers weren't popular. They might not agree with what you said, but they wanted to hear another viewpoint. The speaker would say: "OK, if you think it's propaganda, just look at these headlines in today's *Financial Times*", and there would be the evidence for the point we were making! There was an irritating bloke who came regularly and stood at the back shouting "Go back to Russia". He wore a bowler hat, pin-stripe suit and a Guards tie. We were sick of him turning up at every meeting, but not just us, the audience was too. We had interesting question and answer debates, but this bloke would still drone on with his "Go back to Russia." So I started drawing a red and green Guards tie on the board and Solly soon caught on and said: "You see it's not a simple black and white issue, it's, as Ken's showing you, also a red and green one." He was a smart operator. Then I drew a big green body – you can do that with drawings, manipulate real-

ity – and quickly added a big parrot's head with a speech balloon coming from its beak, saying "Go back to Russia." Everyone laughed, and we never saw that bloke again! You see, drawings can have that power, they can really hurt people. But it wasn't just Solly, Sam and me, it was also due to the strength of the listeners. The two of them knew how to tap into that interest and energy. I remember the last meeting Solly did, and after he'd announced his "retirement", people from the audience queued up afterwards to shake his hand and thank him for his lectures over the past months.'

I was Bertrand Russell's bodyguard

'Bertrand Russell, the philosopher and mathematician, along with a small group of other artists and intellectuals, formed the Committee of 100 in 1960. They did so out of frustration with the lack of progress made on the disarmament front because, despite its growing size and breadth of support, the Campaign for Nuclear Disarmament was making little headway in changing government policy. They thought the time had come for direct action, so they began by organising sit-downs in central London. I was asked to join the Committee, but declined because I'm not a committee person. I supported it from the start, though, because it was "having a go" and I offered to help. The Committee was frowned upon by the Communist Party, because the leadership saw it as just another example of middle class adventurism, and the fact that the trade unions were not involved damned it from the start in their eyes. But that wasn't the Committee's fault, it was largely the fault of the trade unions.

The Communist Party at the time was equivocal about the nuclear disarmament movement in general because it was calling for unilateral disarmament and, as the Soviet Union had nuclear weapons, the Party saw it as undermining the Soviet position.

Russell was a very respected and world-renowned philosopher. Despite his age – he was 89 years old – he was still prepared to go to prison for his principles. He'd once been a supporter of the atomic bomb as a deterrent, but in later life had come to the conclusion that it was immoral and wrong to possess it and threaten its use. One of the Committee's first direct actions was to organise a sit-down in Whitehall. So I had a call a few days before and was asked if I'd be willing to be a bodyguard for Russell. It wasn't that they thought someone would beat him up, but he was in his late eighties and rather frail, so I agreed to do it. It was scheduled for nine on a Sunday morning. There was, of course, little point

in organising a sit down on a Sunday in Whitehall when the ministries were closed and few people about to witness it, but that's what they did.

A few days before the planned event my wife Sheila was taken ill and I was obliged to organise a baby sitter for our three children. I couldn't find a Party comrade willing to help – they weren't going to support middle class adventurism! Saturday evening came and I still hadn't found anyone. Then there was a knock on the door – it must have been around 10.00 at night. I open the door and a CID man is standing there. I know who he is by his trilby hat, turned-up collar and big, heavy shoes. He introduces himself as Inspector X and asks if I'm Ken Sprague. I reply that he clearly knows who I am, as I'm well known in the area as the local Communist candidate.' (Apart from his contribution as an artist to the Party, Sprague also stood as the Communist Party candidate in his Sydenham borough council elections on several occasions, so he was indeed well known.)

'He asks if he can come in. Now in my family there is an unwritten rule that no copper enters the house. My grandfather had been a fence for the poachers in Devon and my father had been a union activist and seen how the police were used to break strikes. I was about to say No, when I realised this guy had no malice, so I let him in.

"Tomorrow you're going to be guarding Bertrand Russell in Whitehall," he tells me. I respond: Yes, you've obviously done your homework. "Indeed," he answers, "We've been watching you around the clock for the last three months." So what did you learn? I ask. "I learned that you've got some good ideas and I came to the conclusion that I don't want to arrest you tomorrow, which is what I've been told by my superiors to do. I've discussed it with my wife and I'm going to refuse to do it." Wait a minute, I say, you're probably in your mid-forties and have children? "Yes, I have three." If you go ahead you'll be finished in your job and probably lose your pension. I suggest you go away and leave me with my problem and just do what you've got to do and there'll be no bad feeling. "No," he said, "it's too late for that, my wife and I have made our decision. I also know that you can't find a baby sitter." (He must have listened in to my telephone conversations) "My wife has suggested that you bring the children to us and she'll look after them until you're let out. I've got my car outside, if you want to come around and meet my wife and see if the house is suitable."

'I'm really thinking now that this is a sophisticated set-up and I'm falling straight into it, but it is so mad it has to be genuine. We drive to his house, not very far away, in the next borough. His wife comes to the door, a real mother earth figure, and she shows me where she will play with the children – it's fantastic. So next morn-

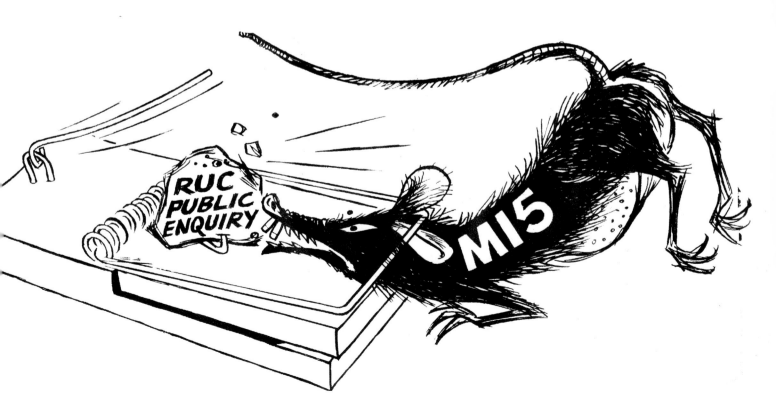

ing I bring the children to her – he's already gone to work and I don't know whether he's decided to take my advice or not, but his wife tells me he's sticking to his decision.

At 9.00 I'm sitting on the road in Whitehall next to Bertrand Russell and about 100 others. By pure chance I meet an old friend, Joe, walking down Whitehall and he stops to chat with me. When the police start arresting us, he is the first to be bundled into the van and he's only stopped for a chat! We're thrown into the Black Maria. I land next to my friend Joe, then Vanessa Redgrave lands on top of me and the late John Neville, another actor, lands on her, until the van is full. A special court has been set up and we are brought before the beak within hours. We are fined. My friend Joe nearly gets us all a prison sentence by asking the judge if he qualifies for a rebate if he pays in cash. His honour replies that we are in a court of law, not on the stage and promptly doubles the fine. Bertrand Russell is brought into court on a stretcher and is sentenced to two months in jail, later reduced to 7 days because of his poor health. I'm released, collect the children and am home that same evening.

About a fortnight later, I decide to go and visit the Inspector and his wife to take a bunch of flowers as a thank you. I arrive, but the house is empty, not a stick of furniture, not a carpet left. I go next door and ask a neighbour what has happened. She tells me the couple moved out a fortnight before. I realise my worst forebodings were correct.

About 15 years later, I'm speaking at a political meeting in Winchester, where I lived during the war, so it is packed and all my old landladies are there too. I begin speaking and then notice in the third row the former Inspector and his wife, so I abandon my speech and think I'll tell the audience about real politics. I tell them the story and remark that the individuals concerned are in the hall. The whole place stands up and claps. The Inspector is embarrassed, but his wife stands up and says she'd like to relate the sequel to the story: "He was sacked the same day and lost his pension, despite having been in the force 22 years, we lost the home because it was a police house. We were put out on the street and ended up living with my mother before coming to Winchester, where he found a job as a social worker and he retired a few days ago as Deputy Director of Social Services."

'He was one of the best allies I had and he was a copper! So you have to be very careful about sectarianism and writing off such people before they're given a chance. It was remarkable what he did, putting his job

and family on the line for a principle, because he decided: what I'm doing is not right. But that wasn't quite the end of the story.

Soon after I'd moved to Devon in 1971 I was forced to sell my library of books, (see the chapter *Jerusalem or Bust* for the reasons behind this) so I asked a local bookseller to value them and offer me a price. She comes with a friend, also a bookseller, and after looking them over, offers me £600. I don't feel that's enough, so decline to sell. As they are going the man asks me if I'm Ken Sprague from Lewisham. I reply that I am. "How did you get your other leg back then?" he asks me. I don't know what the hell he is talking about. I ask him what he means. "My father was a police inspector and he used to spy on you," he said, "and on a couple of occasions he took me, as a boy, with him and I'd play in the car while he did his job. At that time you only had one leg." I wondered what he was talking about, until I realised that at the time I had cartilage problems in my knee and had had an operation. This had left me in plaster and on crutches. For a small boy I was Long John Silver, the one-legged guy!

It is amazing the time and money that was wasted in those days – and for all I know still is – spying on Leftists. My postman would sometimes deliver a pack of letters and say, "Oh, by the way Ken, there's another parcel to come, but Special Branch has to look at it first." He clearly took pride in his job and resented the interference of the police. On another occasion a tele-

phone engineer was doing some work on the wires of the telephone mast outside my house, and when he saw me, he said: "Ah you must be Ken Sprague, we're just putting another tap on your phone". So I said, thanks for the information mate. "That's OK," he replied, "you've never done me any harm".'

The Communist family

Because Communism was a world phenomenon with parties in virtually every country and because the basis of Communist philosophy was internationalist, there was a strong feeling of belonging to one enormous family. Indeed, if comrades travelled anywhere in the world they would always find help, a roof over their head, a plate of food, and a lively exchange of ideas just by contacting the local Party branch. The Party also gave one the opportunity of meeting fascinating and colourful characters, not just working class and trade union leaders, but artists, writers and politicians who belonged to this international fraternity. In this way, but also through his work as a committed poster and print-maker, Sprague had contact with a whole number of internationally well-known figures from that period.

He recalls one such encounter: 'When Pablo Neruda was invited to London to read his poetry at the Festival Hall I designed the programme brochure. I contacted Henry Moore and he donated an unpublished drawing, which we used on the cover. We charged £3

and made several thousand pounds for Chile. It was a wonderful reading and afterwards the organisers gave a reception for him in a comrade's Hampstead home to which I was also invited. After a while, Neruda said he was tired – he was quite old and frail at the time – and I offered to take him upstairs to lie down. A woman came up to him, obviously enamoured, and said how much she admired his poems. He took a slip of paper from his pocket and scribbled something on it and handed it to her. We continued up stairs, I helped him undress, got him a glass of water and put him to bed. When I came back down, the woman was on the stairs crying. I asked her what the matter was and she showed me the slip of paper. On it was written, "I would like to do to you what the spring does to the cherry tree." That was beauty – the relationship between him and her – no serious liaison or serious intention on either side, but a beautiful moment of affection.'

Artists have traditionally had a troubled relationship with organisations which seek to direct or restrict them and the Communist Party was no exception. There is bound to be a tension between the artist, as a strong individual, and the disciplines imposed by a collective will. However, the Communist Party had a tradition of valuing the arts – they were seen as vitally important and not marginal, as so often in capitalist society. The fact that they were taken seriously in the Communist countries was also reflected in their celebration of artists, the aesthetic guidelines laid down and the censorship imposed. Artists there were a privileged community, with heavy state subsidies – as long as they toed the line. The Party in Britain also had this contradictory attitude to artists. On the one hand it needed artists to promote the cause, but on the other it feared their unpredictability, the incipient danger they represented. But no doubt the prominence given to the arts by the Party led to the enormous influx of artists during the twenties and thirties, when there was hardly a leading artist in any field who wasn't either a member or fellow traveller at some time or other.

Sprague points out that this conflict between the artist and an imposed ideological constraint was brought out starkly in 1968 when Soviet troops invaded Czechoslovakia. 'I was incensed by this,' he says, 'but particularly about the hypocrisy of the arguments used to justify the invasion. I tried to make a statement about my own personal feelings over the period of a week and my reactions to the news reports. How can you have fraternal relations when your "brother" has his tanks encircling you? How can you negotiate freely with the barrel of a gun pointed at your head? In one image I

attempted to capture the heroism of the young people, sitting down in front of the tanks in Wenceslas Square. I was accused by some of being anti-Soviet. That is rubbish. I was never anti-Soviet, but I am opposed to tank mentality. They are anti-tank statements and directed at all those people who rush in all too quickly to solve the world's problems with guns.'

Artists, like most members of society, usually have a need to belong, for their art to be taken seriously, to be recognised, but they naturally chafe at any imposed restrictions. The Communist Party gave this sense of belonging and of being needed. Interestingly, a number of artists who left the former Communist countries, even those who dissented from the official ideology, often bemoaned the fact that in the West they were "free" but no one was really interested in their art anymore. Beforehand they may have had their battles with the authorities and the censor, but their art had resonance, it was felt and seen to be effective.

It is no doubt difficult for many today to envisage why someone should join the Communist Party or what the Communist Party represented other than a tiny conspiratorial offshoot of Moscow, composed of dupes and naive idealists. This image, although widely propagated, is far from the truth. When Picasso joined the French Communist Party he was asked by the Party paper, L'Humanité, to explain why he'd joined. He gave his reasons as follows:

"I should rather answer with a picture for I am not a writer; but since sending my colours by wire is far from easy, I shall try to tell you in words: My joining the Communist Party is the logical outcome of my whole life and of the whole body of my work. For I am proud to say that I have never looked upon painting as an art intended for mere pleasure or amusement: since line and colour are my weapons, I have used them in an attempt at gaining continually greater understanding of the world and of mankind, so that this understanding might give us all a continually greater freedom. Yes, I do feel that in my painting I always fought as a true revolutionary. But now I have come to see that even that is not enough: these years of terrible oppression have shown me that I have to fight not only with my art but with my whole being."

This statement was made shortly after France's liberation from Nazi occupation and it is probable that Picasso's views changed in later life, but his statement was valid when he made it.

In the early nineties, shortly after the collapse of the Communist world, Michael Knowles, a Labour Party activist and former secretary of Hackney Trades

Council, wrote in *The Guardian*, explaining why, despite often fundamental differences, he would miss the Communists in the Labour Movement: "Yes, that's what the Labour Movement will miss with the death of Communism. It educated the Labour movement. Let nobody deny it. The party members I knew were as far removed from the dishonesty and corruption and oppression of Soviet communism as could be. They were simply English workers, from socialist families in most cases, who saw the utter injustice of society and wanted it rectified. They spent their lives, in the workplace and after work, trying to achieve some degree of social justice. I shall miss them intensely. I miss them now. I owe them so much."

These are just two comments that perhaps go some way to explain the attraction of Communism, but also the substantial role many British Communists played, virtually unconnected to the sometimes horrific distortions of their ideals carried out elsewhere.

We need art to grow healthy. Without it we are dry husks drifting aimlessly on every wind, our futures are without promise and our present without grace.

<div align="right">Maya Angelou</div>

THE DAILY WORKER

The *Daily Worker* (later to become *the Morning Star*) was the daily newspaper of the Communist Party, but its aspiration was to become the paper of the Labour Movement as a whole. Although established as a co-operative owned by its readers, its editorial policy was always that of the Communist Party. Sprague worked on the paper for five years, between 1954 and '59.

He explains how he began working for the *Daily Worker*: 'Phil Piratin, who was only the third MP the Communist Party ever had, and was a hero of the struggle against Mosley's blackshirts in the East End, was doing a meeting in Carlisle. I was seen in the Party as "the young miner" – I was then working in the mining design office, designing coal washing machinery and such things, but I had also done some real mining, I'd been at the coal face, but I was never a coal cutter – I was a loader. You had to grow up in the business to be a cutter. Largely on the basis of my being "a miner" I was made chairman of the meeting. Afterwards, Phil asked if I'd got any of my drawings at home. Now I'd had the odd one published in party journals, but I was still surprised he knew about it.

He came home with me and I showed him a little folder of drawings I'd done for *World News and Views* (a Communist Party publication) and for the two local newspapers. After looking at them, he said, they were a bit lightweight, and had I got any proper drawings?' That hurt me. I didn't have any "proper" drawings.

We had a little girl at the time who was very ill, mentally handicapped. She was upstairs and was crying. She would cry most of the time and almost drove my wife and me round the bend. Phil asked to see our little girl. We lived in a horrible rented house with one room up and one down, but it was the first place we had together. We went up the rickety stairs and into the room. She was in the cot crying. Phil reached in, picked her up and held her to him and she stopped crying immedi-

ately. He had an inner calm that belied his outward dynamism.

It was amazing, because he could be a bombastic bully, as I discovered later. He was circulation manager at the time. He used to organise my work, although it was actually nothing to do with him. I had to report to him every month about what I'd done. But the point is, he was interested, the others weren't. As far as they were concerned, I could have done what I liked.

A few days after his visit to Carlisle, I received a letter, enclosing a return railway ticket for my wife and me to attend an appointment with a top neurosurgeon who would examine our daughter and advise us what could be done. Unfortunately nothing could be done. He said, "While you're down, come to the *Daily Worker* and talk to David Ainley, the business manager." This I did and was offered the job of publicity manager at £8 a week, which was only about 50p better than I'd been getting in Carlisle, but it was worth it.'

Newspaperman

Sprague saw this new job as an opportunity to place his art at the service of the Party and was thrilled at the opportunity of perhaps even drawing cartoons for the paper and having an audience of like-minded comrades. He would no longer have to pull his punches as he had to while producing cartoons for the local Carlisle papers.

'I joined the *Daily Worker* in 1954', he continues, 'and the first thing Phil said to me when I started was: "Goodness, you've got a lot to learn!" I'd taken the job, but then found I had this bully on my neck and I used to wake up in the middle of the night, thinking, heavens I haven't done so and so which he'd told me to do and I would get into a real sweat about it. So one morning I went into his office and told him that I thought he was bullying me and that I was fed up with it. He was furious and we became very irate with each other. I actually lunged at him, but he rolled against the blow and I realised he knew what it was about. It turned out his father had been a boxing promoter. As he rolled his body, one arm came up to defend himself and the other ready to hit me. And then we both started laughing, because we realised both of us knew about boxing. We never had any problems after that – we grew to like each other. Right till the day he died I would visit him regularly. I'd taken to heart what I'd read on the flag of the American revolutionaries, which they had designed. It had a white snake on a black background with the motto: don't tread on me. If you get a leadership job in

politics, you don't tread on people, but this is what many big organisations and parties, like the Labour Party, are doing all the time. You don't develop people by treading on them.

Although my job was that of publicity manager, the paper's staff shortage meant that there were often opportunities for widening my remit. On one occasion I was asked to interview Ernest Hemingway, who was in London for a short stay. He was in the Dorchester, one of London's top luxury hotels. I arrived to find him surrounded by a bevy of admiring women and had to push my way through to talk to him. He asked me what I wanted to know, and deciding to kick off on a light note, I said I would love to have his recipe for clam chowder. He began reeling off the ingredients and what to do with them, but I interrupted him to enquire about quantities, to which he replied, "fuck quantities!" I left soon afterwards, but had to return as I'd left my scarf behind. I was at the reception desk and Hemingway saw me from the other side of the foyer and boomed across: "Don't forget, fuck the quantities!"

I'm afraid to say this expletive is virtually the only bit of the interview that has remained stuck in my memory and I'm sure that is what the other Dorchester guests present will remember too. So much for my brush with literary greatness.

One day I was surprised to see an outsider come into the office, but with a familiar face. He was a tall, lanky man with dark, horn-rimmed glasses and spoke in a strong foreign accent. He was shown into my office and said diffidently, "You won't know me, I'm Frans Masereel." (Masereel was a leading Belgian artist, famous for his woodcut picture stories.) I replied that I most certainly did and that he was one of my art heroes. This pleased him immensely. His stark and evocative woodcuts had been very influential on me in the early years. His mastery of the black and white image, his seedy urban landscapes, the celebration of human resilience and his scathing critique of our exploitive society captured my imagination.

The role of cartoons

I was really thrown in at the deep end with the job of Publicity Manager. I took over the job from Baron Moss, who'd gone to start his own publicity business. He was a good comrade and showed me the ropes before he left – I knew nothing when I started. I'd never worked in a newspaper office. To begin with my job was to write what are called "puffs", i.e. "Dai Davies in Aberystwyth has sent £5 to the Daily Worker and sold two quire last Saturday, and that is an example to follow". I had to do these things every day and it drove me nuts. So, to keep sane, I started drawing cartoons, which they published because by then Gabriel, the resident Daily Worker cartoonist at the time, was on the way out. When Soviet troops went into Hungary to crush the uprising, he took the oppor-

tunity to go. So they had no cartoonist and started using my work. David Ainley was against it because I wasn't writing puffs as I should have been, and he promoted "Eccles" as the new cartoonist in residence. Eccles was in fact two people, the twins, Sid and Frank Brown. Sid had the ideas and his brother drew the cartoons.' Sprague felt that as a cartoonist he was seen as too uncompromising and provocative for the paper's editorial board, which, he says, was looking for someone to illustrate the party line, albeit with humour. This

viewpoint is, though, probably coloured by hindsight and is not shared by his friend and collaborator Sid Brown.

'I saw cartooning as something different to the party line,' says Sprague, 'I saw it as raising issues that people could argue about and write to the paper about. I was at war most of the time with David Ainley and all the other administrators. That's why they never gave me the job of chief cartoonist on the paper after Gabriel left.' Sprague nevertheless developed a very good relationship with Sid Brown, one half of "Eccles", and they often collaborated in creating cartoons. This developed into a lifetime friendship and Brown became an avid promoter of Sprague's work throughout his time at the *Daily Worker/Morning Star* and since.

'I did receive genuine support from some members of staff at the paper. Johnny Campbell, who'd been jailed for 12 months along with 11 other leading Communists for sedition in 1925, was the editor and he was the most encouraging of all. I would receive memos from him – "First class cartoon Ken. I thought Will Dyson had come back to life." Will Dyson was the cartoonist on the *Daily Herald* in the 1920s and a hero of mine. He was an Australian who came to the UK and became a highly regarded figure. He was a great draughtsman. There is an etching of his depicting god sitting on the clouds with Christ beside him. Christ has his head sunk in his hands and below them, seen through the clouds, is the world on fire – this is at the time of the First World War – and god is saying, "there is nothing I can do my son, the banks have spoken."

'Campbell was editor in a party structure that was already deteriorating and becoming increasingly restrictive,' Sprague says. He was keen to be made the chief cartoonist of the *Daily Worker*, but was not given the chance. 'A cartoonist in my opinion,' he states, 'has to build a relationship with the readers. He learns from the readers and they test him. He will also do things the readers don't like and he will learn from it and they will learn from him. It's not a question of putting over a political line, it's a much more complex issue.'

The stupidity of the Russian brides affair, following the Second World War, for instance, should have been raised in the form of cartoons. There were also the vicious and terribly destructive battles between Communists and Trotskyists in the wake of Stalin's demonisation of Trotsky. Anyone who questioned the Soviet Union or Party policy was in danger of being labelled a Trotskyist. I was accused of being one by

Peter Zinkin, a fellow journalist on the paper, during one of the editorial meetings, because I questioned something the Soviet Union was doing. He actually called for my expulsion. At the time I hadn't even read anything of Trotsky's and wasn't really aware of what a Trotskyist was. But Tommy Jackson, a wonderful old comrade, rose to the occasion and said, "Look comrades, Ken will always be a comrade loitering with the intention of deviating, but he's a damn good comrade deep down." Everyone laughed and the situation was defused.

Every Tuesday there was a staff meeting and there was invariably an underlying current of disagreement, which only came to a head over the Soviet invasion of Hungary. At these meetings, George Matthews from the Party's Executive Committee would present the analysis of the current situation and convey the Party line. Then the editor, Johnny Campbell, would suggest how the issues should be translated journalistically in the paper and the stories would be discussed.

Hungarian uprising

When Peter Fryer's highly critical reports from Budapest on the Hungarian uprising were spiked by the paper, things came to a head. Fryer was the paper's reporter in Budapest when the Russian tanks went in. Peter was livid and threatened to resign from the Party, which he then did shortly afterwards. I believe Johnny Campbell, the editor, didn't feel comfortable spiking Fryer's reports, but he was carrying out the Executive's decision to support the Soviet line through thick and thin. In the editorial meeting – and I was part of the editorial – Peter Zinkin, one of the more hard-line journalists, said: "The Russians are in the right and there

can be no debate!" But Johnny took a different line and said he didn't believe the real problems had even started. How right he was.

The Soviet Union's invasion of Hungary in 1956 had a devastating effect on me as it did on many other comrades. Many left the Party at the time. I was still at the paper and saw things begin to fall apart. During that tense period, I was in the building with Phil Piratin every night, on security duty, protecting the building from people who might try and throw bricks through the windows or actually break in. Feelings were running high and anti-Communism reached a peak because of the Party's uncritical support of the Soviet Union. I stuck by the paper because I felt that was the thing to do and, although I could see that some terrible things had happened in the international Communist movement, I felt we were still working in the long-term interests of the working class. So I stayed with the paper until 1959, when I left to start the publicity firm of Mountain and Molehill.

Although I had left the *Daily Worker*, I continued producing cartoons for it and its successor, the *Morning Star*. By the turn of the Millennium I'd been doing so for over 60 years. I never received a penny, though, and

certainly no more than three or four letters from the editor in recognition, but the printer used to send me notes now and again saying, "Good cartoon Ken."

Sid Brown recalls it somewhat differently and says that Sprague was paid from the fund he himself built up from sales of badges, postcards and posters. "Never what the work was worth," he adds, "but fair within that working environment, when contributors to the paper were not normally paid." Both Sid and his brother Frank Brown had been drawing cartoons since their army days and after the war contributed to a wide range of rank and file papers like *The Metal Worker*, *The Port Worker* and *Challenge*, the Young Communist League journal. Their collaboration continued after Sprague left the paper and he often used Sid's cartoons when he became editor of the Transport and General Workers' Union magazine, *The Record*.

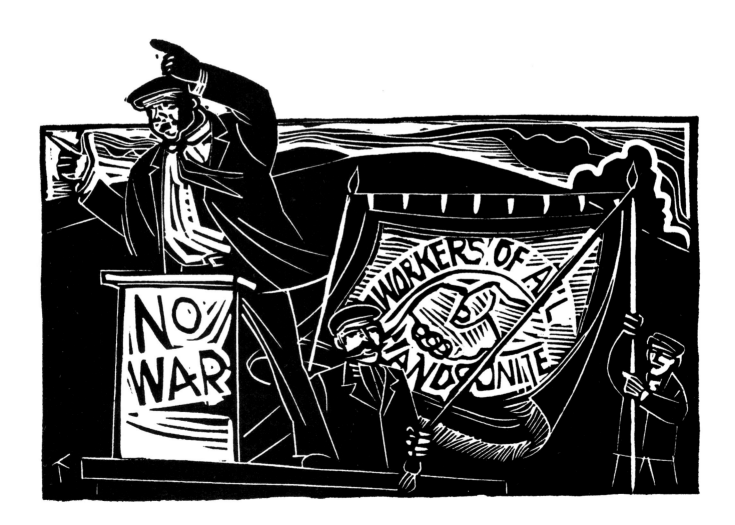

Imagination is more important than knowledge.

Albert Einstein

CARTOONIST AND POSTERMAN

Cartooning is a very specialist artistic area. Cartoonists are often, quite unfairly, not considered to be artists at all. The question, "But can you draw properly too?" is a familiar one to most cartoonists. Sprague was attracted to it because of his urge to communicate with people and his need to convey ideas, particularly political ones. In this sense, it is likely that his fascination with the comic postcard art he'd come across as a boy on the sea front in Bournemouth also played a significant role.

A good cartoon has its origin in a good idea. A cartoon is the pictorial equivalent of an aphorism - the reduction of complex or unclear matters and events to a clear principle or position. Without a good idea a cartoon will not work, irrespective of how well executed it is. You can still be a reasonably good cartoonist even if your draughtsmanship is weak as long as the idea is strong and clear enough, but you can never be a capable cartoonist with excellent draughtsmanship alone. What is essential for a good cartoon is a clear, easily understood message. A cartoon is more like a catapult than a blunderbuss. You need a good aim and a clear target and if you hit it, the result can be very painful. It is a one shot affair and you either hit or you miss by a mile. A blunderbuss is a blunt instrument, scattering and wasting shot all over the place, but maybe slightly wounding multiple targets. Cartoonists can't afford to do that. Their job is to debunk the arrogant, the stupid and the powerful. A cartoon is effective by using a shorthand way of communicating. The drawing is usually, but not always, paramount. The text serves to emphasise

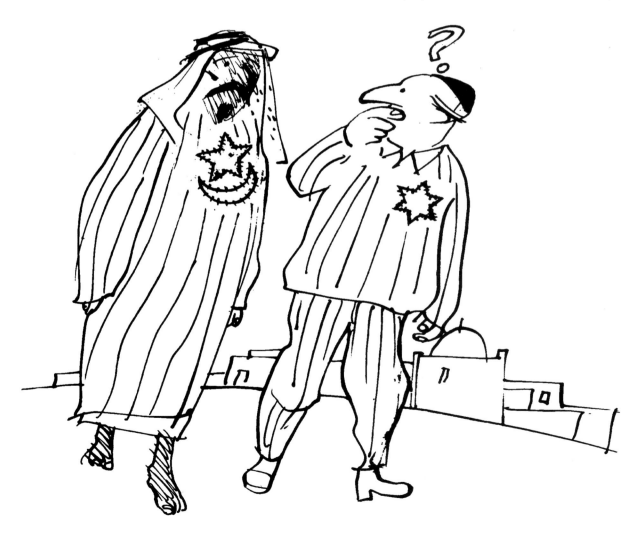

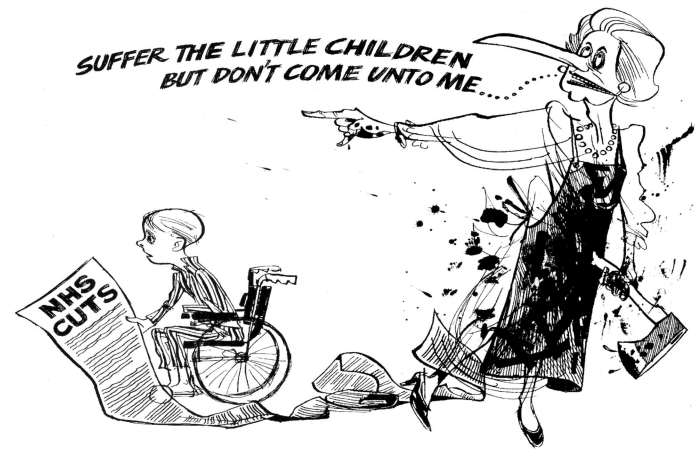

SUFFER THE LITTLE CHILDREN BUT DON'T COME UNTO ME....

or deliver the punch line, but many cartoons function perfectly well without caption or text. The very best cartoonists will combine brilliance of ideas with skilful draughtsmanship, but they are few and far between.

Sprague sees humour very much as a defensive weapon, it's a tool for survival in a world where you don't have the power. Cartoons make it possible for "us" to get even with "them" by poking fun.

Sprague's cartoons are impossible to misunderstand or misinterpret. His symbolism is clear and precise. Some may say they are often too simplistic, the subtlety or ambivalence is missing. But Sprague has a message he wants to convey as forcefully and unequivocally as he can. He's not saying life is simple and straightforward or that decision-making is not complex, but cartoons are not the place to express that complexity. He's letting you know clearly in powerful images what he feels is wrong with society and the way it's run. His cartoons cut through the evasive double-think of politicians and tyrants. There is a strong motif running through most of them: the underdog cocking a snook at authority. They are though invariably amusing rather than vicious, bitter or vituperative. They are at the same time a celebration of Joe Bloggs's common sense and resilience, of a person who is able to see through the web of lies and

pretence, like the little boy and the Emperor's new clothes.

His style has changed considerably over the years. An early one of West German Chancellor Adenauer and Hitler shows the influence of Dyson, Low and Vicky, but already reveals Sprague's strong sense of draughtsmanship. His later ones are lighter in their use of line and usually less hectoring in their message.

He arises early in the morning and will take up his pen and dash off a cartoon on anything happening in the world which angers or outrages him, whether it be the Vietnam War or the death of Stephen Lawrence. He is animated by this continuous inner turbulence and an urge to make a stand, not ignore what is going on around him – which is after all the essence of true citizenship and the bedrock of a democratic society.

His cartoon of Margaret Thatcher as the butcher of the NHS occupied a full front page of the *Morning Star* with the headline in red and blue: "NHSOS" and beneath it a scathing drawing of Thatcher wielding an axe, bespattered with blood. Behind her is a child in a wheelchair reading with despair the announcement of her government's planned NHS cuts. This was the first time the paper had used three colours on its front page and the idea came from Sid Brown. Sprague felt Jesus's

words would contrast tellingly with what Thatcher, an avowed Christian, was inflicting on the National Health Service.

Another which sublimely reveals Sprague's philosophy of life has two workers sitting vertiginously high up on a factory chimney and far below them, looking like a tiny ant is the boss, getting out of his Dinky toy-size Rolls to enter the factory. One worker is saying to his mate: "It's all a matter of perspective." What a wealth of common sense, inner strength and self-dignity is contained in that phrase and that drawing. It makes us all think: "Hold on, I don't have to take this harassment from anyone. I don't need to be bossed around." Life can take on a different perspective and a more optimistic one too.

Sprague has used his cartoons in the service of most of the significant progressive movements and labour struggles for over 50 years. They have appeared regularly in the *Daily Worker/Morning Star*, *Tribune*, the T&GWU's *The Record* as well as in many other unions' journals, in collections of cartoons against Apartheid and for the Medical Aid Committee for Vietnam and for Leeds Postcards.

The cartoon showing how the system at every stage produces the robots it wants is also a powerful statement: school children are turned out thinking the same, workers are turned out to do the monotonous jobs that industry demands and soldiers are fabricated to fight the wars of the rulers. Sprague's loyalties and his politics, like Steve Bell's in his cartoons, are not open to question, they are trumpeted unashamedly and unequivocally. His anger and outrage at inhumanity and injustice are given full rein.

He was producing cartoons and posters against racism, long before it became spotlighted and even before many were aware of racism's insidious presence. Two of his earliest linocuts still resonate with truth and urgent warning on the dangers of the racist virus. The first depicts a typical suburban street with three white women in a group, watching pinch-faced as a young black couple, a few houses down, enter a house with a "For Sale" sign. The women's fear, intolerance and small-mindedness is etched in their faces as they steal a look at the couple without wishing to be caught doing so. Sprague utilises the metaphorical possibilities offered by the black and white of the linocut to underscore the emotional sub-text. The group is framed by houses that are black, impenetrable, the "forces of darkness". The young black couple are framed by white houses – perhaps representing hope, optimism and clarity? There is no caption, no words – the powerful image

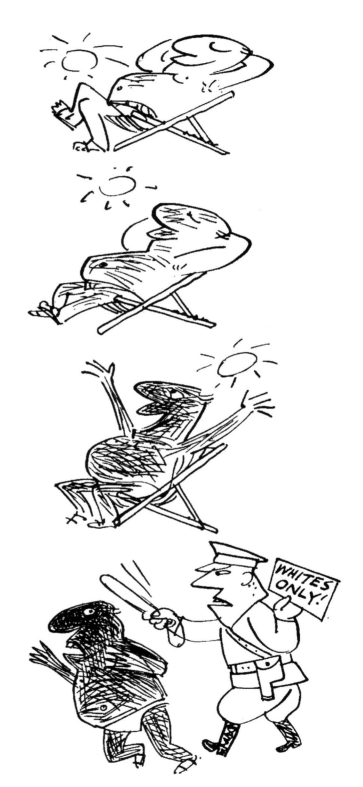

contains all that needs to be communicated. Interestingly Sprague says that the "For Sale" sign he drew was based on that of an actual estate agent and this man happened to be a friend and a member of the Party. After the linocut had been printed and published the estate agent apparently received a number of calls from black house-hunters asking for his help. They'd obviously taken the number from the linocut!

Sprague is intrigued and animated by the idea of developing an international language of symbols. One successful example of this is his fishes print. He relates the story: 'I addressed a meeting of a group of banana workers in the Canary Islands, which are Spanish-ruled. Franco was still in power at the time. They weren't allowed to meet and discuss the formation of trade unions. Since my Spanish was bad and their English non-existent, we had to communicate via images. I made two drawings on a folded sheet and drew it out of an envelope. To begin with there is a swarm of little red fish fleeing in total disorder and confusion from a big black fish. "That's us," they cried, "and the big black fish is Franco, eating us up." I then opened the sheet to reveal the little red fish now banded together and organised in the shape of a big red fish, now chasing their previous harasser, the black predator fish. They all laughed and we'd reached the basic, but common understanding we needed. A few days later, I showed the same picture to a group of Franco's policemen. Now

I wouldn't say they didn't understand it, but they clearly didn't enjoy it. Images like these are bridges that you can cross in both directions. I'm trying to create those bridges.' The poster could be an illustration for R.H. Tawney's famous aphorism: "What is good for the pike is bad for the minnow," but Sprague takes it a step further. It demonstrates clearly what solidarity, working together and will-power can achieve. It is saying to all the underdogs: "Hey, you don't have to be trodden on all your life, you can beat the bosses and the bullies, but only if you work together." The image of the fishes is one of the most renowned of that sixties period and has been copied on innumerable occasions.

This poster is an example of where an "emblem", a single image, can stand for a complex idea, but is more condensed than an allegory. Jenny Uglow, in her biography of the 18th century English artist, William Hogarth, explains that "this method goes back to the mnemonic tools of English dissenting texts and fables." This "low" iconographic style was much used in Hogarth's time, but was, as Uglow says, "derided by theorists of 'high' culture. They were popular because they provided a link with the past, but also because the succinct, cryptic forms were, like ballads, the language of the common people.

William Hogarth was probably the first artist in the

country to merge the formal values of "high" art with the "low" comic tradition, Uglow maintains. In this process Hogarth created a new genre – cheap prints for the general public. Sprague has attempted to do the same, often using money from commercial publicity jobs to finance the art that lies close to his heart – affordable posters and prints, using common imagery, that address ordinary people. Interestingly, Hogarth was also the founder of the first artists' "trade union", primarily in order to protect copyright.

Although Sprague's cartoons can be acerbic and rapier sharp, he prefers working with gentle humour. An example of this style is one he drew very early on in the campaign against the South African apartheid system. It is a chronological sequence of four small drawings, the first shows a paunchy white man sunning himself in a deck chair, in the second he is developing a tan, in the third he is even darker and in the fourth a South African policeman, brandishing a "Whites Only" sign, and a truncheon is driving the now black-looking sunbather from the beach.

He produced a number of cartoons in support of the striking print workers at Wapping, after Murdoch had taken his *Sun* and *Times* newspapers to his fortress there in order to break the strong print unions. Sprague has drawn a visored riot policeman with "*Sun* newspaper"

cartoonists against apartheid

on his armoured waistcoat and wielding a truncheon and shield, with the caption: "It's the new advertising manager."

In his work for the wider progressive movement, he has never been one to jump lightly on bandwagons. He has chosen his campaigns and targets very carefully and has invariably seen through the cant and lies, producing his pictorial commentary long before others have clambered aboard. He was invariably in the vanguard of a campaign long before it became fashionable, something that was never a criterion in his decision-making. There was scarcely a significant movement during his working lifetime in which he hasn't in some way been involved in producing posters, cartoons, banners or publicity.

His viewpoint as an individual cartoonist, though, was often at variance with that of the Party leadership. 'They saw the role as presenting the party line in visual terms,' he says, 'and that's not cartooning in my opinion. The job of a cartoonist is to raise the issues which people can then debate and argue over before deciding policy. You examine your own failings as well as the opposition's, you prod people and sometimes you insult them, you get them going. Drawing and cartooning have a language of their own. The best cartoons, like those of Giles, are "read pictorially". People study the drawing before even reading the caption – they would look at grandma's expression and where she was sitting in the room. Giles made an exacting study of working class family life and that, together with his wonderful sense of humour, is what made his cartoons so popular – they connected with ordinary people.

'I've produced cartoons for over 50 years for the *Daily Worker* and its successor the *Morning Star*,' he says, 'but the overwhelming majority were rejected. The *Daily Worker/Morning Star* never gave me regular work and you need regular daily contact with an audience to develop fully as a cartoonist – they give you feedback.

One of my heroes was Vicky, but even his early cartoons were weak and the drawing was poor, but he developed a rapport with the readership and became a brilliant cartoonist. They didn't understand that at the *Star*.'

In 1998 after Blair had been elected and we really began to see what he was like, I drew a cartoon with a signpost pointing uphill with "socialism" on it. Careering down the hill is a flock of sheep bleating: "Baa, Baa, Blair, Blair..." The *Morning Star* wouldn't print it because, they said, "it was an attack on the Labour membership not just the leaders." In my view they should have published it and dozens of letters would have been written in outrage or perhaps support and a stimulating discussion could have taken place. Now, for me, that's what cartooning is all about.'

'Cartoon work is ephemeral – here today, gone tomorrow. Life has moved on. So you raise issues. Being in a newspaper today means that tomorrow it's old news. You don't even attempt to tell people the whole truth in a cartoon, you tell them part of it and it's up to them to make up the rest. You're not telling them what to think but you're trying to help them understand how to think. I do cartoons also for my own therapy. I'm no longer active in a political party, so each day when I wake up and react angrily to what some idiot politician has done, I dash off a cartoon between seven and eight, then feel better before I go off to work. But I don't produce them just for personal therapy – I like to know they will be used.'

The reader could legitimately ask why, if the Communist Party and the *Daily Worker/Morning Star's* editorial board were so restrictive and blinkered, did Sprague remain loyal for so long and continue producing work for them? It needs to be remembered that Sprague is talking here with the benefit of hindsight and not without a touch of bitterness. His attitude at the time was undoubtedly quite different. It is perhaps surprising for many today to realise how many Communist Party artists and intellectuals of that period accepted party discipline as necessary for the building of socialism. Their individual opinions and ideas would be subordinated to the superior sagacity of the collective viewpoint.

The posterman

Often Sprague prefers to work using the medium of print/poster or small series of prints. Here the cartoons give way to a more consciously aesthetic approach, utilising strong graphic qualities made possible by the larger size as well as colour and often printed on wonderfully-textured, handmade Japanese paper. This form

also allows more subtlety of approach than in cartoon work.

I recall clearly my first visit to Sprague's studio in London during the sixties. He was just pulling a fresh print from his gigantic hand-printing press. As he lifted the A1 sheet of paper from the bed, a magnificent open hand appeared and rose up like a released bird into the room. Hands have been a strong and recurring motif in Sprague's oeuvre – a celebration of this remarkable human tool and source of craftsmanship. Another recurring symbol is the dove – for Sprague not just a symbol of peace, but of life and freedom. His beautiful pastel-coloured print *Bread and Liberty* won a Czechoslovak government award at the 7th Prague Interpress Grafik Biennale in 1976.

Early in his life Sprague worshipped van Gogh and wanted to become a painter, but having his first lino cut reproduced on the front cover of the magazine *Spain Today*, turned him in the direction of printing. 'I like reproduction,' he says, 'when I'm printing I hang the prints on a rack to dry and at first they may look all the same, but then I discover exciting, if subtle differences between them. That's because I mix my colours differently for each one and, particularly if I use cardboard, the way the ink is absorbed will produce change.'

As a graphic artist,' Sprague explains, 'you have to plan and organise the project very clearly before you begin. It is already "completed" in your head – it has to be, because you can't change things very easily once you've begun working, and with linocuts it is impossible. This approach is very difficult to throw off when you're painting. Of course you may need a clear idea for a painting too, but you are freer and can let it grow out of the canvas, emerge according to its own rules.'

One poster I particularly like is based on a momentary observation Sprague made while travelling on the tube overland in London. It shows a series of railway lines crossing and within this linear cage of steel track is a tiny wedge of an allotment, holding vegetables in neat rows, a small tool shed and a man digging. Again this captures one of the leitmotifs of Ken's philosophy of life: resilience in the face of adversity and victory over the powerful. Here is an ordinary individual triumphing over the encroaching tentacles of industrialisation; he's still got his patch of Eden within the hell of it all.

The lino cut Sprague produced as a reaction to the murder of the first black man, Kelso Cochrane, in Notting Hill in June 1959 and titled: "The Road to Fascism", was splashed over two pages of *Searchlight* magazine. The moment of the killing flares up at you with an incandescent horror. The print shows the dramatic stabbing, but at the same time reveals the roots of race hatred in the anti-Semitism of Hitler fascism, rearing-up in all its ugliness behind the killer. The stark black and white of the linocut and the visceral strength of the gouged lines underline the harsh message. Sprague executed the linocut very quickly after the incident and sold the prints himself for a shilling each outside the funeral and at anti-racist meetings to raise money for the campaign against fascism. Interestingly Sprague was the editor of *Searchlight* for a short period between January and May 1976. He wrote a statement of intent which was fully endorsed by the *Searchlight* board, in which it said that the magazine's role would be: 'To campaign against racism wherever and whenever its poison was detected'. It continued: 'We hear of racial discrimination at home and abroad, but no one finds it profitable to find out why there is apartheid, why there is racial discrimination. The television news programmes become so terrifying that to stay sane, we switch them off as though in some magic way we can switch off what's happening too. Why are Protestants and Catholics killing each other in one part of Ireland, yet live happily together in the rest of that country? This magazine aims to find out why!' He wanted to shift the editorial policy and widen the magazine's remit to cover all aspects of racism. In this vein he published a cartoon pillorying Israeli discrimination of the Palestinians and the *Searchlight* board, in his words, 'went berserk'. He was sacked on the spot.

On 10th March 2000 *The Guardian* carried a long article on Porton Down, the government's biological research station, a place unknown to most citizens. The article said:

"Its recruitment practices during the cold war are being investigated by Wiltshire police after human guinea pigs complained that they were tricked into taking part in poison gas experiments. The guinea pigs claim that they had volunteered for research to find a cure for the common cold, but ended up in Porton Down's gas chambers. Wiltshire detectives are also examining the death of Ronald Maddison, 20, an airman who had nerve gas dripped on to his arm in a 1953 trial. Porton Down is believed to have conducted the longest running programme of chemical warfare experiments on humans in the world. At least 20,000 volunteers have taken part in the last 80 years, although even this number has not been enough to satisfy the scientists' demands."

The series of posters on the Porton Down biological war research centre, produced by Sprague in 1969,

Nuremberg), 3. "It's purely for defensive purposes" 4. "It's a dollar earner" 5. "If I didn't do it someone else would" and 6. "We choose to work at Porton". All comments which, in conjunction with the frightening images, raise vital questions for any society about responsibility. The images are printed from lino and cardboard cuts and one from a photo which has been enlarged until the pixels become visible and grainy, again heightening the alienation (in the Brechtian sense) by dehumanising the operator. These posters were later used for demonstrations outside the establishment, calling for its closure.

Sprague's work has often aroused controversy and public comment. A poster designed for the Co-operative newspaper, *Reynold's News*, was banned by London Transport in the fifties for being "political", his poster against the Tory's anti-union laws showing Edward Heath, the then prime minister, being squeezed by a big worker's hand caused outrage, and his series, *Yours fraternally*, on the Soviet invasion of Czechoslovakia alienated a number of his former comrades. He prefaced this series with a statement which said: 'These prints will inevitably be called anti-Soviet, they are not, they are anti-tank, against those men who all too quickly rush to solve the problems of our nuclear world by military action.'

Adrian Mitchell, in a TV documentary featuring Sprague, described him as "a brilliant but unfashionable artist." What he is saying here is that fashion is all about appearances, whereas Sprague is concerned primarily with what is behind things, their deeper essence. 'During the Vietnam War,' Sprague recalls, 'I became very interested in the United States flag as a

thirty one years before this article was written, are as powerful today as they were then. Few people at the time knew what this highly secret and invidious place was doing, and those that did protest against the abuse of science and humanitarian norms at Porton Down were dismissed as leftist extremists. Only recently have some of its horrors been revealed and they only differ from Hitler's ghastly experiments on the victims in concentration camps in their extent and the trappings of accountability. There are six prints and as a thread through them all, Sprague has used an old printing block of a rat. This had been used in the past to publicise the menace of rats and help the rat-catchers. Rats were being used at Porton, but at that time no one was aware that human guinea pigs were being used too. Sprague actually went down to Porton, stood in front of the gate and talked to the workers leaving. He utilises their quotes as captions to the posters. Each poster has one or several men and women in dehumanising gas masks, giving them an alien and robotic appearance. The quotes Sprague uses are: 1. "...but the money is good" 2. "We're only obeying orders" (a reminder of

PAX AMERICANA!

symbol and produced a whole number of posters based on it. I used the idea again during the Gulf War in 1999 and this one was reproduced as a postcard. On seeing Sprague's Vietnam poster with Lyndon Johnson against the red stripes of the American flag dripping blood, Kenneth Tynan commented that it was "the most vicious poster I've seen", adding, "but so it should be."

Sprague was tremendously encouraged by the resilience and doggedness of the women who camped outside Greenham Common in the seventies to protest at the stationing of US cruise missiles in Britain. He produced a series of posters celebrating these women. The idea for the title came during a BBC Radio phone-in. Sprague takes up the story: 'I was on the panel with the journalist James Cameron and while answering a question and quoting Blake's famous poem, *Jerusalem*, he made a slip of the tongue. He intended to say "in England's green and pleasant Land," but instead said "England's green ham pleasant land". So I took up this idea and made it the title of the poster series: *In England's Greenham pleasant land*. Leeds Postcards included one in their postcard series.'

In 1971 the Tory government introduced its *Industrial Relations Bill*, which was aimed at hobbling the unions. Sprague wanted to create an opposing image that would be easily understood and could be taken up by the whole trade union movement. 'I drew a simple picture of a poison bottle, with a spoon lying in front of it and with the slogan in stark lettering, as if on a headstone: "Not to be taken". It was printed on the front page of the T&GWU newspaper, *The Record*. Shortly afterwards it was taken up all over the country and reproduced by working people and hung up on

factory notice-boards. On the great march in opposition to the *Industrial Relations Bill* through central London, the image could be seen again and again, blown-up and reproduced on the banners and posters. Each one was different, seen through the eyes of those who reproduced it.

A poster he designed also against the Tories' anti-union laws in 1971 became infamous. I remember him showing me two versions he'd done. He used a photo of Edward Heath from which he'd cut out the eyes with a scalpel and reinserted them reversed, so as to give Heath's visage a comical squint (a trick later used by Saatchi & Saatchi in 1997 for the Conservative Party's election campaign against Blair, transforming him into an evil-eyed Machiavellian). Heath was being squeezed by a gigantic worker's hand. The logo read: "Crush anti-union laws". The poster was in black and white only, but on the second version he had included a red drop of blood dripping from Heath's squeezed corpus. Sprague wasn't convinced this was in good taste and felt it could be seen as too bloodthirsty or violent. At the time, I recommended leaving it in and

argued that people would surely see it as a metaphor and not take it literally, and this is what Sprague did. (With hindsight, I believe I was wrong)

Sprague told me later of an interesting incident concerning this poster. He'd delivered some copies to the Communist Party headquarters, and Jimmy Reid, the former leader of the Upper Clyde Shipbuilders' work-in, was there. He came up to Sprague and congratulated him on a marvellous poster. Later Reid saw fit to recant his earlier beliefs and loyalties. In his autobiography, he described this self-same poster as an example of the bloodthirstiness of some comrades and gave it as one of the reasons for leaving the Communist Party.

The searing photo of a young Vietnamese girl running naked down a road with her back ablaze with napalm so horrified Sprague that he utilised the flame motif in a series of prints in protest against the American atrocities in Vietnam. These "burning flames of war" were adapted by Mick Daniels into a badge for the Medical Aid Committee for Vietnam. One of these posters has an image of a broken, distorted, figure, lying in the foreground, overprinted with red flames of napalm in a strident black and red. It reminds one of Picasso's Guernica in its angular brutalism.

His grandfather's courage in refusing to gun down ordinary men and women in Ireland when he was a member of the occupying British Army was no doubt in Sprague's mind when he produced his powerful poster against the military occupation of the North. A worker lies on the ground in a pool of blood. He is still clutching a poster on which is written: we demand civil rights. Across the image like a searing scar is a gun barrel with mounted bayonet and on the stock is engraved: "Made in England".

In a flyer for the publicity company G&B Arts, John Gorman, the Director, wrote: "Artists like Ken Sprague work with skill and hope." He goes on to quote William Morris: "If these hours be dark, as indeed in many ways they are, at least do not let us sit deedless, like fools and fine gentlemen thinking the common toil not good enough for us, and beaten by the muddle; but rather let us work like good fellows trying by some dim candlelight to set our workshop ready against tomorrow's daylight, that tomorrow, when the civilised world, no longer greedy, strifeful and destructive, shall have a new art, a glorious art, made by the people and for the people as a happiness to the maker and the user."

The cover features a print by Ken which, well before the Green movement was mainstream, portrays a street choked with black, menacing cars; a small tree in the centre has a halo of yellow light and a few small green leaves are sprouting from its tender twigs.

Martin Luther King

'The marvellous thing about truly great creative people is that they also release the creative potential in others,' Sprague says. 'When I did the publicity work for Martin Luther King while he was in London, I found him an incredible source of stimulation.

One day in 1963 I was called to Canon Collins's office, behind St Paul's Cathedral. He'd just been made Dean of St. Paul's. The reason Collins called me was that I'd done a poster for a Paul Robeson concert in St. Paul's a few years previously. Collins used to call me "my anarchist friend". So I said to him one day, "You actually mean "Communist friend." "Yes, I know Ken," he replied conspiratorially, "but in my position you've got to be a little careful."

Before I actually met Martin Luther King, I expected him to be a sort of Paul Robeson with a bible under his arm, but he was the opposite. Paul Robeson was huge, but Luther King was small, chubbier than me but hardly any bigger. At the time no one here knew who he was, but it was clear the minute he spoke that he knew more about the black situation in the States than anyone else did. He was also someone who was actually interested in you as a person – it wasn't a put on act. It was where he gleaned his ideas – from the people.

He asked me to design a poster for his campaign. So I said, "All right, leave it to me and I'll come up with a few ideas and show you tomorrow". But he actually started telling me how I should design the poster. So I said, "Hold on a minute, if I want to know about the

civil rights movement in the USA I come and ask you, you're the expert and that's your job. If you want a good poster you come and ask me, because that's my job. It was marvellous how he took it, without animosity. It is after all a fact of life – you can't design by committee. A camel is a horse designed by committee isn't it? I actually went back the same evening and showed him my ideas. That's the way things were done then. Today you'd have two months to come up with a design.

Because of the shape the letters of his name made, I designed it in the form of an arrow head pointing down. I printed it in purple and black on white.

Four years later this little man was a world statesman. What had happened in the meantime, as so often in life, was that the situation had changed and demanded a certain kind of figure, man or woman, to rise to the challenge, and he did. These leaders may disappoint later, as they often do, but at the time they are heroes. That's how Jimmy Reid became a national hero during the fight to keep the Glasgow shipyards open, until he deserted those from whom he drew his strength and devolved into a small-time media personality feeding off his past.

Martin Luther King had become a world figure and then the opposing forces had him assassinated because he had become too influential. They did so at that point – and most people have forgotten this – when he started recommending that black and white soldiers in Vietnam should get together and fight for justice. Up until then it was only black liberation, but once it became black and white solidarity it represented a time bomb for certain people.

After his death in 1968 the Martin Luther King Memorial Fund was established and I was asked to design a poster for it. When I met Martin Luther King on that first visit to Britain, I didn't even know what he looked like, but as I entered the room he was in, I felt his immense personality radiating throughout the room, as if the sun was shining. But how do you represent the sun? I intended producing a series of prints as a portrait of the man. I didn't use his face, I wanted something symbolic of what he stood for, an internationally comprehensible symbol. The resulting poster series was used to launch the Martin Luther King Memorial Fund, set up to promote his ideas of racial tolerance and liberation. For the posters, I used sunflowers – the obvious symbol, and one of them had a bayonet against it. That gave me the clue. I also remembered that when Martin spoke, he held up his hand with his two pairs of fingers separated.

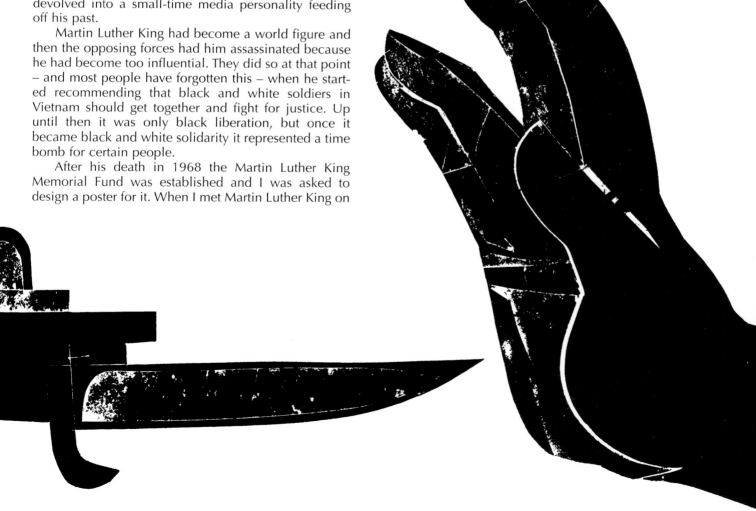

So I drew this hand with a bayonet pointed at it. I felt it was an effective poster. (It won a Council of Industrial Design award and an international poster award in Cracow). There was a man cleaning the studio window at the time I designed it and I asked him what he thought of it and he replied, "Wow, it's fucking sharp!" So, at least on one level, he understood the message.

There is a wonderful photo of the then Archbishop of Canterbury, Lord Fisher, a rather conservative figure, delivering a sermon from a pulpit draped with my poster. The Fund was launched by the Archbishop, the Chief Rabbi and a whole number of leading figures from the worlds of art and politics.

At a Council of Industrial Design awards ceremony at the Savoy Hotel, the guest of honour, making the presentations, was someone I'd contacted five years previously requesting help in raising money for the MLK Fund. He wouldn't even see me. So I said this publicly at the ceremony to everyone's horror. But to give him his due he did blush.

Martin Luther King was one of the true exemplary and charismatic leaders of the last century, but he became a leader by listening to his people. That's how this poster came about, through Canon Collins and his "anarchist friend", who was never an anarchist but was on occasions attracted to some anarchist ideas!'

Sprague has regularly had his posters published in the annual poster design awards collection. He recalls one of these he was particularly proud of: 'It was a poster I did for a concert given at the Albert Hall by the father of American protest song, Pete Seeger, in 1961. It was the occasion of his first visit to Britain since the US authorities took his passport away at the height of the McCarthy period. I did a black brush drawing of Pete playing a 12 string banjo – I blew it up till it became grainy and then printed it on a bright blue background with white lettering. Pete Seeger loved it. On the evening of the concert we pasted the posters up at the last minute all around the circular walkway of the Hall. After the concert was over and people had left, all the posters were gone – they'd been taken by the fans. For weeks later, while driving around London in the evenings, and glancing through people's windows, I was surprised to see how many of these posters I could spot in people's homes.'

Iraq – a difficult decision

As a result of the awards won by Sprague's Martin Luther King poster, he was invited to join the panel of judges for the International Poster Competition held in Baghdad in 1979. While there he did a series of sketches of Iraqi street life which impressed his hosts and led to a second invitation, together with the artist Peter Paul-Piech, to cover the Iran-Iraq conflict in 1981 as official war artists.

On arrival they, together with a small group of journalists, were taken to Basra where they were presented

with a war games charade, organised by the army and which they were supposed to pretend was the real war. Sprague said that for some time the images filmed there by TV journalists were the only ones, ostensibly of the war, appearing on western television screens.

Sprague refused to be fobbed off in this way and went back to Baghdad to see the Minister of Foreign Affairs. He was promised a meeting, but continually told to wait. He says he esconced himself in the Minister's anteroom each morning when it opened at eight and waited all day until it closed, refusing to leave. He did this for five days, managing to maintain his determination and diverting himself by sketching visitors to the office and learning a few words of Arabic each day by asking the visitors what certain words meant and how they were written. At one stage towards the end of these five days, he was sitting with the Minister's office in view and with the Minister at his desk at the far end, so he proceeded to sketch the scene. When the Minister noticed this, he yelled at Sprague that he had no permission to draw him and demanded to see the sketchbook. So Sprague gave him the book, which he proceeded to leaf through and became fascinated by a series of sketches of street urchins who lived by their wits on the banks of the Tigris, stealing, begging and cajoling. He told Sprague that he was interested in the drawings because he himself had once been a kid like these before becoming a widely respected poet and eventually Minister of Foreign Affairs. This broke the ice and Sprague was able to make his plea. He told the Minister that he'd been promised interviews with soldiers, with prisoners and farmers who'd been forced to flee the war front and this is what he'd come to Iraq to see, not the façade of a few specially organised war games.

Within a day Sprague was given an officer as his

minder, was kitted out in a captain's uniform, issued with ID papers and taken to the front where he was attached to an Iraqi regiment. The uniform and papers were essential, in case he was captured by the Iranians and accused of being a US or British spy. He accompanied the regiment during the invasion of the oil-rich town of Abadan and witnessed the full horror of the war. He says that on the one day 582 young men from the regiment were killed in the battle. 'All the young men I drew during my nine days at the front died in the war,' Sprague recalls, 'and that's why many of the drawings betray a shaky hand. Bullets were flying everywhere and grenades exploding. It was frightening.' His bodyguard was killed while climbing over a wall with Sprague about to follow. The pages of his sketchbooks are stained with dirt, from the times he'd been forced to dive for cover or crawl on his stomach.

He filled two sketchbooks while in Iraq. The Iraqi government used a selection of these drawings in a book, published in 1981, titled: *Smoke at the End of the Road*. But the government, not unexpectedly, chose only the more heroic drawings. Sprague kept the second sketchbook which contains more of the drawings done at the front and documents the horrors of the war.

For his courage and the solidarity he showed with the Iraqi people he was made an honorary Arab and adorned with the traditional 'keffiah' headgear and ceremonial dagger. He, along with a small group of journalists, was also granted a rare interview with Saddam Hussein and, as the only artist present, made sketches of the dictator. The Iraqi government organised a showing of his war drawings in a prestigious Champs Elysée gallery in Paris as well as at the Iraqi Cultural Centre in London's Tottenham Court Road, alongside works by his colleague, Paul-Piech.

Sprague's visit to Iraq at this time and his apparent identification with the Iraqi regime resulted in a number of his friends and comrades being very critical and even condemnatory. Sprague maintains that his identification was not with the regime but with the people and that his role was to document the brutality and senselessness of war, not to provide support for a dictatorial regime. He says he made his position very clear while he was there and openly criticised the persecution of Communists and the undemocratic methods used by the regime.

Sprague thinks that his drawings at the front are possibly some of the last such drawings of war and he is probably right. Because with the increased awareness of the power of words and images in propaganda terms, together with the unpredictability of artists, filmmakers and journalists, governments and armies no longer allow non-combatants near the front. Instead they serve up carefully staged and selected pieces of action and slick press conferences, strictly controlling any contacts with soldiers and battle zones. Thatcher pioneered this new method of total containment and control during the Falklands/Malvinas war and the USA followed suit in the Gulf, the Balkans and Afghanistan.

It is not the excitement of battling for a just and worthy end which is the foe to art, but the dead weight of sordid, unrelieved anxiety, the anxiety of the daily earning of a wretched pittance by labour degrading at once to body and mind

William Morris

THE TRADE UNIONS

Mountain and Molehill

'When I left the Daily Worker in 1959 I set up a publicity partnership with Ray Bernard, a comrade who was also a businessman, and a good one too. After working for a Communist paper, you were stigmatised and I knew I stood little chance of finding a job elsewhere, so the only way was to become self-employed.

When it came to finding a name for our new company, it was not easy to come up with something appropriate and not too high-flown. We'd gone through all the names we could think of without finding one we really liked. Then we thought, people always laugh when they see us because Ray was this big, skinny bean pole, six feet eight, and I was about five feet seven and stocky. We were nicknamed Mr. Mountain and Mr. Molehill, so we chose Mountain & Molehill as the company name. We made a virtue out of what was a comic situation, we were the Laurel and Hardy of the publicity world – people often called us that too. It was a graphic arts workshop dedicated to providing a high quality publicity service to the labour movement and anyone else "who was having a go," that is, various charities, voluntary and solidarity organisations.'

The fifties saw the culmination of the Cold War and those socialist and politically-committed artists from the thirties had either mellowed and retreated from the icy blasts into their own inner worlds or jumped the barricades to become mouthpieces of anti-Communism. There were few artists in this period who stuck to their positions. Sprague was one who did. He chose the trade union and labour movement as his political home and it provided the context for much of his work. The irony is that, as he sometimes remarks with a touch of bitterness, the movement was not much interested in the arts, it failed to see their relevance to working class struggles. Britain's long Puritan heritage of mistrust of the arts, artists and cultural celebration was particularly marked

in the trade union movement with its roots in Presbyterianism and Methodism. In their early stages both the Soviet and Mexican revolutions provided a genuinely revolutionary context for artists, who enjoyed active support from those in power.

The artists still had their battles and problems, but their art was fundamentally in tune with the historical momentum. Sprague's chosen context could hardly have been less amenable. The trade unions are in the main conservative organisations, not revolutionary ones, despite the efforts of generations of socialists to transform them into such. Sprague had to fight this traditional conservatism and its image of "long-haired bohemian artists". It is to his credit and that of one or two more broad-minded and innovative leaders like Jack Jones of the T&G and Dave Lambert of the Foundry Workers, that he managed to persuade the trade unions to work with him at all and take on board some of his ideas.

Trade unions had traditionally seen their role as one of protecting workers from the bosses' voraciousness. When negotiations failed, the threat of withdrawal of labour was the method used to pressurise the bosses to give way. The unions had never considered the question of winning hearts and minds by using persuasive publicity. Even as far as recruitment was concerned it was word of mouth and the closed shop, rather than effective information and persuasion. Mountain & Molehill were instrumental in changing that tradition, but it was not an

easy task winning the unions over to the idea of employing an outside company to promote their aims using non-traditional means of publicity and advertising. Both Bernard's and Sprague's experience in the Communist Party and the labour movement had given them a profound understanding of the problems facing the trade unions and ideas on how to tackle them by means of modern advertising methods, but not the sort employed by firms like Saatchi and Saatchi who use eye-catching or sensational images and slogans to sell a product rather than promoting a cause. For them, whether "selling" the Conservative Party, a deodorant or a brassière, the basic approach is the same. Mountain & Molehill unashamedly used the latest sales techniques, but only to publicise something they believed in. To use the clash of bright colours, even psychedelic ones was something completely new to the unions at the time. The use of cardboard cut-out lettering was also innovative as was the use of the emotive word "sex" in a National Union of Teachers' campaign on equal pay for women teachers, who at that time were paid less than men for doing the same job. Much of Mountain & Molehill's output was printed by John Gorman's screen-printing company, G&B Arts, which ensured a top quality product.

Contrary to popular myth, there was very little Soviet gold flowing around Communist Party circles in Britain. Anyone who worked for the Party spent very long hours for a rate of pay barely above the poverty line. Holidays were out of the question unless you were lucky enough to be allocated one in a Communist country or stayed with better-off friends.

Sprague relates how his first foreign trip turned into a busman's holiday: 'Ray had a small family as I did at the time and we managed to scrape together enough cash to send our wives and children off to Sett in the south of France, a small Mediterranean town where French working people took their holidays. We hadn't enough cash for all of us to go by train, so Ray and I hitch-hiked.

Once there, I'm lying on the beach enjoying a holiday for the first time in many a year – I hardly knew what a holiday was – when Ray comes bounding up and says, "Come on, we've got our first job!" I didn't know what he was on about. I'm on holiday, I retorted. "No, we've started the firm and we've got our first job painting some fishing boats." He'd talked some French fishermen into employing me to paint the all-seeing eyes and the boats' names. So while Ray continues relaxing on the beach, I'm sweating in the sun painting name-plates. That's how we got started, although we had already begun toying with the idea of a publicity organisation for the labour movement.

We managed to pull off some quite remarkable publicity stunts. We took on the bosses in a number of single issue campaigns and were often victorious. With Gagarin's visit (see story below), though, we took on the whole establishment and by using a creative and spontaneous approach, we actually won. In doing this we got no help from the Party, in fact some comrades accused us of doing it to line our own pockets: we were muscling in, we were entrepreneurs out to make money. Neither of us ever made more than an average engineer's wages and it wasn't until I started working for the holiday travel business that I really made money.'

In 1960 Mountain & Molehill organised a publicity campaign for the Garment Workers Union in London in order to unionise the notoriously underpaid and mainly women workers who slaved in the garment sweat shops. They used posters placed strategically at Underground stations which would be seen daily by garment workers on their way to work. As they left the Tube they were handed leaflets by union stewards which were based on the posters. The campaign had as its slogan: "Dressmakers create beauty". It was taken up again at Christmas time and a record was produced, written and sung by Ewan McColl called *Come on Gal!* with the refrain: "Now you've heard it, come on gal and join the union." The record was handed out like a leaflet and became quite a hit at factory Christmas parties.

This idea was taken up again in 1961 for the National Union of Boot and Shoe Operatives in a drive to recruit young workers. A record was to be cut with

MR. ACKER BILK AND HIS **PARAMOUNT JAZZ** **BAND**

MARCHING UNION

45 r.p.m.

for the National Union of Boot and **Shoe Operatives**

Acker Bilk and his Paramount Jazz Band to lyrics by Lionel Bart. Unfortunately on the day of the recording, Bart failed to turn up with the lyrics as promised, so Sprague and Bernard, together with their long-time friend and copywriter, the East End Communist councillor, Solly Kaye, were forced to write their own lyrics in about half an hour flat. In the middle of the recording, Bilk and his band just broke up with laughter over the improvised lyrics, but this was retained in the final recording, giving it a "live performance" feel. It was called *Marching Union* to the tune of *Marching through Georgia*. The record was supported and launched by show business personalities like the East End actor Alfie Bass and ballerina Beryl Grey. This record was also

handed out as part of a new members' pack when operatives joined the union. It was an adventurous attempt to present the union to young people in a way that would find readier acceptance than the conventional trade union methods of leaflets, speeches and demonstrations.

Mountain & Molehill were described in a feature in the WPN &Advertising Review, a leading magazine of the advertising trade, as formed by "two enterprising young publicity men extending the frontiers of advertising into the field of trade unionism." Mountain & Molehill had indeed become a byword for innovative, radical trade union publicity and all sorts of people would turn up at the studio asking for their help.

'One day two Canadians knocked on our studio door in Arlington Way, behind Sadlers' Wells. They'd flown over on "the jet" as they called it. So we nicknamed them the jet-age pickets. Several thousand workers had gone on strike to save their jobs in a big textile factory. The company had decided that it would be more profitable to relocate the factory to South East Asia, where labour was much cheaper. The company's headquarters were in London, so the other workers had clubbed together to send two guys to London to picket the company offices and try to persuade the bosses to see sense.

They asked if we'd be willing to do some posters for them. Of course we said yes, but we didn't fancy their chances much. The head office was located in a side road next to the Dorchester Hotel and these two men stood there with Ken Sprague's pathetic little posters and were duly ignored. There was a newspaper photo of the boss driving out of the gate to lunch in his Rolls, passing them by without so much as a glance. They came back to the studio very dejected. So we decided to change the rules of the game and play it the way we wanted. My partner Ray found out where the managing director lived, in Surrey's stockbroker belt. So we alerted the press and descended on his house.

I knock on the door and it is opened by his wife. She's a pleasant woman and asks what it's all about. She invites me in, but then feels it's bad manners to leave the others outside, so invites us all in. She appears sympathetic to their cause. While we're sitting there talking to her, her husband enters and nearly drops dead when he sees us all in his sitting room, placards and all. He tries to recover his dignity and play the captain of industry again, but he knows he can't with his wife there. He then admits we have a point and agrees to talk with the Canadian managers. I ask him if he'd be willing to do it there and then. We don't want to put you under undue pressure I said, we'll leave, but the two Canadians will stay. He agrees and phones Canada. In the end the closure didn't take place. The workers didn't win all their demands, but at least the factory was saved.'

When Gagarin came to town

'Now, with satellites in profusion circling the earth, probes sent off to Mars and Venus and regular manned flights to the Mir space station, it is difficult to imagine the frisson that went through the people of the world when the first man was catapulted into space in 1961. Hearing the crackling voice of Yuri Gagarin coming through the ether to us from his Vostok capsule was almost as if god were speaking to us directly. Man had conquered the ultimate. In the USA it was met with disbelief that a "backward" country could beat the world's leading industrial nation into space. This was the height of the Cold War and relations between East and West were as icy as ever. But Gagarin's boyish good looks and his open, smiling expression made him an ideal person to melt the Cold War.

When the news about the launch of the first Sputnik came through, we went outside and could actually watch the satellite, like a small, bright star, moving across the night sky. Now you can see satellites every night. On hearing the news of Gagarin's space flight Ray I and thought: here is the Columbus of the twentieth century. If we could manage to bring him over to Britain, what a crack in the Cold War that would represent. We went into work the next day and puzzled over a plan for getting him over.

We discovered Gagarin had been a foundry worker before he became a pilot and the Foundry Workers Union was a progressive one. We thought we could bring him over and make him an honorary member of the union. Dave Lambert, the youngest trade union general secretary in Britain at the time, agreed with the plan. The following Saturday was the union's national conference in Yarmouth and we were invited to address the conference! So Ray and I worked all that day, through the night and all next day, designing a medal, a certificate and posters. I've never worked so hard in my life. I went to the conference and I spoke – and I'm sure this has never happened at a trade union conference before – they voted unanimously for the idea. But then all our approaches to obtain permission for the visit were blocked. We went to the Soviet embassy and they drove us nearly nuts. They wouldn't even let us in, just opened the door a fraction and told us to "ring back in the morning". This went on for weeks. All the applications we

made to our own government were turned down, we couldn't get anywhere.' But like two terriers who've found a juicy bone, Sprague and Bernard tugged and chewed at it, refusing to give up. Eventually the green light was given – the visit could go ahead. 'But,' says Sprague, 'we had the sense to get the trade union movement behind us beforehand. The first thing I did was go to the TUC and obtained total support from them.'

He continues the story: 'Coincidentally there was a Russian exhibition on at Earl's Court. It was terribly unimaginative, because the Soviet Union was still unaware that in today's world everything is about presentation. They had just laid out their products with no sense of presentation at all, so very few people were visiting and it was about to close down. Charles Clore, the notorious, but wealthy property tycoon rented Earl's Court and had leased space to the Russians who paid him.

Ray happened to hear on the radio that Clore was to be at Lancaster House for dinner that evening, so he jumped in the van, drove over and waited on the stairs until Clore came out. He went up to him and said: "I've got an idea to make you some money!" Clore responds: "Come to my office tomorrow morning!" and that's what Ray did. He's there at nine in the morning, tells Clore about the idea of bringing Gagarin over to the exhibition to give a boost to the visitor numbers. Clore took the bait and we then had him on the side of two Socialists for goodness sake! From that point on things began to change.

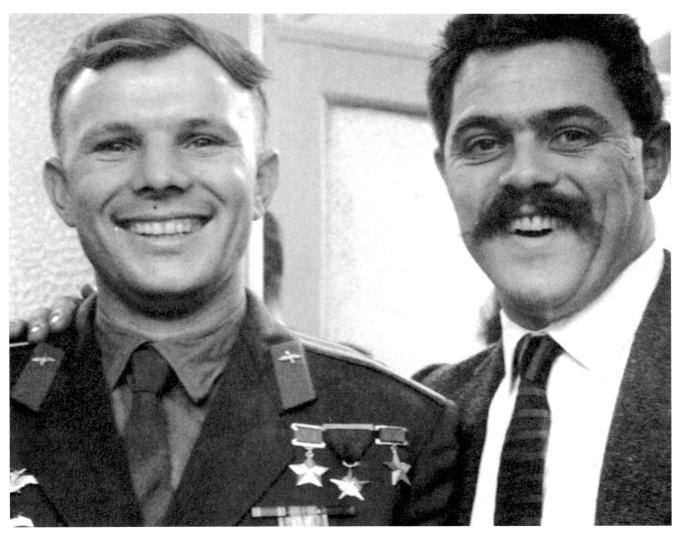

We were innocents. Clore put a guy in charge of the project – a body snatcher. I didn't know then what a body snatcher was. If you have a fête or big event and you want a big star to open it for you he gets them. That's his job. We'd booked a train to take Gagarin and all the press to the union headquarters and we had to paint the whole building up – it hadn't been painted since about 1883. We were spending a fortune that we didn't have and the union didn't have. We wrote to the Lord Mayor of Manchester requesting that he meet Gagarin at the station. I've still got the letter he wrote back, which says: "I cannot meet Major Gagarin at the railway station, but if you come to my office in the town hall at three in the afternoon, I'll be pleased to welcome him, if I'm free."

Now Clore's man moved in and organised things and took it right out of our hands. He'd got all the right contacts, he'd arranged for a plane to take Gagarin to Manchester and we're right out of it. He'd even arranged a banquet at the town hall with the town silver. What can we do? We hear that a good friend, an upright Christian-socialist by the name of Fred Hollingsworth, is going to Moscow on a trade mission. So we go to see Fred – a beautiful old boy with a shock of white hair – and said: Look Fred, when you get there you'll meet Kruschev. At the reception they'll all be pissed out of their heads, but you as a teetotaller will keep your cool. You choose the right moment, go and talk to Khruschev and say: "Listen, we want this guy in London for us and not for those crooks." And that's how it happened. Gagarin comes to London and Clore's man arranges for him to take tea with the queen and we have to let that one go. After this, the mayor who wouldn't come to the station to meet Gagarin is now falling over himself to lay out the red carpet. So Ray, John Gorman and I go to see him and tell him the banquet is fine, but only after Gagarin has visited the big local AEI engineering firm. He is to go around the foundry with the Soviet ambassador, then speak at an open air meeting for all the workers and then go on to the luncheon. All was agreed and he asks if we would like anything else. Yes, I thought, we'll have the police band outside in the square – Peterloo Square – playing the *Red Flag*, not the *Internationale* or the Soviet national anthem, just the *Red Flag*. And we want the red flag, not the Soviet flag, flying over the town hall. He almost shits himself. So I say, look, here's the letter you sent me, out there is the world's press, if you don't agree, I'm going out there to show them what an arsehole you are. A year later, in an ironic twist of fate, he was prosecuted for embezzling funds and was sent to jail.

We tour the factory, past great pits of molten metal and red hot steel being dragged everywhere, and instead of just two or three people, we are now about 100. All the world's press is there. The Soviet ambassador got pushed over into a sand pit in the crush. We emerge from the factory, amazed that we're all unscathed. We'd hired something like 30 taxis, all driven by union members. Every one has a foreign office official planted next to the driver to ensure that they take the delegation straight to the town hall and no factory gate meeting is allowed to take place! It catches us on the hop. We had no idea the games they would play. We'd hired the Rolls Royce used by the Duke of Edinburgh, the only open-top one in the country. It was scratched in the mêlée and putting that right cost more than the hire charges!

I said to Ray, we can't let this happen, we'll walk slowly in front of the car with Gagarin and Fred Hollingsworth in it, up to the factory gate and then sit down in the road and nothing moves and then we'll do a deal. We get to the factory gate, but there is a big puddle, inches deep. It doesn't matter, I said, we sit down. But then we see in the road opposite 12 police horses. They'd worked it all out, it was amazing. They moved forward to clear us out of the way, but Ray did the best thing I've seen him do in his life. He strode forward and in his posh English shouted: "Get these hosses ote of her!" It was the officer class speaking. They didn't know what to do. Some tried to turn their horses and their stirrups became entangled, it was chaos. The car turned the corner, proceeded down to the factory gates and we held a fantastic meeting. Gagarin breaks into song – and he has a terrific voice – they loved it. We then continue to the town hall for lunch.

Looking back it seems quite remarkable that we could pull off something like this. Such successes are worth reiterating in this period when we've had nothing but disasters and losses over recent years. If you go about things in the right way, you can win – on single issues at least.'

Centre 42 – the arts and unions

After years of pressure and the doggedness of a few socialist and communist trade unionists in their own unions (primarily Equity, the musicians and cine-technicians unions), the 1960 Trades Union Congress passed resolution 42 expressing concrete support for the arts. This was a real breakthrough as the unions had traditionally ignored the arts as not really relevant to trade union goals. Arnold Wesker, with a number of other

progressive artists, attempted to put flesh on this resolution. A derelict shunting station in Chalk Farm was purchased and Centre 42 was launched as a centre for working people to enjoy the arts.

'Mountain & Molehill did much of the design work for Centre 42,' Sprague recalls, 'I was very supportive, but I realised from the start that a missionary approach of "taking art to the deprived masses" was not going to work.' Sprague felt Wesker was "pandering to the working class", whereas he was "keeping in touch", particularly through his publicity work for the unions.

'Despite the fact that Arnold had attacked my work savagely, particularly a mural I'd done for the International Telegraph Workers, as primitive social realism, I wanted Centre 42 to be a success. I knew also that without the big unions behind it, it was doomed, so I arranged a meeting between Arnold and Frank Cousins, at that time General Secretary of the Transport and General Workers Union and a very powerful man in the country. In those days if one of the big trade union leaders opened their mouths, people jumped and governments trembled.'

Mountain & Molehill were doing work for the T&GWU so I had good connections. The meeting was arranged for ten in the morning in Frank's office. Ten o'clock came but no Wesker. Ten fifteen came and still no Wesker. Frank was becoming impatient, after all he'd got work to do and government ministers to meet. At ten thirty Wesker arrives. It is January and dull, but he has sunglasses on and an ankle length fleece coat. As if that is not enough, he has two puppies under his arms and Beba Lavrin, the Croatian daughter of a famous sculptor, in tow. She's also wearing shades and is made up with all the glamour of an East European extrovert. I want to sink into the floor. Wesker himself described her colourfully in his autobiography as someone who enjoyed shocking people and hated being upstaged.

Tension is already in the air. I try smoothing things over and we get down to discussing the issues, while the puppies are whining all the time. Then Arnold puts one of them on Frank's desk and, as a fitting climax to the drama, it pees all over his papers. She'd certainly upstaged us all this time, or at least the puppy had! Frank throws us out and it takes me months of delicate negotiations to re-establish my reputation with him. Damned artist, I thought, you haven't a clue!

This incident seemed symptomatic of artists' relations with the trade unions and only served to confirm existing prejudices.

Centre 42, based at Chalk Farm, was transformed into the Round House theatre and enjoyed a short but

lively existence for several years. Differences in approach among the leading promoters, lukewarm support from the unions as well as funding problems led to its eventual demise. It was, though, a remarkable breakthrough and established the precedent for collaboration between working class organisations and the arts.

A more fitting relationship

Over the years, Mountain & Molehill and its successor company, The Working Arts, worked for virtually every trade union in the country apart from, Sprague says wryly, 'the Jewish Bakers' Association which only had 28 members and hardly required to buy in publicity.' Over 30 years, the two companies produced more than 500 poster designs which were printed in two million copies.

Mountain & Molehill also designed a number of trade union banners: for the Amalgamated Union of Foundry Workers, the Glasgow Branch of the Union of Post Office Workers, and the national banners of the Electrical Trades Union and the National Association of Local Government Officers. Sprague complains that he was hampered in this area of work because it invariably

involved committees in the acceptance of the designs and they interfered in the work. His sister, Pat, who Sprague inveigled into taking on the production side, recalls how it all began: "In the early seventies, when Ken was given the job of designing the first banner, he asked me if I'd be willing to make them. He actually said: 'Do you want to do some embroidery on a trade union banner?' I thought it would be working on a smallish panel, so said yes, not realising what I was letting myself in for. When I did, it was a real shock. They turned out to be full-size twelve by six feet banners with complex panels of different fabrics, padding and stitching. For the NALGO banner, I had to clear out the front room of our modest terraced house to create an adequate working space. Every morning my father would come before going to work and help me clear the furniture into the corridor and then, at the end of the day, put it back in again. It took me about 18 months to complete the work."

The Labour Movement was notorious for paying very little, if anything, for publicity work and Mountain & Molehill were sometimes glad to take on other forms of publicity and design work, as long as it didn't conflict with their ethical position. Towards the end of the

sixties they were asked to mount an exhibition for the Indian High Commission.

'Nehru was there,' Sprague recalls, 'and I remember him being introduced by a venerable elder member of the Academy, who proceeded to address him as a worthy representative from the colonies. Nehru didn't bat an eyelid, although we were all terribly embarrassed. Despite this faux pas, he was clearly impressed with what we'd done and later we were invited to design another exhibition to commemorate the work of Rabindranath Tagore, the famous Bengali writer, and it was to be opened by Nehru.

Tagore himself possessed a marvellous insight into human behaviour. He was very conscious of the role memory plays in writing, particularly the way it distorts, magnifies or erases, and he compared the workings of memory with the way an artist works:

"I do not know who has painted the pictures of my life imprinted on my memory. But whoever he is, he is an artist. He does not take up his brush simply to copy everything that happens; he retains or omits things just as he fancies; he makes many a big thing small and small things big; he does not hesitate to exchange things in the foreground with things in the background. In short his task is to paint pictures, not to write history. The flow of events forms our external life, while within us a series of pictures is painted. The two correspond, but are not identical."

Tagore was also a great humanist who clearly recognised the responsibility artists have towards the society they live in. In a reply to Yone Noguchi, a Japanese poet who wrote to him in 1938, in an attempt to enlist his support for Japan's brutal invasion of China, he replied:

"I cannot accept such separation between an artist's function and his moral conscience. The luxury of enjoying special favouritism by virtue of identity with a government which is engaged in demolition in its neighbourhood of all salient bases of life, and of escaping, at the same time, from any direct responsibility by a philosophy of escapism, seems to me to be another authentic symptom of the modern intellectual's betrayal of humanity."

'It was this humanity which attracted me to him,' Sprague says, 'and I felt privileged to be given the job of mounting an exhibition in his honour. 'What particularly sticks in my memory from that exhibition,' he says wryly, 'is hauling on my shoulder a heavy bronze bust of Tagore by Jacob Epstein all along The Strand, from his studio to India House. At the ceremonial opening of the exhibition Nehru actually presented my son Sam, who had helped me set things up, with a Tagore memorial medal as a "thank you". That was a touching gesture and recognition for a child, when, as so often in life, they are either ignored or patronised by adults.'

Who delivers for the postmen?

In 1971 the postal workers went on strike for a 15% wage increase. It was the first national strike and the union hadn't got a clue how to organise it. Postal workers had never been on official strike before and they had no contingency plans for strike pay. They saw themselves as public servants, so even collecting boxes were rejected on the basis that public servants don't beg. "During discussions at the *Morning Star*", Sid Brown recalls, "it was suggested asking the other unions to impose a levy for the postal workers, but this would have meant balloting their members, and the strike would most likely have been over by the time this had been done".

A few weeks into the strike, a big trade union march against the *Industrial Relations Bill* (introduced by Robert Carr, Edward Heath's Employment Minister) was being organised. It turned out to be an enormous success, concluding in a final mass rally in Trafalgar Square. Sid Brown came up with the idea of raising some money by producing twenty-five thousand postcards backing the strikers. These were to be sold for half-a-crown (today's equivalent would be 25p) each to the marchers and then posted in a huge pillar-box at Trafalgar Square, to be emptied at the end of the rally and delivered to 10 Downing Street. Brown outlined the idea to Sprague, who was organising the publicity campaign for the Union of Postal Workers, and he took it up with alacrity.

Sprague takes up the story: 'We built a giant pillar-box and sold many of the postcards that people then "posted" in the box, to be delivered to Downing Street. We made a considerable amount of money for the postal workers in this way. What we hadn't bargained for, though, was that people actually put money as well as cards into the pillar-box, so that when we came to move it from the square we couldn't. Even with a gang of blokes it was impossible because it was so heavy and the bottom started to fall out. So I called some policemen over and asked them to guard it, which they did, while we fetched a lorry to move it. We found it contained over £3,500! It was full of postcards too. That is just one of those marvellous occasions that can happen and for which you haven't planned.

Sprague continues: 'Mountain & Molehill designed a big newspaper campaign for them – the first time a trade union had undertaken such a public advertising cam-

paign to explain why it was striking and to get the public on its side – and it worked. Solly Kaye wrote the copy. The slogan was: 'Who will deliver for the postman?' We had photos of a counter clerk, a postman, a telephone engineer, with the copy: "They deliver for you everyday, but who's going to deliver for them?" The strike was a success – the union didn't win all its demands, but it shook the government that never imagined that public servants would actually strike. There was a lot of public sympathy at the time for the postal workers.

When Harry Pollitt said, "we need artists", I think he meant a lot more than just that. He used to say: "You've got to be a leader, an organiser, get your mates to listen to your ideas, got to help them learn for themselves." This was exactly what we'd tried to do and it had worked.'

The Record

Sprague first began producing work for the Transport and General Workers Union under Frank Cousins and he recalls the first time he spoke to Frank to discuss a poster campaign. 'He wanted me to draw a working man in overalls,' Ken says, 'with a cricket bat, together with the slogan: "Play it with a straight bat – join the T&GWU!" It was a puerile idea, full of ruling class ideology and very old-fashioned. I did what he wanted, but also showed him some of my own ideas and, after some deliberation, he chose the latter.

When Jack Jones, at the time Executive Officer of the Transport & General Workers Union, had the vision of developing an innovative publicity campaign for the union, he turned to Mountain & Molehill again. In an interview Jones explained Sprague's contribution: "I wanted to pull the union out of its rather reactionary traditions and give it back to the members. From that time on I formed a very high opinion of Ken and his work. His father was an engine driver and two of my brothers had worked on the railways, so that was also something we had in common, and we developed a fairly close and very friendly working relationship. I was particularly interested at that time – the late sixties – in making changes to the union journal, *The Record*. That was our prime means of communication with the members, but at the time it was a rather dull parish magazine type of publication, filled largely with reports of presentations made by the General Secretary – glorifying the leaders rather than the membership. It was not much use in terms of putting across policy or building the confidence of workers to begin to fight. I was keen to publicise local organisations and local activists, so that others could emulate that. *The Record* became a useful instrument in realising that aim. It wasn't easy to change the culture though. *The Record* became a newspaper with news of local activists, ordinary workers and of union successes throughout the country. It was the first trade union tabloid journal and was followed later by others. Everyone was impressed and it won a number of competitions as the best union journal. There was no better publicist and graphic artist than Ken to achieve that. I admired his work very much indeed.

During my time as General Secretary of the union Ken and I launched the huge 'Kill the Bill' campaign against the Tory *Industrial Relations Act*, with which they intended to muzzle the unions. At first we suggested 'down with the bill', but it was Ken who said, 'No, we have to kill the bill' and that then became the slogan. Later there was also a similar campaign against the Labour government's *In Place of Strife* Bill, which led to

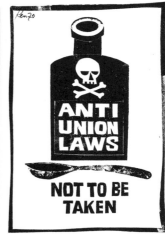

its defeat. Ken played a very effective and active part in that campaign too. It was essential that we had our own newspaper circulating in the factories in order to maintain rank and file support for what we were trying to do. The rest of the press was harassing the unions and I was called an ogre, and together with Hugh Scanlon of the Engineering union, we were dubbed 'the terrible twins'. I felt Ken 'banged the drum' for the union at that time, and we needed it.

Later, after I'd retired, I was actively campaigning for the pensioners and at a Labour Party conference I was trying to press the Labour Party to do more for pensioners and launch a mass campaign. I made the rash promise that the union would produce a million broadsheets within a week, and, to everyone's amazement we did. Without Ken that would have been impossible. I felt he was a great bulwark of our union and of the trade union movement as a whole. He's also been a great opponent of nuclear weapons and his work in that area was always sharp and dramatic and got the message across."

Apart from his short spell as editor of *Searchlight*, the anti-fascist and anti-racist journal, taking on *The Record* was Sprague's first job as a journal editor. He brought to the job years of experience from working at the *Daily Worker* and as a freelance designer and graphic artist with Mountain & Molehill, involved in a whole number of workers' struggles and campaigns.

Sprague explains what he did on *The Record*: 'I became managing editor, designer, cartoonist, photographer, the lot, although at the peak we had ten staff working on it. During my time we managed to push the circulation up to one million, and that was real orders, not the print run.

Although I loved working with Jack Jones and we formed a very amicable relationship, it was not always a smooth run. In 1970 the annual TUC came along and it was in Brighton that year. Wednesday was the high-

point when the big union leaders delivered their speeches, everyone waits for this. I'm there covering it for *The Record* and Jack Jones is the main speaker. Now many of the speeches were drafted by Johnny Oxenbold and me at my house, working together for Jack, but he'd go over every single word and change things to suit his style. We didn't write every word for him by any means. He makes his speech and comes to the point where he says: "The Labour government fell (it had fallen a few months before) because it was full of long-haired intellectuals" – that was certainly not something we'd written. The place erupted, everyone was on their feet, cheering the roof off. Anyway I wrote the piece up with Johnny and took it for Jack to look at before we went to print. He went through every single word in that paper. Our position was, that although we were independent, not employees of the T&G, we followed the union's policy as democratically decided at conference and took it as our own policy. We might have our own views, which we did, and we might sneak in the odd idea of our own, which we did too, but in principle we stuck to T&G policy. So I took it in to Jack and he read it and said, "but you don't mention my standing ovation." No, I replied. "But that was the high point of the speech". I said, yes. "But it's not here," Jack says, offended. No, I replied, I left it out because what you actually said was that the Labour government fell because "it was full of long-haired intellectuals". That's rubbish, it fell because there was not enough socialist intellect, which is very different. Long hair means students so the audience loved that and "intellectuals" plays to the long tradition of anti-intellectualism among the British working class movement and something that has dogged it over the years. You were playing to the gallery and you got your ovation. So what, it's not true what you said. He was furious and said, "Get out, you're fired!" Fair enough, I thought, he's the boss, but I was sad because I was very fond of Jack. I went home and thought, am I being too pompous? I'm perhaps taking upon myself what's not part of my job. Anyway the very next day I received a phone call from Jack's office, asking me to come in and see him the next morning at ten. I arrive, go into his office and he is sitting there with his three assistant general secretaries – Alex Kitson, Moss Evans and Ron Todd. Jack says, "Yesterday Ken and I had a row over my standing ovation. He was right and I was wrong! That's all comrades, thank you very much." After which, they left. I realised, it takes a big bloke to do that. That was the only row we ever had. My being fired was never mentioned again and I carried on working for another year after that. I think that shows tremendous leadership. He could have talked to me in private without the other three present, but I think he was showing them what too much hubris can do to someone in power. I had a marvellous working relationship with Jack.

It was Jack Jones who was largely responsible for establishing the shop stewards' movement, when he was regional secretary in Coventry. He was genuinely determined to devolve power to the grass roots. He is a hero to me and the nearest I've ever come to meeting a truly honest person in my life, apart from Johnny Campbell, the editor of the *Daily Worker* and Willie Gallagher, the first Scottish Communist MP.'

As life is action and passion, it is required of a man that he should share the action and the passion of his time, at the peril of being judged not to have lived at all.

<div align="right">Bertram Gros</div>

JERUSALEM OR BUST

Sprague's move from the Metropolis to a 13th century farmhouse in North Devon with his first wife, Sheila, in 1971 was seen by some of his comrades as a retreat from the struggle to his personal rural idyll. He vehemently rejected such aspersions, counteracting it by retorting that he was now living and working among hard-working hill farmers and running a very busy cultural centre. He was also returning to his family roots. North Devon was where his father's family came from and it was associated in his memory with many a boyhood holiday.

Sprague's life had been bound up with the trade unions and politics, but by the mid-seventies he was acutely aware that the fight had temporarily been knocked out of the Labour Movement. 'I was no longer producing materials on a daily basis for the Labour Movement as I had been,' he says. 'The unions weren't fighting anymore, they were capitulating. I was only designing travel brochures and doing other commercial work, which brought in good money, but it wasn't what I wanted to do. The Communist Party was riven by internal arguments, the communist countries had reached a stage of stagnation and the Labour Party was in full retreat from socialist positions.'

All these factors helped persuade him to take a new direction in life. He admits, though, that he had begun to think, 'Why don't I go and build my own dream, make my own Jerusalem in England's green and pleasant land? If I do it, maybe it will be a reminder to other people that it can be done and that they can come and take part in it. What is simply a pile of stone and mortar becomes alive because other people come and make it a living place.'

With his wife Sheila, a potter, Sprague transformed Holwell, an old, moated, former farmhouse deep in the North Devon countryside, near Barnstaple, into an art centre, where people could come and study art, listen to lectures, become involved in the theatre or listen to

concerts. Not long after moving to Devon he produced his print series *Jerusalem or Bust* that gave an incisive perspective on our society and indicated a way forward to build Jerusalem. Inspired by William Morris, Sprague even designed his own wallpaper for the rooms, hand-printing the linocut blocks on the premises. With a strong graphic quality, its joyful, cheeky images of laughing suns and crowing cocks reinforced the ambience of a rural idyll.

Not long after the move, in February 1973, Sheila died of cancer and the dream was temporarily frozen. Fortuitously, shortly after this traumatic event, he met a young American woman on a visit to England and they fell in love. Marcia Karp, who was a fully qualified and experienced psychotherapist, made a quick and momentous decision to stay in England and join Sprague in his rural idyll. Together they set up the Holwell International Centre for Psychodrama and Sociodrama and this then became the central activity at Holwell.

This small outpost of Jerusalem came crashing down in a totally unexpected manner in 1998. Sprague, despite his skills as a marketing and publicity man, had never been one who considered money central to life. For him it was more of an associated, even though necessary, irritant to the real work of artistic creation. The ideas of financial planning and dealing with accountancy issues were apparently anathema to him. Marcia

was too involved in the day to day running of the centre to concern herself intimately with the financial side of things. A number of financial problems had been building up, and Sprague's nine months of virtually unpaid work on the mural (see *The Muralist* below) hadn't helped. But the final blow came from the VAT man. They had been unaware over the years that the Holwell Centre had been running they should have been charging the students VAT. They were, in any case, once they were told this, outraged that poor students and people with enormous psychological problems should have to pay VAT for their therapy. A number couldn't even afford the course fees and were given odd jobs to do around the farm as a form of payment. When Customs and Excise demanded over £46,000 in back payments of VAT, they were unable to pay and, not long after, were forced to sell the farm.

Immediately prior to this Sprague had been diagnosed with cancer of the colon and had to undergo immediate, radical treatment to cure it. He was, for the six months he was in hospital, unsure whether he would live or die. In his ward and the adjoining one during that period thirty-two people did die. He survived minus a section of his colon, which led one of his more witty, if less sympathetic, friends to dub him "Mr. Semi-colon", a nickname he was now fit enough to laugh about.

Sprague is convinced that his sense of optimism and intense determination to live and keep working helped him survive. He emerged from this trauma with a determination to utilise the time left to him even more productively and with a new realisation that 'politics is not about doing things for other people, but about inspiring them to do it themselves.' His cancer had obliged him to interrupt the degree course he was taking at Perth University in Australia, but, while in hospital and very much based on his experiences there, he was able to complete his thesis on the psychology of survival. He also filled a number of hospital-life sketch books!

Psychology of art or the art of psychology

Despite the loss of Holwell, Sprague and his wife stayed on in Devon, moving to a more modest house in Lynton, with magnificent views over the Bristol Channel to the Welsh coast on the horizon. They named this house Hoewell, and from here they continued their psychotherapeutic work and Sprague has a studio in the centre of the small town.

Psychodrama and Sociodrama are based on the work of the Viennese psychologist, Dr. Jacob Moreno. He was working in Vienna in the twenties when it was a focus of intellectual ferment – Freud, Mahler, Trotsky and even Hitler were all living there. Europe had just emerged from a devastating war, the Bolshevik Revolution had shaken the ruling elites and the worm of fascism was boring into the rotten woodwork. This was the context in which Moreno began developing his ideas. He had read Marx, but felt that his ideas were lacking in one essential dimension – the spiritual. He agreed with Marx's economic arguments and witnessed the poverty which capitalism engendered. This provided Moreno with a philosophical basis different from, although connected with, other psychotherapeutic methods being developed at the time. The essential difference was that Moreno emphasised the social as well as the individual component. He was intent on exploring the social and political forms of human conflict as well as personal and familial pathology. He developed

the idea of the Living Newspaper, bringing the day's news on the stage through individual experience. He also organised prostitutes in Vienna, something no one had done before and least of all a doctor. Moreno obtained medical aid for them and helped them organise against their often abusive pimps. Sprague has done similar work in Norway with heroin-addicted prostitutes, but he also utilises visual art techniques and his own special skills as an artist and communicator in his therapy work. Moreno is credited with being the first professional to use group therapy in his work with the prostitutes. Here, too, he experienced human misery first hand and the dire consequences of exploitation. Although the family was deeply orthodox, he had already rejected Judaism and realised that religion without science made no sense in this new era, but he also recognised that science without "religion" or the "spiritual" is not a complete answer either. He sought a third way, which recognised the necessity of a scientific approach but also the requirement of a spiritual dimension. It is reported that Moreno met Freud one day on the street and Freud asked him what he was doing. Moreno replied: "Dr. Freud, you analyse people's dreams, I'm trying to teach people to dream again."

He left Vienna in 1926 for the United States where his methods were avidly taken up. He called his method of working with groups of people in a social context: psychodrama. Sprague was attracted to Moreno's early idea of a psychotherapy not for individuals alone, but for society. Now most doctors and psychiatrists are aware of the intrinsic contradiction implied in treating individuals and then sending them back to the same social conditions which contributed to making them ill in the first place, but they have no solution.

In the British psychodrama movement Sprague has been instrumental in promoting Moreno's original philosophy, because Moreno himself complained that the medical profession had taken up his ideas for treatment, but had ignored his philosophy. For Moreno, one major aim of group therapy is social change, not simply the analysis of individual problems. Sprague relates: 'I was interested in using his methods of treatment in society, not in the clinic. I wanted to break out of the confines of clinical treatment. Once you limit treatment to a clinic,

you also confine the ideas and the possibilities of real healing. I've used these methods for working with Downs Syndrome and sexually-abused children as well as in educational training programmes for T&GWU activists in North Devon. We use role-play simulating real life situations and work out how to behave constructively within them.'

Sprague, as an activist, needs to feel a strong communal tie and to play a social role. Now he sought an organised form of activity to replace the one that lay shattered. Psychodrama offered this and it suits his character with its stress on group working and solidarity. It also allows him to remain in control, even though he enjoys working in a team. He saw that group therapy implementing Moreno's methodology and philosophy could help change people's lives for the better, particularly some of the most vulnerable in our society. It could help them recreate or remodel their own lives, become more "whole" and better able to reintegrate into society with a more dignified, confident and meaningful role.

As a psychodrama tutor he also found a new role for his art and undoubted facility as teacher. His sessions invariably involve his clients in some kind of creative work, printing, painting or building. His belief in a more just form of society, which is supportive and where individuals can realise their potential, finds its justification in his therapy work. He says: 'People dream and work to make life better for their children than it was for them. It is a rather endearing human habit but it drives dictators and bureaucrats stark raving mad. Because dictators aim to take decisions for people rather than empowering them to make their own choices.'

This is what the Argentinian generals did over the Falklands/Malvinas Islands. In 1985 Sprague was invited to a medical conference in Buenos Aires in the aftermath of the Falklands War in 1982. There he met a local doctor who was working with young Argentinian soldiers and their families, who had been traumatised by the war, using group therapy methods. Through this doctor he met some of those young veterans and was able to work with their families who were trying to cope with the worry, the grief and impotence of knowing that their sons had been sent to fight a senseless war in which many of them had been killed or were maimed. 'We brought many of these people together,' Sprague relates, 'and I was asked to run psychodrama sessions on the conflict. Families had been left in suspense during the war. Some had been unaware that their sons were out there fighting, or whether they'd been killed – these soldiers weren't even issued with ID tags. The doctor I worked with was able to bring these families together and created, through the group therapy sessions, a sense of mutual support and a sharing of information and experience. We were able to deal with the conflicts both on the personal and social levels and I was able to view the war through "enemy" eyes and share their anguish.'

Sprague feels that his interest and involvement in psychodrama has helped retrospectively explain what he has been doing with his art. He now understands more of the theory behind what had previously been a largely instinctive practice. A barrier had been breached, allowing a deeper insight into motives and aims.

A short career in television

Cinema Action, the radical film-making group, commissioned Sprague in 1971 to produce some linocuts for an animated sequence in their film *Fighting the Bill* aimed at the Tory government's *Industrial Relations Bill*. The film was shown widely at trade union meetings up and down the country. This minor artistic contribution was

Sprague's first tentative involvement with film-making. Being a natural and charismatic communicator, the medium of television would appear to be an ideal medium for Sprague, although the idea had probably never entered his head before the the BBC Omnibus film about him in 1976.

I was drawn to Sprague as a potential subject for a documentary film after seeing his poster work in publications like *Peace News* and *Tribune,* and after reading an article about him and his wife Sheila in *the Guardian* in 1971. Together with Gina Kalla, I completed the project in 1972 and we premiered the film at the 1974 Communist University in the Conway Hall. Jeff Perks attended the session on culture, during which the film was shown, and this inspired him to propose filming his own portrait of Sprague for the BBC's arts and culture programme, Omnibus. This was made and broadcast in

May 1976 under the title: *Posterman*, and was introduced by Humphrey Burton. It turned out to be one of the most popular art films of that period, generating dozens of letters, and persuaded the BBC to put on a repeat showing – quite exceptional for an arts programme. Following the success of *Posterman*, came a pilot film for a planned new Omnibus series in 1978, also directed by Perks, under the title, *Everyone a special kind of artist*.

'The artist, Eric Gill paraphrased the Indian philosopher and writer, Ananda K.Coomaraswamy: "It's not a question of an artist being a special kind of man, but of every man being a special kind of artist." However Gill anglicised it, and in typical middle class manner, took the politics out of the original. What Coomaraswamy actually said was: "It's not a question of an artist being a special kind of man, but of every man *who is not a parasite or idler* being a special kind of artist". Now that's stronger, that's politics. I used part of this quotation as the title for my television series.'

Sprague, in his role as communicator and publicist, has given numerous lectures or led workshops on art and culture. In this role he very often became a catalyst for young aspiring artists and encouraged the development of their art. He was often invited by individual, or groups of, artists to talk about his work. One such group inspired this pilot film.

'During the Upper Clyde Ship-builders work-in in Glasgow in 1978,' Sprague relates, 'I was invited up to make a programme about a poster workshop formed by a group of four spare-time worker artists, two who worked in the Clyde shipyards: Bobby Starrett – a very gifted cartoonist and Roy Fitzsimmons, and two local teachers: Bobby McGeogh and Archie Forrest, who later became a celebrated painter. Unfortunately, despite the film's manifest popular appeal, the BBC got cold feet about using such radical film makers, and the planned series was shelved and Sprague and Perks were blacklisted.

The producer of this pilot Omnibus film was questioned at the time by Lord Trevelyan (the then Director General of the BBC) as to why he was employing Communists. He replied sarcastically: "I'm only sending them to interview a few innocent artists in

the country, not putting them on board a bloody Poseidon submarine for god's sake!" 'It was courageous of him,' Sprague says, 'but it didn't change Auntie's blinkered attitude and I was never offered another chance to do work for BBC television nationally.'

However, what the BBC rejected, Channel 4 was more than ready to embrace. The result was a series of six films for Channel 4 with the same title as the BBC pilot. This series portrayed a number of "ordinary" people, unknown or little-known amateur or professional artists, working in media as diverse as quilting to postcard illustration, in order to demonstrate the creative talents we all have, in some form or other, often dormant within us.

This series was followed a year later, in 1979, by a series of 13 programmes for BBC South West, co-presented with Joan Bakewell and called *The Moving Line*. Sprague relates how this came about: 'Joan Bakewell was the lead presenter and they were looking for a male

co-presenter. I applied for the job along with ten others. We had to present a piece to camera. I took along a Whirlygig toy made by my uncle and used it to talk about art. I was selected for the job and the other applicants were sent home. I was invited to a celebratory drink in the Green Room to discuss the terms of the contract. "Can you start immediately?" they asked. I replied, "No, and I'm not sure I want the job". They were horrified. They had planned a series of hourly programmes, each covering six artists who had connections with the West Country, people like Wayne Sleep the dancer and Patrick Heron the painter, who both lived in the South-west.

Now I really had them in a cleft stick, because they'd already sent the other applicants home. To do justice to six artists in an hour, I said, would be impossible; it could only be superficial. I'll take the job on if it's three artists in an hour, I offered. Joan does one, I do one and we both do one together, but I choose my own people and they won't all be artists in the usually understood sense. They agreed.

The first "artist" I featured was the local baker and I showed the art that went into baking the wonderful loaves he produced in such a profusion of shapes, sizes and flavours, as well as the cakes he baked for the school children – they have a real sculptural beauty. We covered the history of baking. This was the best item of the lot. The series was very successful and viewing figures shot up. But Joan was difficult, although incredibly professional. She'd come on the set just a few minutes before shooting and she knew the script by heart, but I didn't think there was much personal involvement; it was just another job for her.

I never used a script, it was all impromptu. The scripts were actually written retrospectively after the programme was shot, to satisfy the powers that be. Half

way through, after about seven programmes, Joan unexpectedly pulled out and returned to London to present *Kaleidoscope* and she took a number of our ideas and contacts. Her role in *The Moving Line* was taken over by Jackie Gilot, who was a lovely woman to work with. We did a great show together but then were told the series was to be chopped – a consequence, no doubt, of Thatcherite policies and the demand for audience ratings. Clearly, "minority" arts programmes were the first to fall under the axe. Jackie went home and killed herself. She may have thought the programme's demise had something to do with her, but she was the best thing on the show.'

Sprague was clearly not a comfortable figure for television managers. He didn't fit into the usual "presenter" categories and refused to be tamed. Even on the show he was an iconoclast. If someone mentioned the queen's birthday, for instance, he'd make an irreverent quip. He admits that he had a love-hate relationship with television: 'The producers were always pressing me to speed things up, be more snappy, but I refused. I did love the contact with the audience though.'

Are you or have you ever been?

In the late forties, when Sprague was in the Forces, he was given a little booklet called *Get to know your allies*. It was an introduction to the US army, with a reproduction of a mural by Ben Shahn. This was the first time Sprague had come across him, but even at this early stage in his artistic life, Shahn's work clearly left a deep impression. 'I don't know how he came to take on such a large role in my later life,' Sprague says, 'but here was an artist clearly interested in working class people and he'd produced some fine posters, which struck a chord.'

Ben Shahn came to prominence during the Roosevelt Works Progress Administration (WPA) era, but he'd already worked as an assistant to Diego Rivera and that's where he no doubt acquired much of his painting experience and probably some of his revolutionary ideas. But Shahn was rarely overtly political, although his work always had a strong humanitarian message and was invariably a celebration of working people. He became a leading figure in the North American poster art movement.

Sprague began corresponding with him after the war and was invited over to work with him. However, as an avowed Communist and unwilling to deny it, he was not allowed into the USA. It was many years later before he eventually managed to obtain a visa.

Sprague explains his fascination with Shahn: 'There

is a beautiful painting of his in the Kennedy Gallery in New York. It is of a photographer standing next to his old wooden box camera on a tripod with brass fittings. A rubber band – the sort made from a discarded inner tube – is around the camera and photos are held by it, like feathers in a head-dress. There are photos of farmers and their wives, labourers, ordinary Americans, a sort of folk history. It is titled in meticulous hand lettering, the kind you can still come across in the USA today, despite all the new technology. People still do their own signs. I remember going past a dirty little garage in Queens New York and a sign said: "Flats fixed" – in England it would be "punctures mended" – so American, straight to the point. It was all in hand lettering. That was one of the things that attracted me to Shahn, his background in lettering – he'd been apprenticed to a sign writer. He was also very much influenced by the photographic medium.

He often had figures half in or out of the frame as if caught in a snapshot.

I always wanted to paint murals but never had much opportunity to do so. Ben Shahn painted one in the Library in Jersey Homesteads, now called Roosevelt – a housing estate built for unemployed garment workers during the New Deal. I went to see it. It begins with Einstein's landing on Ellis Island and takes in the history of the labour movement in the USA – it's very moving. I also visited Shahn's small house not far from Roosevelt, but the house was clearly uninhabited, so I knocked on the neighbour's door and discovered it was his daughter-in-law's house. She was initially frosty, but when I told her of Ben's invitation to me years before, she warmed, invited me in, and told me of his death from cancer in 1969. In her house she had paintings of his I'd never seen and lots of ingenious toys he had made for his grandchildren

from old tin cans. So, I was never able to actually meet the man who'd been an artistic paragon for me.

I realised though, quite early on, that this man I'd learned so much from, had become an incredible burden. I found myself facing an artistic problem and thinking, how would Ben tackle this, not, how would Ken do it? I managed to throw him off my back eventually; he'd never climbed up there, it was me who'd put him there.'

Ben Shahn's influence on Sprague's work is clearly visible – the strong graphic quality, the recurrence of lone figures in urban landscapes, and the fascination with typography. But, as Sprague emphasises, 'his experience was very different, he lived the savagery of US labour history, ours was not the same.'

Sprague explains how he eventually got his ticket to "God's Own Country": 'I was kept out of the United States for many years, firstly because I was a member of the Communist Party, and probably also as a result of my anti-Vietnam War prints. But I was in good company. Picasso and Siqueiros were only two of a whole number of Communist or left-leaning artists banned from entering the United States at the height of the Cold War, because they posed a threat to "democracy and freedom". Every time I applied for a visa, I had to fill out the usual form which had the obligatory question: "Are you, or have you ever been, a member of the Communist Party or any of its front organisations? This question succeeded ones which asked if you'd ever been convicted of committing an offence against a minor, of taking drugs, or suffered any mental illness". What an insult!

In 1969 I did try to enter the United States without a visa, by crossing over from Mexico. But I was apprehended at the border and, after being roughed up by the immigration authorities, I was taken to Tampa and put on the first plane out to Jamaica which, being a former British colony, was obviously deemed an appropriate destination. I had to spend a week there with no money and nearly died of starvation. I later planned to attempt the crossing again illegally, but rejected the idea in the end.'

After he had met Marcia, his second wife and a US citizen, they toyed with the idea of going to meet her parents. They'd also decided to get married, because that was the only way for Marcia to obtain an extension of her British visa – she had already overstayed her permitted time. This was in 1976.

'I wracked my brain about how I could obtain a visa for the US. It then occurred to me that Charles Gosford – Viscount Gosford – could maybe pull some strings. He had been a client of ours. He was also a good painter and we'd become friends. So I rang him. "As a matter of fact," he said, "my mother is taking tea with the Ambassador in a few days time. I'll talk to her." 'His mother, Viscountess Gosford, rang me up and asked what it was all about. I told her I was a Communist and had been kept out of the States. "You're a friend of Charles's", she said, "and that is good enough for me, I'll see what I can do."

The morning after she'd had tea with the Ambassador his personal secretary rang me. Now this could only happen with Americans, they are a remarkable people. It certainly wouldn't happen in Britain or in Russia. This was the conversation that took place: "Good morning Mr. Sprague, I am the Ambassador's personal secretary. I understand you are having difficulty obtaining a visa for the US." Yes, I replied, for nine years. "Right, I'm very sorry about this. The Ambassador has asked me to handle it personally. The problem is that whenever people apply for visas, all applications go via Frankfurt, the headquarters of the CIA in Europe, and we hate those bastards." (This is word for word, Sprague assures me.) "You will receive your visa in the post tomorrow morning and if there is any difficulty, ring this number and ask for me personally." The very next day it arrived as promised. At last I could travel to the States without the risk of being kicked out as soon as I arrived.

During this short visit I married Marcia. We made a

point of choosing for our marriage a place with a notorious, but for me highly symbolic, history, in order to cock a snook, in our own tiny way, at the American establishment with its intolerance and anti-Labour tradition.

The Chicago City Hall was the place where the worst vendetta against the organised Labour Movement found its expression. It was here that Sacco and Vanzetti, the two Italian anarchist workers, were sentenced to death, where Labour leader, Big Bill Heywood was sent to jail and the Chicago seven were condemned to die. It was also where Mayor Daley put eight anti-Vietnam War demonstrators on trial in 1968 for "conspiring to cross state lines to cause riots" during the Democratic Convention. We thought it was about time something decent happened, so we chose it as the place to make our marriage vows. The very next day Mayor Daley died!'

In 1984 Sprague returned to give a lecture in New York. However, visa or no visa, the immigration authorities in the States are a law unto themselves and despite having a perfectly valid visa, he is pulled out of the queue and given a thorough going over: 'A very unpleasant experience,' he emphasises.

'I'm staying with Fred Wright, the cartoonist for the Electrical Workers' Union in New York and on arrival there, I unpack my bag and discover that the customs officials have taken my lecture slides and the glasses, which I need for reading. Fred tells me not to worry. I can

get a new pair of glasses within minutes in China Town.

My first day in New York was nothing if not eventful and was a rapid immersion for me into United States' reality. I decide to walk back to Union Square from China Town, although New Yorkers think I'm mad. I haven't gone far when I see one of those enormous US lorries parked on the pavement and the driver is underneath, repairing something. I have my sketch-book with me and decide to make a sketch. While I'm drawing, the lorry suddenly disappears into a hole in the ground – I can't believe my eyes. I suddenly recall that there had been a bloke beneath the lorry, so tell people and the police soon arrive. In the meantime a crowd has gathered and out of the crowd the driver appears, covered in blood. He'd noticed the pavement giving way, had rolled out of the way of the falling lorry, but been trampled by the crowd.

I continue on my way and see an old guy coming towards me and I realise he's going to ask me for some money, which he duly does. So I tell him, look I'll buy you breakfast if you tell me about your life and let me do a few sketches. He gives me a fascinating picture of his life as a New York docker at the time it was dominated by Italian immigrants and the Mafia, about the bitter union struggles to organise the dock workers. The stories he told me were like scenes from Arthur Miller's play, *View from the Bridge* or Kazan's film *On the Waterfront*. I do a drawing of him in the diner with the sign in Chinese lettering above his head. I pay, say goodbye and head off.

I haven't gone far before I hear a screech of brakes and a hell of a crash. Round the corner is a woman standing in a state of shock, but not badly injured – she's driven down a one-way street and hit a bus. I immediately start sketching this incident. The woman spots me and says: "Fuck me, that's all I need, someone drawing this mess!" I invite her for a cup of coffee to steady her nerves. A truck comes and tows her car away. I'm just about to leave and she realises her handbag was in the car, so I have to lend her twenty dollars – it was almost all I had on me. I received the money from her in the post at Fred Wright's house the next day.

I've already got a sketch-book full from the day's incidents when I arrive at last at Union Square. I'm surprised to see a glass door with "Garment and Hosiery Workers International Union of America" over the door and I decide to do a drawing of the building. It's ironic that it's here because Union Square refers to the union of the United States, not to trade unions. As I'm drawing, I hear what sounds like heavy revolver fire. Around the corner a bloke is running hell for leather and behind him

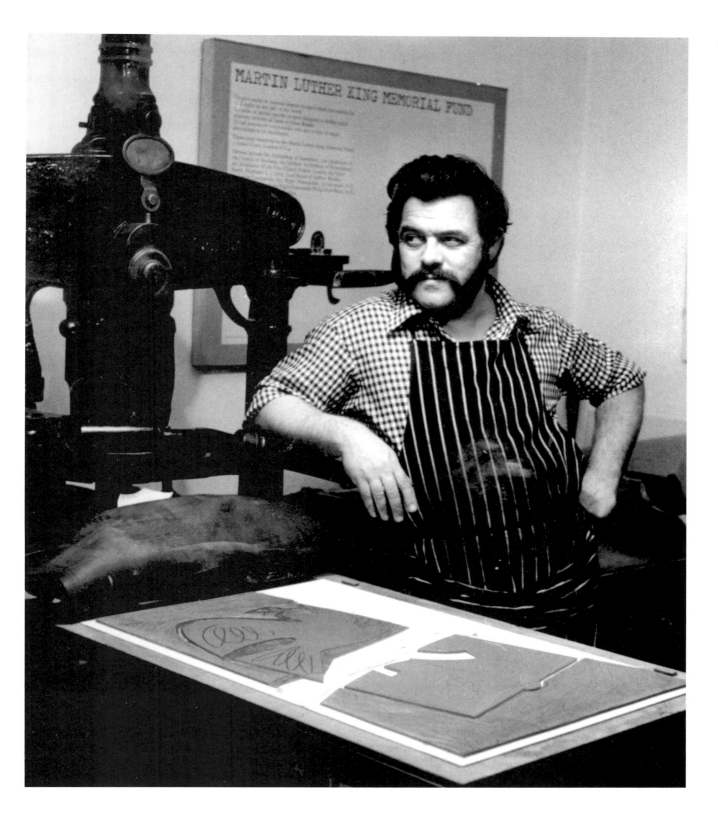

three policemen firing away. I think someone is making a cop film, but then the fugitive collapses on the pavement and there is real blood. I start drawing this. The coppers come over to me and demand to know what I'm doing. When I show them, they are fascinated and start pointing each other out in the drawing. They ask me if we can go down the road and make a photocopy. What about the bloke in the road, I ask. "Oh he won't be going anywhere in a hurry," they reply. So I make them copies and they are happy. I finally decide the day is becoming a bit hairy, so retreat to Fred's flat to recuperate. Fred Wright, by the way, regularly carries a pistol with him as protection from company goons. We never had to take that sort of precaution in Britain. The United States has had much more vicious and bloody labour movement struggles than we have.'

It is ironic that despite Sprague's uncomfortable relationship with the United States, and the artistic barbs he has flung at their imperialistic policies, all his Vietnam prints have been bought by Santa Monica College in California.

The local activist

Everywhere Ken Sprague has lived, he's rapidly put down roots and become a colourful and respected figure in the neighbourhood. Despite his politics, which some would no doubt find problematic, and despite his "outsider" status as an artist, people have immediately recognised that here they had a man they could rely on, a man who spoke the truth irrespective of which way the wind happened to be blowing or to whom he happened to be speaking, and also someone who put his words into action. In almost everyone he encounters he seems to be able to ignite enthusiasm and admiration. The artist who bought his old farmhouse at Holwell, wrote to me to say: "Everywhere you go in Barnstaple, people remember Ken Sprague."

In 2000, Sprague became a leading figure in the Lynton Residents' Association and was embroiled in a campaign to save the town hall from demolition or private development. 'I told local residents,' Sprague explains, 'that they'd have to reject the confrontational approach – not all councillors were for selling it off, but they recognised that the hall needed a quarter of a million pounds spending on it to restore it. Where would it come from? So we had to come up with a better proposal.'

An alternative concept to that of the private developers was presented. It was drafted largely by Sprague's son, Sam (an industrial design professional), in an

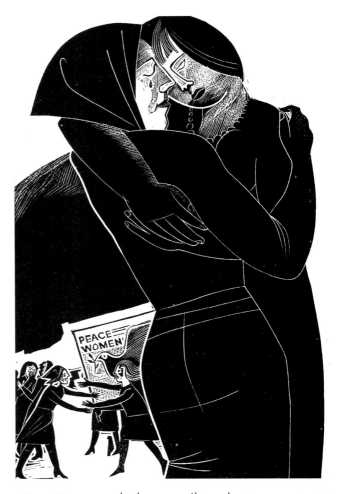

attempt to persuade the council to adopt a more appropriate compromise solution to save the town hall. The battle was waged by the two opposing camps: either keep the town hall, including within it a museum, to which an entrance fee could be levied, or hand it over to a private entrepreneur with all the associated dangers of tatty profit-orientated development. What astounded the councillors was that a small residents' association was able to come up with a very professional solution. 'And that's what politicians forget,' says Sprague, 'that ordinary people have brains.' The campaign to save the town hall was victorious.

In his infectious enthusiasm and integrity Sprague is a model for young people. He himself says: 'For an old codger like me, there is not much left but to help young people find the confidence to plumb their own creative depths and get more out of life by realising their creative potential.' Together with his friend, John Bowden, he recently formed a local "Pensioners and Young People's Alliance" to enable the generations to work together for common goals.

Sprague is often invited to lecture or run workshops

at various festivals and events. For instance, he gives an annual William Morris lecture at Plymouth School of Architecture. In July 2000 he was invited to the local village of Hatherley to mount an exhibition of his work and run an art workshop for local children. Over 80 children turned up for the workshop and the exhibition brought in people from the surrounding area. The organisers had put up a sheet for visitors to make comments about the exhibition. Sprague examined these out of understandable curiosity and noticed one that said: "I find this exhibition deeply offensive." He thought it rather unusual because he felt there was only one picture in the collection which could have possibly caused offence and that was the painting about the Stephen Lawrence murder. On making enquiries, he found that the comment had caused a discussion among the villagers too. It turned out that the writer was an ex-police inspector and former local mayor. Sprague decided there and then to challenge him to a debate about the picture, so he wrote to him saying: I promise

to respect you as a person in view of your background as an ex-police officer and mayor, but I won't necessarily respect your views. The village agreed to the debate to take place in the village hall, in the presence of the picture. They agreed to make a small charge to those wishing to hear the debate, the proceeds going towards funding the following year's children's workshop. Sprague is still awaiting a reply!

Sprague can also be light-hearted and the Christmas card he designed in 1981 to raise funds for the South West Arts Association is a good instance of his mischievous and subversive streak. It caused such a furore in the locality that the local newspaper took up the story. This was then recycled by the national press including *the Sun*. With a supreme absence of irony it published the story adjacent to a full-page photo of a topless model in suggestive pose. The copy read: "A Christmas card showing a naked woman sold by the public-funded South West Arts Association is in bad taste according to several complaints."(sic)

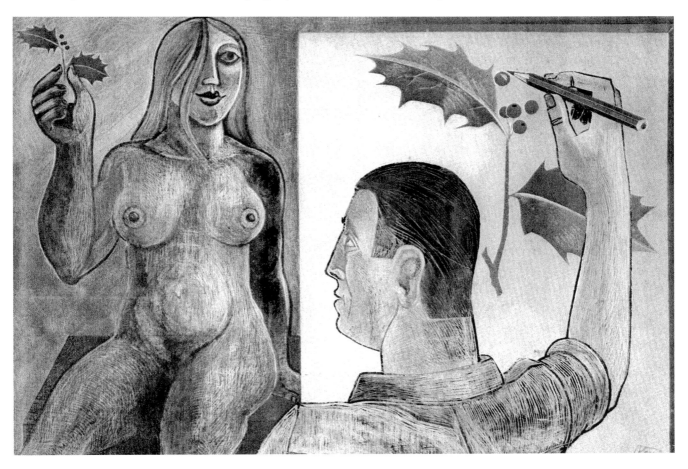

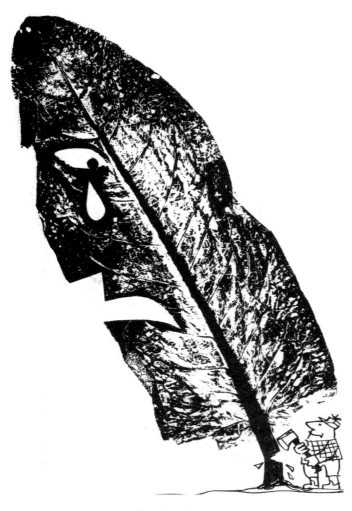

tually an integration between those students with learning difficulties and the mainstream students developed. This led to a once weekly mixed class. The two groups would do drawing exercises together, those with learning difficulties felt good about attempting classes with others and it helped bring out more creative behaviour in them. There was also a useful two-way relationship between the two student groups who would, under normal circumstances, have had little contact with each other. Those with learning difficulties brought a refreshing spontaneity and naiveté into the class and this helped the mainstream art students.'

This was confirmed to me when I read a thesis by one of these students on Sprague and his work. The student wrote: "It is beneficial to us because it breaks down our fear of mental disorder and generally loosens us up in our approach..."

Sprague believes passionately in art, not only as a creative process, but also as a means of bringing people together and of releasing that dammed-up creativity that lies locked in so many of us. Increasingly he also sees its role as a vital psychological release mechanism for expressing what is often suppressed and thus contributing to a healing process. Art is not just for artists.

The artist in everyone

A hand-painted sign above Sprague's studio reads: "It's not a question of an artist being a special kind of man, but of every man, woman or child being a special kind of artist." Sprague is convinced that there is an artist in everyone, but in most of us this creative spirit is often crushed early in life or is later never given the opportunity of expressing itself. He is not suggesting that everyone has a talented artist trapped inside them, but that we all have a creative need and each of us has something unique to express with a potential to develop the means of doing so. To underline this conviction, he tells the story of a children's class he took:

'I recently led a children's art class as part of an arts festival in a little fishing village called Appledore. I had 120 kids! One little fellow comes in and wants to draw something, so he does a footballer – a tiny, crude little figure in the corner of the page that he then scribbles out because he's not happy with it. He does it again, but it's hardly any better. So I make a football from screwed-up newspapers and get a couple of the children to kick it around a bit. He then produces a drawing with much more movement in it, but now everyone wants to draw a football picture. So about 20 of us go outside and have

Four Seasons School of Art

Sprague also runs an art school in his studio as one aspect of the activities of the Holwell Socio- and Psychodrama Centre. There are four courses, one in each season, giving it its name: the Four Seasons School of Art. 'Drawing', he says, 'gives you a freedom to imprint your own personality on to the world, it gives you a sense of power over the world in the archaic sense of understanding events and happenings and of achieving control. You are not a mere hewer of wood.'

He also teaches at the local art college. One cold winter's morning while he was teaching there, a row of faces appeared at the studio window. The children in the group outside were gesticulating and indicating that they wanted to come into the art class. They were children with special learning difficulties on a class outing with their teacher. Sprague invited them in. 'Their spontaneity was boundless and their interest high', he relates. 'I was delighted by their enthusiasm, and artists need spontaneity'. To begin with it was chaos, but even-

a kick around. It's pissing with rain – and I'm glad their mothers aren't there to see what I'm doing with their kids. I get seven of them to watch from the sideline, then we go back in and draw again. The kid who began with a scruffy little sketch now produces a big picture of a footballer, full of movement – it's a Rembrantian leap, I'm serious. It's not a Rembrantian drawing, but in terms of learning, if you and I were learning at that rate we'd be at the top of our field in days. Just as an acorn already has the tree within it, that kid had this talent within him – all that is necessary is encouragement and the practical means of doing it. Now that's the way we in political organisations ought to work. What that kid achieved in three-quarters of an hour is more important than what most politicians do in years. That boy's creativity could be part of the solution, depending on how it's encouraged. Children still have a delight in exploration, in the magic of words and images, playing with the magic of artistic creativity. When Eric Gill spoke about every one

being a special kind of artist, what I think he was getting at was that there is an innate creativity in everyone of us, but it is often dammed up by all sorts of economic, political and social circumstances; but in children the dams have not yet been constructed and that's why it's such a joy to work with them and help bring out that burgeoning creativity, before it is walled up.'

Muralist

Sprague always had visions of being able to paint murals. After visiting Mexico and seeing the awe-inspiring murals of Rivera, Siqueiros and Orozco, he felt this urgency even more. But Britain is not a country with the weather or political conditions conducive to mural painting and commissions are extremely difficult to come by, as prospective public patrons are unwilling to meet the costs.

Sprague has, nevertheless, been involved in several small mural projects: 'I helped paint a ceiling mural in the Russell Cotes Art Gallery in Bournemouth and also one in a children's home there. In Switzerland I painted one in a climbing lodge, and one for the International Postal and Telegraphic Workers Union in an old freemasons' hall. The most recent commission I had was for one in the Devonshire village of Torrington to celebrate the local people and their culture. I'd have liked to have done many more murals but the opportunities were few. There has never been a real mural movement in Britain although there have been several attempts to start one.

When the newly created Plough Theatre and Arts Centre in the small Devon village of Torrington advertised a mural commission and invited local artists to submit ideas, Sprague jumped at the chance. Here was an opportunity for which he had waited a lifetime. But the dream developed into something of a nightmare, as he relates.

'Like most people in Britain, the members of the committee didn't really understand what a mural was. What they actually wanted was a wall decoration. £5,000 were available. If you paint a 10' x 6' wall decoration you can manage it for that sum and even pay yourself a small fee at the end of it. But I was attracted to the idea of a mural on a sizeable scale, all around the auditorium, on the theme of local creativity, with allusions to local festivals and customs. One of only 10' x 6' would hardly be noticed in the theatre. It's like carrying a small, six-foot banner on a demonstration, it gets lost. So I managed to persuade the committee to let me paint all three walls.'

The sum of £5,000 for a proper mural is a ridicu-

lously small amount and reflects the status artists and their work are accorded in our society. Out of this pittance the organisers expected the artist to produce a scale model, buy all paints and materials, transport and install the mural in the theatre and agree to return after three years to undertake any necessary renovation and retouching.

Sprague went about the commission in thorough fashion. He had waited sixty years for such a challenge. He re-read texts by the Mexican muralists, made numerous photos and sketches as well as keeping a fascinating and detailed journal of the whole process. He was determined to create a genuine celebration of the community, involve local people and depict their history. As he put it in his journal, 'I want the mural to move and to sing with energy'. He saw it as a form of community billboard, something that would involve everyone.

In reflecting local history, he wasn't interested in nostalgia but in a past that is still alive in the present, that is a part of everyone. It is replete with symbolic elements and metaphors. The traditional "Red Devon" cow, in a prescient comment on the Foot and Mouth outbreak to come, becomes a radical protester. It carries on its back a poster saying "cull the politicians not me". The local parliamentary candidates are wearing clown masks, to reflect the perceived insincerity of most politicians, who obscure their real faces from the public. The last battle of the English Revolution was fought in Torrington and this too is brought alive in a graphic depiction of the annual re-enactment. Sprague was inspired by the Mexican muralists' use of zooming perspectives and foreshortening and, like Rivera, packed his mural's surface with dozens of individual characters in a vertiginous whirl of colour and drama.

His journal reflects the enormous amount of energy, commitment and sheer back-breaking work that went into the mural – it was undoubtedly a labour of love. The journal tells, too, of his moments of doubt, impatience, crises of confidence in his ability to maintain the aesthetic momentum over such an enormous surface, but also his delight when things worked.

'The audience for the theatre comes from a radius of about 25 miles – the distance farmers are prepared to drive. That covers most of North Devon. It includes the old fishing villages, the heartlands with their sheep fairs and all the little villages that organise local events and have histories I was completely ignorant of – and I thought I knew the area well. So my theme was the people's own drama.

My idea was that when the theatregoers were seated in the auditorium, they would see on both walls, either side of them, events and scenes from the villages they came from. When they turned to leave the auditorium in the interval they would face, on the rear wall, the village of Torrington, in which the last battle of the English Civil War was waged and where Cromwell with General Fairfax signed the armistice with the Royalists.

The idea for the mural was agreed, but once I started it took on a life of its own and there was no stopping. I painted the panels in my studio and people started to come in to tell me stories about the area I knew nothing about. And if I didn't know them, it meant most people didn't.

Visitors or settlers from London and the South East see Devon as a cultural desert but that's wide of the mark. In the thirties, for example, there were 38 separate breeds of sheep in Devon, for 38 different types of terrain. Long haired for the cold windy uplands, shorter haired for the sheltered valleys, and so on. They produced 38 different types of wool which were used to knit, for instance, the thick lanolin-coated jumpers for the fishermen or the finer, more delicate women's cardigans. That's just one aspect of the cultural richness.

On the right hand wall I painted Hatherleigh, a mid-Devon village built on a very steep hill. They have an annual festival – the running of the tar barrels. Arrangements for it are highly secret. It's almost impossible to find out when it's going to take place. I tried ask-

ing the postmaster. "Oh yes", he told me, "the 6th November at six in the evening is when they roll the tar barrels". I'm just going through the door, very pleased with having found the information I wanted, when he calls after me, "Of course that's not the real thing. That is at four in the morning on the day before".

So on the 5th November I drive to the village in the pouring rain at four in the morning, but there is not a soul about. I think I've been fooled, but then I see a man coming up the road in oilskins and grasping a big car horn and a bell. He tells me he's about to wake up the town. Some other characters arrive with bells and saucepans and start creating an incredible cacophony. Then the church bells strike five. There is an explosion at the top of the hill and suddenly the village becomes alive. People emerge from their houses, wearing pyjamas beneath overcoats, children are wrapped in blankets and the women carry buckets of cold water. Over the crest of the hill a sledge appears, carrying steel drums with holes cut in them. They are full of tar and aflame. About 15 men on either side are straining to hold ropes soaked in water and attached to the sledge. By the time they reach the bend near the bottom of the hill, the sledge is trundling faster than they can run, so they are now trying desperately to hold back this inferno careering down. As they fly past, some are actually on fire and the women throw cold water to douse them. I've never

seen anything like it. In ten minutes the whole thing is over. They've reached the bottom of the hill, there's a bonfire and then everyone goes back to bed. It's total madness but high excitement. That's in the mural and alongside that I've depicted the mummers' play that takes place in Dolton, and next to that is Beaford.

I had some drawings of mummers, but they were at least ten years old, so I decided to refresh them. I arrived on a wet night at an isolated village hall. There was an atmosphere of middle-class stuffiness. Small groups of woolly-jumpered people sat at plastic-covered trestle tables in silence. I felt like turning on my heel and leaving. An older man, who looked like the local bank manager, stepped on to the stage and apologised for being inadequate at what he was about to do. Our hearts sank. Then, suddenly there was a ripple of movement and a whisper went around, "The mummers are here". The change was magical. A be-ribboned man led a hobbyhorse between the tables and it nibbled at men in check jackets and nudged twin-setted ladies. Tension was introduced, something was about to happen. We were being challenged. The man with the hobby-horse announced that the horse was looking for a maiden "who kicks all her bedclothes off when she dreams of her lover." There were some meaningful glances and titters. We all thought we knew who it was going to be – a large-bosomed and glamorous woman in the front row. The horse advanced and lunged, teeth bared towards her. She screamed and we all hooted, but the horse darted past her and embraced an old lady in the back row. We were all now caught up in the spirit of the drama. I was able to make a whole number of new drawings, which I could incorporate into the mural.

In Beaford they have a week of revels and elect a mayor for the week. The year I painted these revels, the road sweeper had been elected mayor. They dressed him up in mayoral robes, with a big horse-chain sprayed gold around his neck and a tricorn hat on his head. Then they pushed him in a wheelbarrow around the pubs, where he was given beer, cigarettes, chocolate and other gifts. On Saturday, the last day of the week's revels, there is a festival on the village green and there he is tipped out on the dung heap. He's honoured by being elected to public office and then humiliated on the dung heap. That's a marvellous parable in itself. The vicar, too, is put in the stocks and people throw wet sponges at him. It's fantastic and it raises money for the village.

There was an awkward corner in the theatre I had to paint and I was unsure what to do. Then the vicar of Chittlehampton turned up at the studio and asked if his village was going to be included, but I told him I hadn't

considered it. The only thing I knew about the village was that it had the tallest church spire in Devon, despite being only a tiny place. He then proceeded to tell me the story behind the building of the church. In the15th century a local girl had a vision, but the rulers at the time, fearful of her powers, had her killed. She was beheaded with a scythe and where she was murdered a spring emerged from the ground, and around this spring scarlet pimpernels, the red of her blood, grew and still do to this day. She was made into a martyr and her death had been commemorated each year until the Reformation came and the grave was desecrated and she disappeared into history. Now, the ceremony has been revived and once a year they commemorate her death in the village with a small procession – six people carrying a small banner with a scythe on it. In the 15th century it was as important a place of pilgrimage as Canterbury – thus the immense church. Thousands used to come and the roads became so crowded that they had to build a bypass, the first in Britain, which became the lower road to Exeter. So I relented and painted Chittlehampton in this corner.

On the rear wall is Torrington, the theatre's home. They've built a motorway which ends nearby and it is reckoned that by the year 2010 cars will be bumper to bumper on this road. So I depict this on the mural, with the motorway terminating in the Civil War, which is still re-enacted annually by the villagers. I've also included Torrington's May Day fair. No one remembers its real significance, but a policeman appears on this day in full uniform and over it he's wearing women's underwear. With his truncheon he's belabouring a prostitute, all tarted up. "Who, though, is the prostitute?" That's what I think it's about.

I included a lot of the local people, farmers from around and the three local parliamentary candidates. While I was painting the mural in 1997 an election was called and polling day was the First of May, so I include the Tory candidate in his camel-hair coat, gloves and Rolls Royce, wearing a big rosette, on which it says, "vote for me." Then the Liberal Party's Paddy Ashdown, then MP for Taunton. I portrayed him in blue Wellington boots because that was the fashionable colour at the time, but the blue looked wrong – I already had too much blue in the painting – so I made them orange. Blow me down if he doesn't turn up on May Day in yellow Wellies! In the mural he also sports a big rosette that says "Me". Then I depict the Labour candidate, with his hands pointing in opposite directions and his rosette says "New Me". Everyone enjoyed the painting and saw the fun – so you can enjoy politics on that level too.

On both side walls I include the plough and the Pole Star because it's called the Plough Theatre. This also has resonances with Ireland. Sean O'Casey, the great Irish playwright, lived in Devon for a time, not very far from Barnstaple. His play, *The Plough and the Stars* is about Ireland's battle for liberation; and while he lived there, we became friends. The plough and stars is also the insignia of the Irish Communist Party.

Working on the mural was a delight and, as well as my friend, the artist Norman Saunders-White, I was also able to involve a number of local people as assistants. I included about 15 villages and a whole number of events and historical festivities. Before it left the studio around 300 people had come to see it – not just gawp at the artist, but bringing photographs with them, showing their parents or grandparents taking part in the events I was painting or to tell me stories from their lives. One couple would tell me about how they'd been evicted from their tied cottage and others would relate obscure events that most people had forgotten. I was able to include most of these stories in the mural. There can't be many artists who are privileged to experience that sort of intercourse.'

There was a rather bitter ending to the mural project though, which sadly reflects Britain's often penny-pinching attitude to the arts. After winning the commission, Sprague says he must have spoken to, and had visits from, well over a dozen individuals from various funding bodies in order to secure the funding, 'none of whom took even the slightest interest in the painting,' he says. After working on the project for nine months, for the princely sum of £5,000, the panels were completed, but the money had now run out. The panels still had to be transported to the theatre and that had to be paid for. The South-West Arts bureaucrats refused to give another penny. They had guaranteed the original sum and that was it! So Sprague threatened to organise a big bonfire and burn the whole mural and to invite the press. That threat loosened the purse strings and the panels were eventually installed to much local acclaim.

At the inauguration he addressed a packed audience of local people in the theatre and told them of the tribulations involved in completing the mural. He underlined the fact that it been done for only £5,000 and pointed out the iniquity of measuring everything in purely financial terms. 'We are told,' he said, 'that we can no longer afford a decent health service and that there is not enough money to pay for free education, yet for weapons of mass destruction like Trident, or for adventurous wars as against Iraq, there is apparently an unlimited budget and no need for accountancy.'

People's artist

In a world characterised by the domination of appearance over essence, of consumer gratification and immediate satisfaction of desires, the daily promotion of the "new", an art that redirects us to essential human and social values is of inestimable worth. It is clear that Sprague is centrally concerned about reaching wide sections of people through his art, and particularly addressing the concerns and interests of working people. His works do not demand a sophisticated artistic or aesthetic pre-knowledge. Could Sprague, therefore, be described as a popular artist?

Popular culture, as Stuart Hall clearly recognised, is a mutating subject matter and difficult to define. Are we talking about popular in terms of mass consumption, or in terms of being against the grain of the hegemonic culture? In the latter sense Sprague's art could certainly be considered part of popular culture. His work is produced expressly to be comprehended by, and to reflect the lives of, ordinary people and it is accessible. He uses symbols and signifiers which can be "read" by ordinary people. His art is produced outside the élitist "art world" and is relatively immune to the influences of movements, fashions and -isms. It holds doggedly to realist values, to figurative elements and to the concept of art as a conveyer of ideas, of entering into a dialogue with the viewer. Sprague says that he finds the creative process and the dialogue that ensues with visitors and onlookers while the work is in progress, more rewarding than the finished product. He compares it with building bridges, making connections through his art. His studio has always been an open house, welcoming a steady stream of visitors and Sprague has thrived on the social intercourse. His art is also traditional in the sense of betraying a strong consciousness of its roots in the craftsmanship and socialism of the nineteenth century, both in its decorative (aesthetic) values and its social function (purpose).

Sprague's aim, in his own words, is 'to build a picture road to socialism, to the Golden City or, as Blake called it, Jerusalem.' The real road to socialism has suffered fundamental erosion since it began as a dream and collapsed in a nightmare. There is still a very long way to go before it can ever be rebuilt and completed. But the road doesn't have to be finished for the building of it to have been worthwhile. Andre Breton said: "A work of art has value only if tremors from the future run through it." These tremors certainly run through Sprague's work. In every piece he's done he has portrayed a reality that is changeable and in doing so has helped change it in terms of that future for which he strives. 'Perhaps I'm trying to do the impossible?',

Sprague says. He probably is. Certainly in our visually overloaded world an individual artist's puny images can hardly compete. Commercial interests and big business have kidnapped some of the most talented image creators and hijacked some of the best signifiers and symbols. The images of yesterday's rebellion become today's fashion accessory or corporate sales tool, whether it be Che Guevara, Soviet flags or the CND badge.

On top of his public art, Sprague, like most artists, has also kept sketchbook diaries, where much of his personal life is documented, his relationships, family tragedies, travels and his ideas. These are a rich source for his posters and paintings, but also provide additional evidence of his skills as a draughtsman and keen observer of humanity. However, many of his paintings and prints have their origins in his dreams and 'they're in colour and very detailed,' he says, 'but of course when I use them in a painting they change – a dream is one thing, a painting another. I had one yesterday: It was very clear, my dreams usually are. It was crystal clear and very decorative in the best sense of the word. There was a pavement – grey paving stones, whose colour I could mix exactly. Two thirds of the way down was the edge of the kerb. In the dream I toyed with the idea of a drain cover, but this got lost. On the pavement was a black youth – obviously Stephen Lawrence, but I didn't dream Stephen Lawrence. He was on his back and his arms and legs were trying to protect himself from the blows from four thuggish men around him. They were dressed like East End gangsters, similar to some of the boys I grew up with. They were kicking the youth on the ground and one had a blade in his hand. There was a single upright post – the bus stop. The whole image was framed around the edge of the rectangle by policemen all looking outwards. When I awoke, I thought of tilting the frame of policemen to the right, so that you would see all the faces of those looking outwards to the right and on the left you see only the policemen's backs, their hands clasped across them. This left two small spaces and in the bottom right hand corner I put a sergeant looking at his watch and in the top right an officer looking up the road, so all ranks were included in this image of "institutionalised racism". I was still in the half dream, half awake stage, but the "dream" rejected the idea as being too clever, but it was a good image that might have worked.'

More importantly, though, Sprague has held fast to his dreams in the metaphorical sense. Despite the fact that humanity is perhaps farther away from realising them than it ever was. But, as Oscar Wilde wrote: "A map of the world without Utopia is incomplete."

Sprague, like a tenacious cartographer, insists on sketching in the outline of that nebulous country in our atlas. When mankind in general and artists in particular stop dreaming, the world will undoubtedly become an inhospitable place. Without a dream of Utopia there can be no belief in the betterment of the human condition, only fatalism or, even worse, a profound cynicism, which leads irresistibly to social implosion.

One could credibly argue that we are, historically, at such a critical juncture now. The glorification of technology and the globalised levelling of artistic production, the rapid incorporation of virtually all innovation and creative initiative by commercial forces, make it increasingly difficult to hold on to one's dreams. Is Sprague, then, simply indulging in nostalgia? Is he a sort of "old Labourite" of the art world, to use Tony Blair's simplistic and dismissive terminology, or does his art still have legitimacy? Is he simply using an out-dated language addressing long-forgotten goals or is he employing an appropriate language to address modern-day realities? The reactions of many ordinary people who see his work are a resounding affirmative to the second part of the question; the reactions of the gallery world and art critics are more opaque.

An overwhelming majority of working class people aren't in the slightest interested in art, any art, whether Ken Sprague's, Damien Hirst's or Ben Nicholson's. I ask Sprague how he deals with that in terms of his own life? 'It's difficult to answer,' he responds. 'In a way it could be seen as a minor tragedy, because I've missed an enormous number of opportunities where, for instance, I could have painted more murals, which would have given me access to a larger public. I've always been convinced that working people are not born with a lack of interest in art, but that the educational system and general environment don't encourage such an interest, in fact they stifle it.

But faced with the blunt question: would you have lived your life differently? I must answer no, because I would have had to sell out. Selling out is an emotive term, so let's perhaps say I'd have been ashamed of myself. I could go out and take photos if I wanted – a seemingly objective reflection of reality, but art for me has a different purpose. The aim of my art is to be decorative, I try to create images that people want to place on their walls, because they're fun and/or beautiful.'

This attitude rhymes with the words of the French surrealist poet, Andre Breton, who wrote in a catalogue preface to an exhibition of surrealist art in the thirties that the demand of Marxist theory for realism from revolutionary painters had been "absolutely curtailed by

photography and therefore the only valid function left to the painter was the necessity of expressing internal perception visually."

Sprague has remained consistent throughout his life. To use his own definition of an artist, he has not compromised his integrity either artistically or ideologically. However this doesn't mean he hasn't changed – he's been innovative and responsive to social and political change. He has, though, produced too prolifically for it all to be of lasting worth. Much has been ephemeral or simply run-of-the-mill – this is unavoidable given such creative energy and prolific output. If the critics were honest, they would readily admit that a significant number of Picasso's works, for instance, are not exactly first rate. Among Sprague's enormous body of work there are undoubtedly images that have attained an iconic character, are disturbingly beautiful and remain branded in the memory. Recently a retired engineer wrote to him asking if he could purchase some prints, which he recalled with utmost clarity, despite having seen them only fleetingly in the BBC television film *Posterman*, twenty years previously!

Sprague is not interested in artistic experimentation for its own sake, but he fully recognises its importance in the evolution of artistic expression and doesn't shy away from being innovative himself. John Gorman said of him that he's an innovator. He started printing from cardboard while others were still using wood, he introduced the use of established type faces and cutting them up, something that is now part of the canon. When he started designing holiday brochures he began using yellow filters to give an overall sunshine-glow effect to the images. That's done as a matter of course now.

'At the moment,' he says,' 'I'm doing a painting in which I use up to ten different perspectives, so I am interested in formal innovation and experiment, but never for its own sake. Innovation is important in art and politics but I'm not interested in pure formal experimentation. When I designed the first Anti-apartheid Movement logo – two stylised heads, one black and one white with a black and white AA on them, reversed out, I was only able to do that because the cubists had already developed the idea of combining several perspectives in one face. But for many of them it was an exploitation of form which didn't go anywhere, but that doesn't mean it wasn't an important development.'

Despite being well past retirement age (he was 75 in 2002 at the time this book was written) Sprague can't afford to withdraw from the fray. He has no private income from stocks and shares and receives only the basic state pension, so has to continue working to main-

tain himself and his two student children.

In September of that year, 2001, he went into hospital to have an operation on his knees and after his discharge was obliged to use crutches during convalescence. As a result of this he developed an inflammation in his arms, which was treated with drugs and which in turn induced a paralysis of the hands. He was unable to hold a pen or brush for weeks. As if this wasn't enough, he began suffering from internal bleeding – a consequence of the old colon cancer. Then to cap it all, his wife, who had been suffering from severe depression and was in treatment, left him, a blow that coincided with a visit from the bank manager to inform him that his finances were in a parlous state!

Not to be laid low by all this, he developed new projects, one of which was to take him to Yugoslavia. He was incensed by the recent revelations of the lethal effects of NATO's depleted uranium bombs on the civilian populations in Iraq and Yugoslavia and of the general plight of the victims of those raids. He got in touch with the campaign against the use of depleted uranium weapons and offered his services as an artist. Through links with some former Yugoslav students of his, he decided to fly out to Belgrade at short notice, despite crutches and useless hands, and do what he could. The trip was financed by friends and family.

This is typical of the man, despite his own intractable problems, he doesn't shrink from taking on those of the world. Once in Belgrade, amazingly, he is able to get around and even regains the use of his hands. He returns with a sketchbook filled with drawings of refugees and victims of the bombing and his head stocked with the harrowing stories told him by those he met. Once back home he then embarks on a series of lecture tours, using the drawings and relating what he's seen and heard about the atrocities inflicted by the NATO forces. He really inspires his audiences with his moving stories and amusing anecdotes, often poking fun at himself. His simple line drawings in pen and ink, with perhaps a small pale dash of colour, provide the visual evidence for his report. In a year scarred by the World Trade Centre attack and the war on Afghanistan, he was able to dispel the doom and gloom with his ebullient and infectious optimism and commitment.

Not long after he returned from Yugoslavia, economic necessity, following the separation from his wife, forced him to sell his romantically situated house on Lynton's cliff-side, with its magnificent sweeping views over the Bristol Channel and the Welsh coast, and to move into a more modest one. Now, living by himself, he has taken stock of the new situation and calculates soberly that he has perhaps another five active years left to him. He is in the process of completing a big canvas based on his childhood memory of meeting Gandhi in London's East End. He has already begun to redesign the walled garden, has just printed a new brochure to publicise his work, called "Creative Action", and written a CV in order to apply for a new job. At the same time, he is preparing a series of lectures on his experience in Yugoslavia and the new dangers facing humanity from President Bush's jingoistic and simplistic world view, and is still commuting back and forth to Norway to work with sexually abused children. Oh, and he has just begun a new amorous liaison and the evidence, in the form of some wonderfully sensitive erotic drawings, lie just completed on his window-sill, lit by the spring sunshine. Ken Sprague is irrepressible!

Perhaps a short piece written in the *Methodist Recorder* in 1971, after Sprague had lectured at a Methodist School, sums up his infectious and inspirational effect on people across almost all political and religious divides: The article says: "Ken Sprague, a Communist artist, was a tremendous inspiration and challenge to members of the Methodist School. His talk entitled: "Creativity: making mountains out of molehills" proved to be one of our most memorable sessions. 'Faith, hope, love, they were all there,' said one member afterwards...we left the hall feeling a tingling of enhanced awareness of the powers latent within each of us."

Surely artists like Sprague are just tilting at windmills? George Steiner asks rhetorically: "In the aftermath of the Nazi holocaust, Stalin's Gulag and the Gulf War can a new Mozart, a Rembrandt or Shakespeare arise? And in our obsession with wealth and consumer gratification where is the need for an artist with conscience?" Leaving aside the possibility of modern day Mozarts or Rembrandts appearing, there is little doubt that our world is in dire need of artists with conscience. And Sprague is indeed one of those rare species in today's world – an artist of conscience.

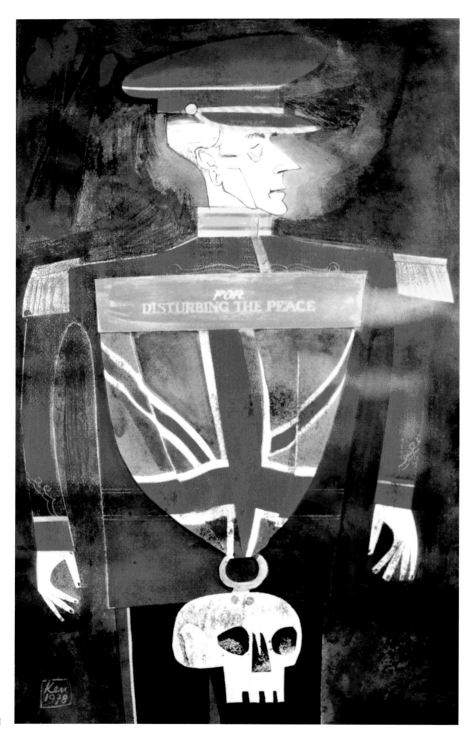

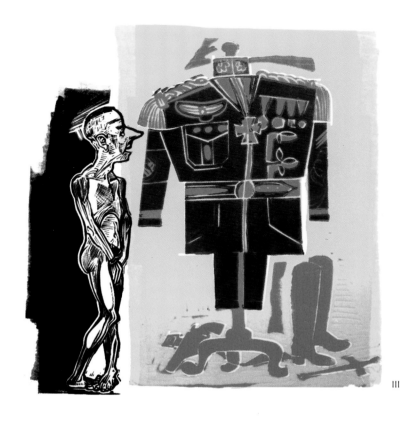

III

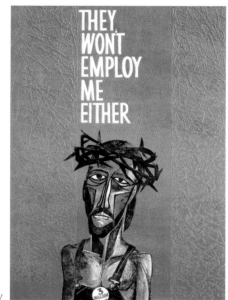

IV

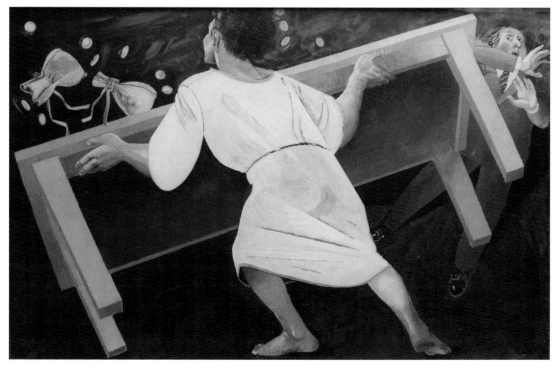

V

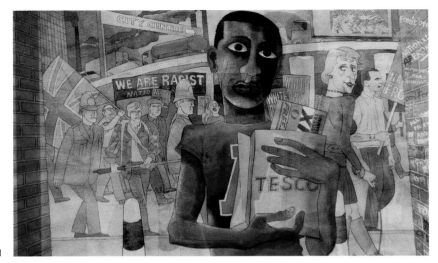

VI

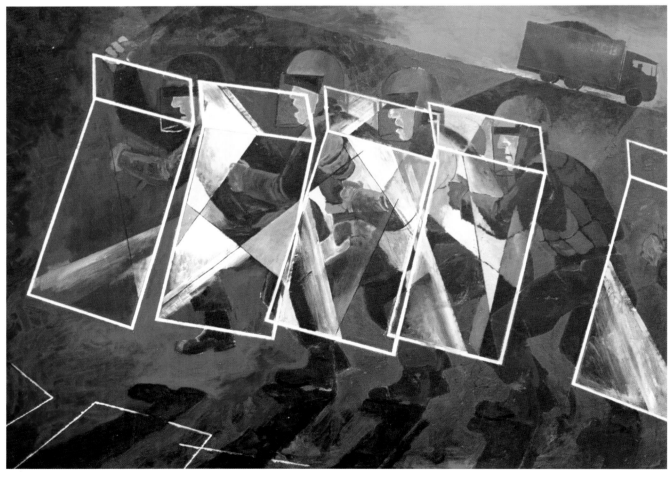

VII

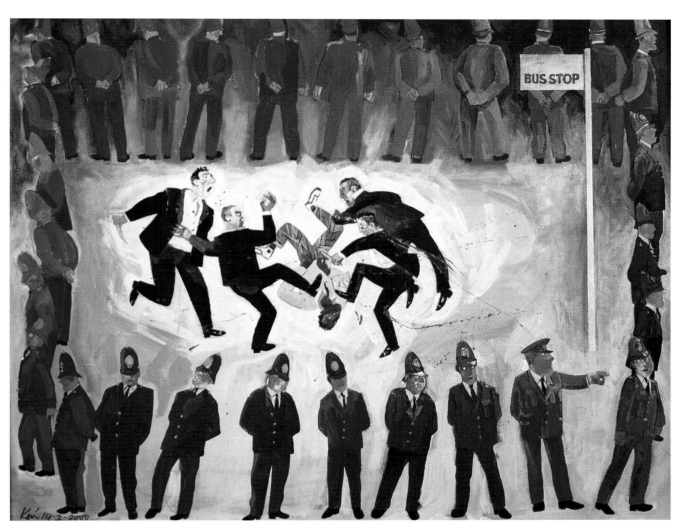

VIII

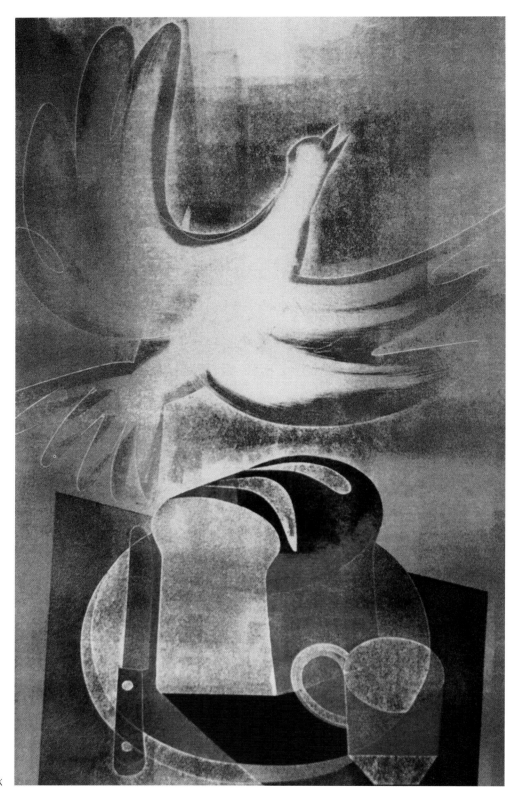

IX

X

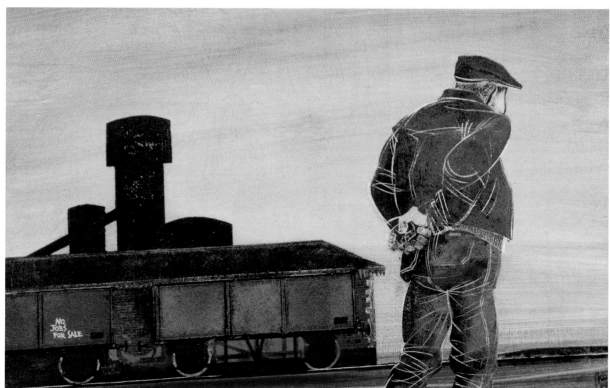

XI

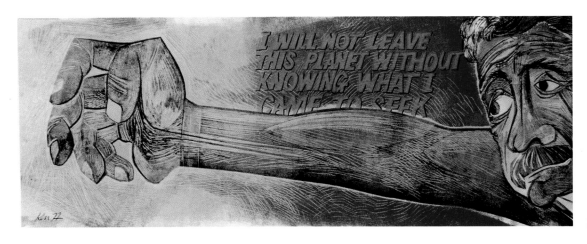

XII

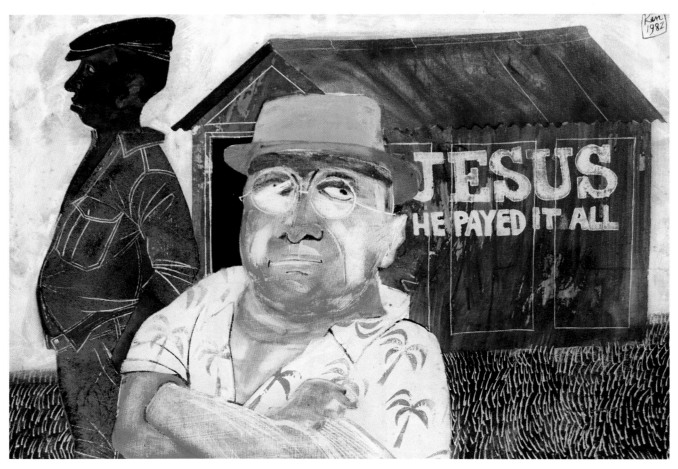

XIII

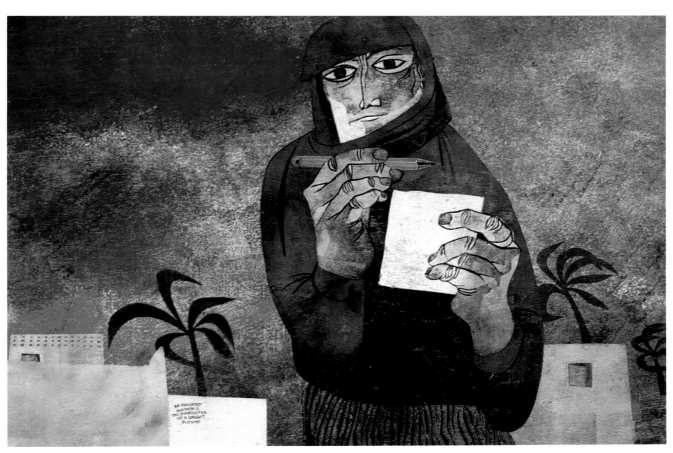

XIV

(b)

XV

(a) detail

(e)

(f)

(d)

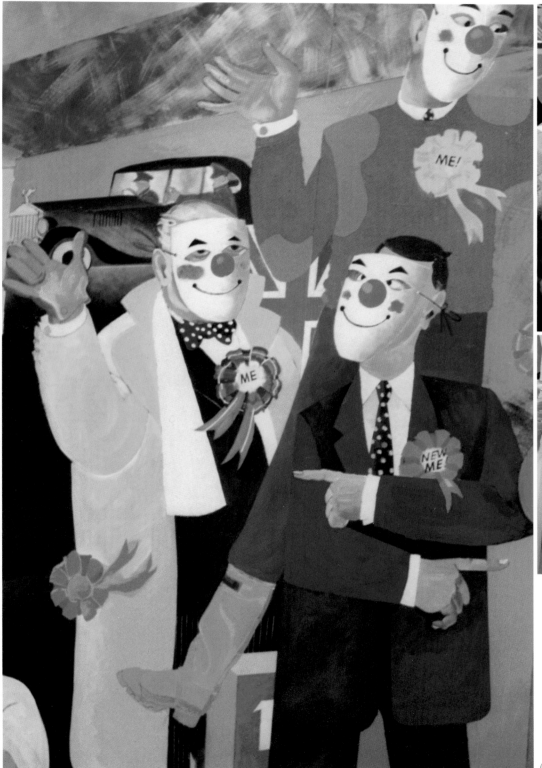

(a)

(f)

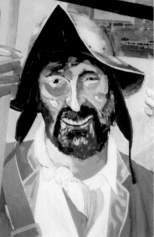

(c)

XVI

XVII

XVIII

XIX

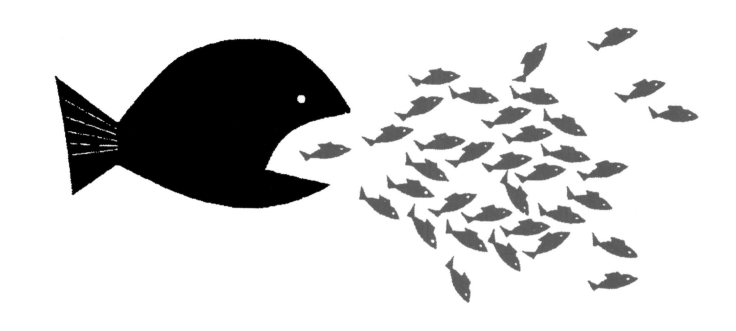

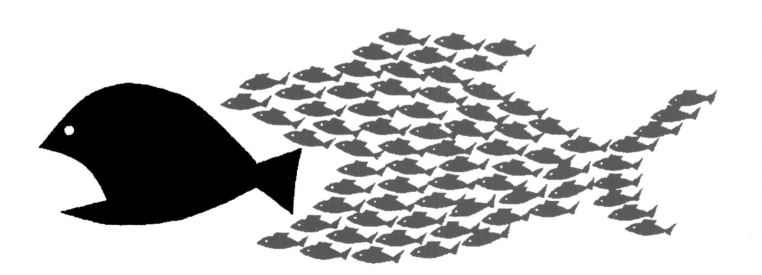

XXI

XXII

XXIII

What do you think an artist is? An imbecile who has only eyes if he is a painter, or ears if he is a musician? On the contrary, he is at the same time a political being, constantly alive to heartrending, fiery or happy events, to which he responds in every way...No, painting is not done to decorate apartments. It is an instrument of war for attack and defence against the enemy.

Pablo Picasso (1945) quoted on a panel in the Tate Modern.

THE ARTIST AS SOCIAL BEING

It has no doubt become clear in this biography that Sprague's work cannot be fully appreciated or understood without reference to this wider context. His social role and political stance are inseparable from his art.

Unfortunately, in Britain, a number of contemporary art critics since the sixties have viewed historical analysis and social context as largely superfluous in face of the challenge of individual aesthetic experience. They are of the opinion that to look at art and artists in this way is not useful, and it is certainly not fashionable. This viewpoint needs to be challenged. The dramatist, Harold Pinter, has pointed out that artists who are at the same time political activists are rarely taken seriously in this country, whereas the tradition in continental Europe is the opposite. Writers like Sartre and Grass or film makers like Rossi and Pasolini are accorded standing and their views given a respect rarely afforded such artists in Britain.

The early historical roots

Art developed out of magic and ritual and although created by individuals, it served a social function. Before science it was a means of overcoming fears and was perceived as an aid in controlling nature and conferring immortality on depicted objects. It related directly to the lives of the community of which the "artist" was an integral member. This ritual function later mutated into a religious one and it began to serve an élite class of overlords, becoming largely a means of ideological control for organised religion. As science increasingly drove out our primitive fears, art lost much of its original social function. However, this ritual origin still resonates in much of contemporary art and art apprecia-

tion. Every artist is a product of the history and traditions of his predecessors and Sprague is no exception. Of course, artists will take from the past, consciously or sub-consciously, that which they feel comfortable with and, if they are innovative in any way, will add something unique of their own.

The age, though, to which a number of artists refer back in an often nostalgic fashion, is the Middle Ages. Then the artist had a clearly defined, all-encompassing religious (and, implicitly, social) role to play. His (in this period it was a male profession) work was seen as a useful social contribution; he was employed and paid a wage accordingly. The idea of an artist painting away in his garret, for his own satisfaction, without a commission was unthinkable.

As an individual artist, though, he had little influence on how the prevailing ideology was to be communicated visually to the populace – he was bound by strict rules and conventions. He was invariably an anonymous mouthpiece, a corporeal means "through which god revealed himself." With the onset of the Renaissance, this role began to change. The liberation of the artist as an individual, brought with it the libera-

114 tion of ideas. Art no longer served the sole purpose of representing god and disseminating the Christian religion. Before the Renaissance the concept of the artist as a special individual didn't exist. He differed neither in origin nor training from a craftsman and was viewed no differently than a smith or carpenter. To become an artist you underwent an apprenticeship in an established artist's studio and if you showed talent and aptitude, you would perhaps proceed eventually to establish your own studio. Many artists were journeymen, offering their services to church or wealthy merchant as and when they could.

Even by the time the Renaissance dawned there was little concept of "great art". It was considered that there were simply capable or less capable artists. Those artists whose work has indeed outlasted them and continues to have relevance for succeeding generations are those whose work reflects deeper and fundamental human values beyond the specific context in which the works were created, and whose works were in some way innovative. This is what we now deem to be "great art".

With the emancipation of the bourgeoisie in the Renaissance and the development of the idea of the free individual, the liberated artist, too, now extended his skills by studying nature rather than copying his master. Art increasingly adopted the perspective of the individual artist. It was Leonardo da Vinci who first asserted that art was something higher than mere fabrication because it was intimately connected with the individual artist and was inimitable. With this new-found freedom, though, came the beginning of artistic fragmentation. Artists developed into spokespersons for different forces – the church, the monarch, the lord and in succeeding centuries the bourgeois merchant and finally for him- or herself alone.

The increasing individualisation of artists and their liberation from convention was accompanied by a creeping alienation from their society – they became more marginal figures. The gradual decline of the church's wealth and the demise of a feudal aristocracy in much of Europe also compounded this process, culminating in the nineteenth century romantic image of the starving and lonely artist in his garret.

All pre-modernist artists in one way or another were passing social comment on the societies they lived in, without however being necessarily "political". Some works of art manage to be both affirmative and subversive of particular views of the world simultaneously, like those of Breughel and Goya. The former produced the obligatory illustrations of biblical events, but clothed the oppressors in the vestments of the Spanish colonial

forces who occupied Flemish territory at the time. Goya would earn his bread and butter fulfilling aristocrats' commissions, but at the same time produced his Disasters of War and the acerbic social caricatures of the Capricios. Perhaps artists like Breughel and Goya could, with some justification, be called political artists, but it would be facile to project our modern concept of "political" onto a historical period in which political parties were unknown.

It is not surprising that a group of eminent British artists, in the mid-nineteenth century and influenced by the ideas of Ruskin and Morris, sought an exit from the artistic alienation resulting from the ravages of the industrial revolution. At that time industrialisation had, in terms of human degradation, horror and ugliness, reached its nadir. These artists sought an escape from

what they saw as the corruption and debility of contemporary, conventional art and sought inspiration in an idyllic, if largely mythical, past. They considered that the period before Raphael, the painter who for them epitomised the high Renaissance, provided that model. It was an era, they felt, where art lacked artifice, expressing a natural beauty and where the artist was still a socially integrated and unsullied figure. They wanted art to break out of the stuffy cloisters of the Academy, to take up contemporary themes and be rooted in real life. The Brotherhood of Pre-Raphaelites thus came into being, significantly, in 1848, a time of revolutionary upheaval in Europe and the year in which the Communist Manifesto was first published. William Morris was a member of the group, but he later moved on from that rather precious and nostalgic view to adopt a more active, forward-looking and avowed socialist position. Sprague is a great admirer of Morris, but he, too, is not seeking a return to a perceived idyllic era as the pre-Raphaelites appeared to, nor is he looking for the imposition of an immutable and autocratic ideology as pertained in Mediaeval times. He is, like Morris, seeking to rekindle that spirit of the integrated craftsman-artist serving a useful social purpose.

Industrialisation in the late eighteenth and nineteenth centuries brought about a fundamental crisis for artists and crafts-people by replacing their individual handcrafted products by mass-produced ones. Form and image became easily reproducible. The advent of photography, towards the end of the nineteenth century, with its mimetic capacity, of course compounded this crisis and sounded the death-knell of the artist's socially

accepted role as historical recorder in the form of portraits, landscapes and still-lives. These could now be produced with more verisimilitude by the camera. Walter Benjamin examines the significance of this fundamental change in his essay: *The Work of Art in the Age of Mechanical Reproduction*. As a result of this fundamental change, the artist was forced to seek a new role. During the early years of the twentieth century, this new role was sought in the realms of constructivism, cubism, expressionism, abstractionism and various other -isms.

The only serious attempts at a social reintegration of the artist on a national level in the modern era have been in the Soviet Union and Mexico after their respective revolutions and in the USA under Roosevelt's New Deal. Sprague has been strongly influenced by the example of all three movements.

Socialist Realism – the Soviet model

In the earth-shattering revolutionary changes that shook the world in Russia in 1917 artists played a seminal role. Artists from all disciplines – Isaac Babel in literature, Vladimir Mayakovsky in poetry and graphics, Wsevelod Meyerhold in theatre, Sergei Eisenstein in film, Marc Chagall and Natalia Goncharova in painting, Sergei Prokoviev and Dmitri Shostakovich in music, to name but some of the most famous, – used their imaginative skills and innovative talent to promote and support the revolution in a unique creative frenzy not witnessed anywhere since. In other words they were able to identify with the revolutionary ideology driving society at the time and put their talent and art at the revolution's disposal. In the twenties those visual artists belonging to the centrally significant group around Malevich, Lissitsky, Kandinsky, Tatlin, Pevsner and Rodchenko, all believed that art could have a profound influence both on the individual and on social developments. After that initial explosion of artistic creativity during the early years of the revolution, the period of Stalin's domination, after the death of Lenin, ushered in a period of centralised artistic control and the state endorsement of one type of art – socialist realism.

The germ of a socialist realist concept can be traced to Zola, the father of "Naturalism". When he became transformed from an apolitical writer to a politicised one by the experience of the Paris Commune, he said: "A detailed investigation of the reality of today must be followed by a glance at the development of tomorrow." But the term "Socialist Realism" was first expounded by Gorki and in the first instance referred to literature. It was an attempt to delineate the difference between the traditional bourgeois novel form and its successor – socialist literature. Gorki saw socialist realism as an extension of bourgeois critical realism. It added a consciousness of the proletarian historical role. Socialist realism attempted to unite the critical tradition of realist fiction with proletarian consciousness. Socialist realist art was supposed to portray a recognisable reality, while simultaneously revealing the social and class forces at work changing society and pointing the way to the socialist goal. Under Stalin and his cultural commissar, Zhdanov, this came to mean a glorification of ideology as interpreted by Stalin and of the achievements of the Soviet people and its Communist Party. Reality became lost and any attempt at a critical appraisal was damned as counter-revolutionary. At the height of the Stalin era there was still widespread awe and respect among Communists for the Soviet Union, and socialist realism was accepted by many Left artists as the way forward for art. Of course, just like all the other -isms, it was interpreted by each individual artist in his or her own way.

Sprague is fully aware of the damage the narrow, Stalinist interpretation of socialist realism inflicted. 'Yes,' he says, 'that was what we did as Communists. So I tried to do it too, but was hopeless at it. It was trite, but I only understood it as trite in trying to do it. I "bought" the political line and saw the importance of producing for working class people. But once I started trying to do what I thought was expected of me, I realised there was no basis to it. I was always decorative. I wanted to make a shape that fitted a certain area and it just didn't work for me. It was like smoking; I was never a smoker because when I tried, I became sick! The aspirations of socialist realism were fine but when Stalinism took over and a lot of philistine bureaucrats turned it into "the party line" it became an oppressive strait-jacket. Then someone like Neisvestny comes along and puts his boot through it all.'

It is perhaps important, though, to remind ourselves that socialist realism, even in its distorted Stalinist version, was a relatively popular art form and cannot be completely dismissed as an irrelevance. In their volume, *Realism, Rationalism, Surrealism – art between the wars*, Briony, Batchelor and Wood have this to say about socialist realism:

"In the former socialist countries, the artists may have had their freedom restricted, in terms of choice of style and content, but they were given a social purpose. In the West, devoid of all responsibility to patron or audience, art was in permanent danger of being left with nothing to say. Western art was at the mercy and whims of the art market, Soviet art was at the beck and call of the state. The relationship between artist and

patron ultimately differentiated Western from Eastern European socialist art. How to create a humane society in which artists will be respected and cared for, yet given the freedom to enquire into unexpected and unfamiliar territory, remains the question and the dream."

Walter Benjamin takes the discussion further: "The aim of a radical artist," he says, "should be to change 'consumers' into 'collaborators'." This was said in the mid-thirties in response to Lukacs' aesthetic of socialist realism, which tended to be contemplative: "you looked at realist art to receive a well-wrought message about the true condition of the world, granted by the knowledge of the artist and the skill that allowed him to transform his perception into the micro-world of the art work." Benjamin's argument is Brechtian in the sense that he is appealing to artists "not to imitate the world, but to act upon it, albeit through 'semantic' action as much as practical action."

"The notion of realism," Benjamin goes on to say, "is not something secure and given, something conceptually and technically conservative, an avenue of retreat from the searching questions of the modern, but something radical and risky – to be won, precisely, from the conditions of modernity that has so often been experienced as dissuasion from realism of any kind. The social relations of developed capitalism have given rise to a culture industry whose principal motifs have been distraction and fantasy. It is this condition that debates about modern realism have striven to resist, and against which it finds its most appropriate measure." (*opus cit*)

An artist's intentions are not the same as the artist's reasons for producing a particular work or what that work actually communicates. Knowing an artist's intentions is insufficient evidence to substantiate the social determination of his/her art. We may be able to recognise the behavioural motives or intention in a work of art but that doesn't mean that we have to accept the reasons for it. One has to ask: what are the relations between material conditions, actions and the agent's intentions? An account of an intention doesn't show how the agent came to believe what he does. It is not an adequate causal account of what he does. So often, though, official Communist Party or state approval of socialist realist works of art was based more on the former criterion than the latter.

John Berger in his book *Neisvestny* cites an example of this attitude. At the All-Soviet Artists' exhibition in 1962 Khruschev stands in front of a Neisvestny sculpture and says it looks like a donkey's arse. "It's all shit, it's a disgrace!" he shouts. Neisvestny confronts him and says: "You may be Premier and Chairman, but not here in front of my works. Here I am Premier and we will discuss as equals." Two security guards immediately grab Neisvestny's arms and are ready to cart him off. "You are talking to a man perfectly capable of killing himself at any moment. Your threats mean nothing to me," Neisvestny retorts. The security men release him on Kruschev's orders and the two of them proceed to discuss art for over an hour. The entourage is becoming impatient, the tension remains high. Eventually Kruschev, on the urgings of his advisers, departs, but in the doorway he turns and says to Neisvestny: "You are the sort of man I like. But there's an angel and a devil in you. If the angel wins, we can get along together, if it's the devil who wins, we shall destroy you."

It's amazing, but they hit it off. When Kruschev died it was Niesvestny who designed his headstone. After Kruschev's demise, he emigrated to the West and disappeared from view. A similar fate befell George Grosz. Sprague tells me he visited a gallery in the States and it turned out to be owned by a man who used to sell Grosz's work. He told Sprague that the United States' authorities had imposed a condition on Grosz that he could only stay in the country if he stopped doing critical paintings about US society. They didn't want his Communist-tainted ideas. He went on to produce many, rather anodyne watercolours of landscapes with lone figures in them.

It seems a tragic irony that throughout history some of the greatest art has been born out of a struggle against oppression. It is almost as if artists need oppression or

censorship to be really creative. One wouldn't like to think so, but in the western democracies, we can, in a sense, witness the opposite phenomenon: artists have complete freedom, if one forgets financial restraints, so have nothing to rebel against and end up producing insipid art. As Sprague puts it: 'They produce scruffy beds with their menstrual knickers on them and then kid themselves that they're protesting against the establishment!'

Grosz, in his autobiography, recognised this trend much earlier, when he wrote: "In a commercial world the artist is bound to give a great deal of thought to patrons, for they are his mainstay. Modern art is a kind of merchandise to be sold with shrewd publicity just like soap, towels and brushes, and the artist has been transformed into a conveyor belt bearing goods for display windows that have to be dressed anew as often as possible. He has no time to develop his skills, has ceased to be his own man, has passed into public ownership, and takes his orders from public figures, be they merchants or workers and soldiers' councils."

Sprague, like many other former Communists, became acutely aware of a missing dimension to Marxism as interpreted officially by the leading Communist parties in the West, particularly as Stalinism increasingly infected the thinking and behaviour of those parties. Marx and Engels never intended their ideas to become dogma or religion, and the humanitarian goal of their ideas was never ignored in their own writings. But in the Communist countries, and reflected in the wider Communist movement, a bowdlerised Marxism became institutionalised like a religion and led, in those countries, to a closed and restrictive society. A self-proclaimed élite became the high priests, determining what was and what was not Marxist – dissenting voices were silenced. What began as a creative philosophy with humanitarian goals became its own caricature. Marxism became a pseudo-scientific dogma divorced from its profoundly humanist core. It was this separation that led to the show trials, the suppression of dissent and the eventual collapse of the system.

The Mexican muralists

In Mexico it was a group of muralists, most notably Rivera, Siquieros and Orozco who had a similar utopian vision to those artists in the young Soviet republic. Fired by the success of the proletarian revolution there, as well as their own home-grown one, they felt that public art could be an educator, a social inspiration and a monument to the people's struggle for liberation. Supported by the Mexican government and its

Minister of Public Works, Sr. Obregon they were able to transform some of their dreams into reality. Desmond Rochfort in his seminal work, *Mexican Muralists*, gives a fascinating and dramatic account of the Mexican mural movement and its social roots. In his introduction he looks at the role of the artist as a social being.

The Mexican muralist Siqueiros issued a rallying call to all artists when he published his manifesto to launch the newly formed artists' trade union in Mexico in 1922. The manifesto states:

"We repudiate so-called easel painting and every kind of art favoured by ultra-intellectual circles, because it is aristocratic, and we praise monumental art in all its forms, because it is public property. We proclaim at this time of social change from a decrepit order to a new one, the creators of beauty must use their best efforts to produce ideological works for the people; art must no longer be the expression of individual satisfaction (which) it is today, but should aim to become a fighting educative art for all."

Ringing, triumphalist words in an era when such optimism and fighting rhetoric had a certain validity even if today they appear to us, with historical hindsight, romantic effulgence. Almost thirty years later, in 1951 the art critic Herbert Read again takes up the theme but is considerably more sceptical. In his *The Philosophy of Modern Art* he wrote:

"We must wait, perhaps for a very long time, before any vital connection can be re-established between art and society. The modern work of art...is a symbol. The symbol by its very nature, is intelligible only to the initiated (though it may appeal mysteriously to the uninitiated, so long as they allow it to enter their unconscious)...It does not seem that the contradiction which exists between the aristocratic function of art and the democratic structure of modern society can ever be resolved."

This statement is as correct today as it was then, perhaps even more so. It is artists like Ken Sprague, not part of the artistic "aristocracy", upholding a realist and figurative tradition, who maintain a tenuous link with that wider, democratic society Read is talking about and who battle on to re-establish that "vital connection between art and society."

The Mexican muralist movement was a considerable inspiration for Sprague and he travelled to Mexico to see, first hand, those "walls of fire". Many Western critics, though, have dismissed it as an anachronistic and exotic outgrowth of the mainstream, in its total rejection of modernist tenets and aesthetics. It is seen as clinging to outdated realistic forms, having propagandistic aims and incorporating quaint folkloric imagery. It is seen, quite rightly, to be in deliberate opposition to the course of modernist art as practised in Europe and the USA. Herbert Read himself talked about Rivera as "a second-rate artist". This has created enormous problems in its appreciation. As Rochfort says: "In standing outside and against the main thrust of modernist practice, Mexican mural painting has often become the hostage to critical fortune. Arguments have prevailed for and against its self-proclaimed premise as a revolutionary art of substantive social function, of creative and aesthetic originality."

The three "greats" among the Mexican muralists – Rivera, Siqueiros and Orozco – each employed different aesthetic principles in their work. Rivera was the most traditional in his narrative frescoes, as well as being the most accessible, Siqueiros was the most experimental, using new technologies and daring perspectives, while Orozco was the most painterly and expressionist, as well as being the least political of the three.

Sprague painted a small number of murals, including two for trade unions – one for the TUC and another for the International Postal and Telegraphic Workers' Union – and the more recent one in the Plough Arts Centre, Torrington, in Devon. Sprague would have liked to produce a lot more murals. 'In fact,' he says, ' I would have liked to have been a mural painter, but there just weren't the opportunities. I like the idea of working in a team, I enjoy working with other people. But here in Britain people think murals are just wall decorations.'

It would be naive to compare a movement such as the Mexican mural movement with a single artist like Ken Sprague, but there are nevertheless links and interesting parallels. We have had no mural movement in Britain – the climate is not exactly conducive – although there have been attempts to create one, including a small group of artists around Desmond Rochfort and David Binnington who formed Public Art Workshop in 1977 and produced some substantive works like the Royal Oak Mural in West London and, with others, one commemorating the defeat of Mosley's fascists in Cable Street, Stepney. The mural he completed together with Paul Butler in the TUC's Education Centre was later, in an act of institutional vandalism, painted over by those overseeing the redecoration of the centre.

Rochfort says: "The whole project of Mexican muralism was presented as a synthesis of art and the popular imagination, a concept described by Brecht as being 'intelligent to the broad masses, adopting and enriching their forms of expression, assuming their standpoint and correcting it...relating to traditions and developing them.' Mexican muralism," Rochfort continues, "represents a significant challenge of the commonly accepted view of the role and position of the artist in Western society. That position is sometimes seen as one of intellectual and economic isolation, in which the primary function of the artist is a revelation of self, expressed in a hermetic relationship formed by the will to create and the work created. The Mexican muralists were neither artistically nor intellectually isolated from Mexican society. They played a central role in the cultural and social life of the country following the 1910-17 national revolution. Rather than a revelation of individual self, in the first instance the murals expressed a communality of national experience."

The Mexican Mural movement, as Rochfort rightly maintains, can be considered the benchmark against which any revolutionary or popular art can be meas-

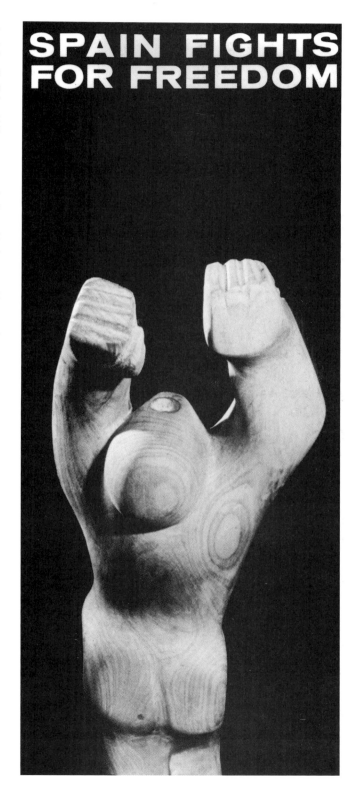

SPAIN FIGHTS FOR FREEDOM

ured. It strongly influenced the artistic movement in the thirties in the USA and resonates in the work of Ken Sprague.

The New Deal era and the Cold War

During the worst period of the thirties depression in the USA, when the Roosevelt administration embarked on a policy of state-funded initiatives to alleviate hardship, supporters of the Federal Arts Project looked to the Mexican mural movement as a model of a new democratic and radical art. In May 1933 the artist George Biddle wrote to Roosevelt:

"There is a matter which I have long considered and which some day might interest your administration. The Mexican artists have produced the greatest national school of mural painting since the Italian Renaissance. Diego Rivera tells me it was only possible because Sr. Obregon, the Minister of Public Works, allowed Mexican artists to work for plumbers' wages in order to express on the walls of government buildings the social ideas of the Mexican revolution...The younger artists of America are conscious as they have never been of the social revolution our country and civilisation are going through; and they would be eager to express these ideals in a permanent art form if they were given the government's co-operation."

As is now well known Roosevelt's eventual funding for the arts through the Public Works of Art Project (PWAP) and Works Progress Administration (WPA) led to a great artistic upsurge in the arts at the height of the depression. In the visual arts alone, artists funded by these projects produced around 2,500 murals, 17,000 sculptures, 108,000 paintings, 11,000 designs for prints, and over 2 million posters. A whole number of artists who were later to become household names in the USA and worldwide gained their basic training on WPA projects. Some, like Jackson Pollock and Ben Shahn, worked for a time as assistants to the great Mexican muralists. Shahn worked on the Radio City mural with Rivera in 1933. It had been commissioned by Rockefeller, who was so incensed by the mural's political message that he had it erased. Rivera engaged Shahn after being impressed with his Sacco and Vanzetti series of prints.

Interestingly, Shahn, who was an excellent print maker as well as muralist and painter, became one of Sprague's models and a correspondence friendship developed between them (see Chapter 8).

Anton Refregier, one of the artists who took part in Roosevelt's WPA, said of the period: "There was a close comradeship among the artists, a respect for each other regardless of the direction each of us chose – the realist painter along with the abstract and surrealists felt a common bond. Recognising our obligations as citizens, we participated in all major social and economic struggles of the day. We were not degraded by personal opportunism, we were not manipulated by art entrepreneurs, critics nor museums. Our projects were administered by fellow artists taking turns away from their work and by sympathetic people in Washington. We jealously guarded our freedom of expression, recognising at the same time the necessary disciplines and obligations that go with freedom. Together, with writers, musicians, actors, dancers and poets we were creating a people's art." (*The Other America*) The Right attacked the new deal programme relentlessly, labelling it "state communism" and eventually succeeded in destroying it.

Another American artist from that period whose life and art has close parallels with Sprague is Ad Reinhardt. He could also be seen as a metaphor for the way art became implicated in the ideological struggles of the Cold War period.

"Reinhardt," Corris tells us in his book, *Art has no History*, "was born in Buffalo USA in 1913 of working class parents. Throughout secondary school he had been a precocious cartoonist and illustrator who seemed poised for a promising career in commercial art, but he decided not to pursue commercial art professionally because he was interested in fine art." Reinhardt, during the thirties and forties, worked concurrently as an artist, labour organiser, political activist, illustrator and typographic designer. In the thirties he was a militant defender of modernist abstraction and saw the possibilities these innovative forms offered to the revolutionary left. During the forties, before the CIA and the North American establishment had latched on to abstract art as the key cultural weapon in the Cold War, he was a popular proselytiser of American Abstract Artists (AAA) a group of radical abstract artists. For him revolutionary politics and abstract art went together, citing the Soviet avant-garde artists and Picasso and Leger to support this position. He had an exceptional and original talent for cartooning and illustrating. He was instrumental in introducing innovative design practices during his time working on *New Masses*, the leading, Communist-led, left-wing cultural magazine in the States.

Reinhardt's cartoon "Hack" challenged the division of art into fine art and commercial or graphic art. It attacks the cultural inequity among artistic practices in capitalist society. He wrote: "Exactly how less creative are those artists who change our world everyday...with

their practical limitations, than the fine artists, with their imaginative restrictions?" Reinhardt's aim was to help develop a truly public art and he saw in the WPA/FAP, under Roosevelt's New Deal, a great opportunity for achieving this. A public art of course already existed in the form of comics, magazine pictures and films. "And," he says, "it may be low grade and infantile public art, one which fixes illusions, degrades taste and reduces art to the commercial device for exploiting the feelings and anxieties of the masses; but it is an art which the people love, which has formed their taste and will undoubtedly affect their first response to whatever is offered them."

When asked for whom the artist paints or carves or what value the work can have for the new audience of class-conscious workers, he replied: "Working towards a synthesis of the arts, to an eventual absorption of the imaginative artist in a more collective and anonymous job of creating better places for people to live in."

Corris concludes: "Any study of Reinhardt that seeks to re-evaluate the significance of his political activism must attend to the issue of Reinhardt's versatility. That is, his ability simultaneously to enact and integrate the multiple roles of artist, graphic designer and political activist." This could apply equally to Sprague.

Tragically, many of the works of art created in this period under the auspices of the WPA were destroyed after it was turned over to the War Services Program in 1942 and entrusted to a Col. Somervell. Not only the works themselves, but all the records of the WPA have also disappeared without a trace.

Although the first third of the twentieth century saw an increased left-leaning politicisation of society in general and of artists in particular, it was the victory bugles at the end of the Second World War that simultaneously sounded the call to arms in a new, cultural war, reversing that process. This new war was to polarise artists as never before into two mutually exclusive camps. The Cold War period in the aftermath of the Second World War saw art and culture being forged into weapons, and artists, whether conscious of it or not, were drafted into that war. In their book, *Realism, Rationalism, Surrealism – art between the wars*, the authors, Briony, Batchelor and Wood, state: "In the realm of high art, the story was complex. Pro-socialist sympathies were widespread within the European intelligentsia, whose Communist Party members boasted such eminent artists as Pablo Picasso and Fernand Leger in France, and the Socialist-Realist Renato Guttuso in Italy. While the ideology of socially-committed art was still hotly debated in the first post-war decade, by the mid-fifties American-led, 'apolitical' aesthetics were to dominate." Before this happened, though, we saw in the United States, at the height of the depression in the thirties a tremendous progressive artistic movement promoted and funded by the government.

Jackson Pollock, despite being a one-time assistant to Rivera, was one of the precursors of purely abstract art and had a seminal influence on succeeding generations of Western artists. His mature paintings are not intended to be meaningful or refer to objective reality, being voluntarist and spontaneous splashings of paint on canvas, devoid of content. However, at the height of the Cold War, the CIA saw in the work of Pollock and other abstract artists a means of combating communism culturally, and actively promoted such art. Anything which ran counter to socialist realism was grist to their mill. They feared the seductive power of communist ideas on artists and sought ways to counteract it. As Stonor Saunders reveals in her book, *Who Paid the Piper – the CIA and the cultural cold war*, although abstract art was anathema to many of the cultural philistines who ran the CIA and to the Cold War warriors in government, the need to counter what they saw as the seductive power of socialist realism took precedence over personal aesthetic viewpoints. The freedom from constraint symbolised by abstract art became equated with the capitalist "free market" and was counterposed to the "regimented" and

"old fashioned" concepts embodied in figurative art. In 1957 The Tate Gallery in London mounted a large exhibition of American abstract art which had a profound effect on many artists at the time. It is perhaps a quirk of history that many of the early abstract artists were drawn to Communist ideas until Stalinist domination of the Communist movement led to its condemnation. This then gave Western governments and their own cultural commissars the opportunity of belatedly espousing it and championing it for their own narrow political goals.

It is not surprising that this crude utilisation of art in pursuit of Cold War aims was strenuously denied – art was politically neutral! Still today, there are leading art critics and artists who deny or ignore the fact that art is invariably political even with a small "p". This is not suggesting, though, that all artists are therefore political artists, but that every artist's work has political resonances. A good example of the above attitude was dis-

played in a recent BBC radio programme on the Brazilian-born artist Anna Maria Pacheco who, at the time, in October 1999, was artist in residence at the National Gallery. She sculpts over-life sized, wooden figures, polychromed and disturbingly powerful and, in her paintings, uses the iconography of the church.

The BBC programme described new works of hers, inspired by paintings in the National Gallery on the subjects of the Martyrdom of St Sebastian and the Temptations of St. Anthony. Her St. Sebastian became a black-hooded figure, roped to a post and pierced by stainless steel arrows – in many ways a very modern victim, echoing the horrors of torture in Chile, Iraq or Northern Ireland. He is surrounded by over life-sized figures dressed in modern-day clothing and in various poses of horror, indifference or sympathy. Her triptych, based on the temptations of St. Anthony shows a group of cowering figures threatened by helicopter gun ships rather than the mediaeval demons that plagued St. Anthony. Again she is raising contemporary issues of imperialist war and civilian massacres. Yet the producers of the programme and the critics interviewed did not mention politics, oppression or social injustice once in the whole half-hour programme devoted to a discussion of her work!

Artists are political, whether consciously or unconsciously. This relationship is beautifully demonstrated in Gen Doy's essay on the North American artist Cindy Sherman in *Art has no History*. Sherman uses consumer images of women and deconstructs them. She denies any ideological or conceptual approach in her art, but Doy clearly shows it to be very much part of, and determined by, the specific cultural and economic context of her times. Of Cindy Sherman, she says: "There is a paradox at the heart of Sherman's success in that her work is owned and exhibited by collectors who appear to espouse the very ideology of consumerism, glossy media imagery and capitalist lifestyles which it challenges." Sherman's work deconstructs images of women and how they are used by the consumer and media interests. She, though, is typical of many Anglo-Saxon artists who deny at any cost that their art could be political in any way. Some do so out of real conviction, others because they fear being categorised and marginalised or of losing lucrative patronage.

What is a socialist artist?
Sprague calls himself not just a political but also a socialist artist. What, then, is a socialist artist? When Sprague is asked this he is at first stumped for an ade-

quate answer. He reflects for a while and comes up with a definition with which he's happy: 'It is really a two-part question and there is a two-part answer. A socialist is a political activist of integrity with a philosophy of social-ism – and here I'm talking of the real thing, not New Labour versions. Artists should have a strong feeling of integrity towards their art, to the wood, to the paint or to the stone with which they work and they should have the philosophy of a craftsman – to do the best possible. Occasionally these two aspects will be found in one person and then you have what I would call a socialist artist.'

Socialist artists want to be seen as an integral part of the society they live in, and in which their art is needed, appreciated and understood. This dream of reintegrating the artist into society has been a preoccupation of socially progressive artists and intellectuals since the Renaissance, but became a particularly significant philosophical discussion in the 19th century where the alienation of both the artist and the craftsman by industrialisation became acute. John Ruskin, William Morris and their associates are probably the best-known advocates of a more equitable and integrated society in Britain, where the artist could take his or her rightful place alongside all other crafts-people and workers. Sprague sees himself as following in that tradition.

In *Art has no History* John Roberts writes: "There is a general and widely held view that a Marxist analysis of art involves seeing art simply as a passive reflection of the economic system, class interests or ideologies. There are, however, few, if any, serious Marxist art critics who would hold to such a crude and reductionist approach today. Few Marxist critics would now see the artist's role as a passive model of authorship, in which he is merely reflecting inherited ideological materials." Hauser, for instance, defines the relationship in the following way: "Artistic agency is to be seen in terms of choices taken ideologically at the level of specific materials and modes of representation. In this way the relationship between the artists, their works and society is maintained but is viewed dialectically, not mechanistically."

By applying the Marxist base and superstructure model in an inflexible and hierarchical manner, many Marxist critics committed themselves to a conception of art that was narrowly political, reductive, tendentious and prescriptive. They were wedded to a reflectionist theory of culture and subordinated imagination to a reductive "representation" of reality. They undervalued aesthetic experience.

Sprague's espousal of the psychotherapist Moreno's teachings is an attempt to remedy the imbalance as he

AGAINST APARTHEID

BOYCOTT SOUTH AFRICAN GOODS

MARCH 1ST TO 31ST

Issued by The Boycott Movement . 293 New King's Rd. S.W.6

designed & printed by MOUNTAIN & MOLEHILL (T.U.), London, E.C.1

sees it between the "scientific" and the "spiritual", as far as his own life and work is concerned. Science without the spiritual is a dangerous tool with no moral or ethical framework, the spiritual without science is blind and impractical. Spiritual, as understood by Sprague, is the humanitarian or sensual component of life.

Sprague argues that in Britain the industrial revolution largely destroyed working people's relationship with art and their appreciation of its value. 'And,' he adds, 'of course, one shouldn't forget that many artists were, in the eyes of the workers, part of the "enemy" – they produced for the bosses and the clergy. The working class in general rarely went to church; the peasantry did maybe, but not the working class. So it's not surprising that they mistrusted artists.'

Since the 19th century we have seen a continuity between romanticism and Marxism in British socialist traditions and British socialist experience has been very much a blend of liberal, non-conformist and socialist-utopian traditions with a smattering of Marxist theory.

This, too, has had its impact on politically committed or aware artists. These separate threads are clearly discernible in the weave of Sprague's work.

Sprague does not see his art 'as an attempt to change people's attitudes. I'm under no illusion,' he says, 'of how minimal, if at all, that influence often is. But when I say people's attitudes I include myself in that. Because when you actually create something, it changes your attitudes too. Something tells you you've put green there, you bloody fool, and it should be red. Now where the hell that comes from I don't know. It's a form of collective learning, continuing history. You're learning from something much bigger than yourself. In the past most people would have said it's from god. I don't object to that, but I see it more as an unbroken flow of human creativity which becomes part of us. You learn in the process of doing something. Why do you make that line thicker at that point on the drawing? All this brings with it a certain integrity in being an artist – a sense of responsibility to be honest and truthful which you can't avoid. And as soon as you start thinking about it you're thinking of philosophy and that leads to politics. There is no escape from it. One has to be crazy, particularly in England, to try to be an artist, but it's hard being a gardener too – I was no good at anything else like maths or English, but I could draw.

The crisis of art

Just as it is important to understand how artists like Sprague fit into the social context, it is also instructive to take a brief look at how they fit into the general art-world context. There is a real need for a polemic with modern western art practice and criticism because critics, in the main, have raised one type of contemporary art onto a pedestal and denied the legitimacy of other forms, other visual discourses. Sprague is one of those who find themselves marginalised by this attitude, but there are many others too.

Art is no longer an intrinsic part of our lives. Today we make special visits to galleries and museums to look at art as something special, separate from us. On leaving the gallery we leave art behind and return to our normal lives. Art in this context doesn't impact on our daily lives, it is merely one more element in that mass of ephemera surrounding us, something the broadsheet cultural guides tell us we "have to see".

To define adequately the enigmatic term "art" is virtually impossible and is perhaps not even very useful for this discussion. Suffice to say that it has a multiplicity of meanings as well as functions and serves diverse needs.

In this chapter, I'm concerned with art that is consensually recognised as such by the art-interested public and has been produced to be sold or made accessible to the public. Within the long tradition and history of such "public" art there will be works that have a stronger validity than others in terms of their impact on society. Any society will have broadly accepted criteria for judging art, whether aesthetic or in terms of craftsmanship, and these will change according to historical and cultural circumstances. Art which enjoys longevity will find its worth and relevance determined by the "objective" criterion of history (although even our historical legacy is the result of a series of subjective selections). History is a brutal arbiter in terms of what is allowed to survive and what not; what survives will, by definition, have a greater validity and relevance than that which doesn't. The battlefield of history is littered with the corpses of what were once deemed to be great works of art and/or were often extremely popular in their time.

Few artists, art critics or the interested public would disagree widely in their assessments of who the great artists of the past were, but when we reach the modernists and post-modernists views and evaluations drift radically apart. Because pre-modernist art is realist, everyone is able to compare the artists' images with their own perceptions of reality as well as evaluate the artists' skill in conveying their subject matter. Until the early part of the twentieth century almost all art had been figurative and/or decorative and very often narrative – those works which most convincingly created the illusion of reality were deemed great. The era of abstract art broke fundamentally with that tradition in several ways. With abstract art, where content has been ousted by form, one can only respond to the use of colour, line, shape and pattern, to "the effect". Cognitive abilities are hardly demanded and any technical prowess on the part of the artist is extremely difficult to assess – or has it become irrelevant? Abstract art and the new conceptual art have only real significance to a narrow élite of cognoscenti. For artists, art critics and collectors it has an esoteric meaning in terms of art movements within the hermetic art world itself, but has little relevance outside this rarefied space. It rarely connects with ordinary people.

The accepted craft and skill of the artist lost much of its validity, or at least could no longer be easily recognised as such in abstract works, largely because comparisons with earlier or even other contemporary works were rendered almost meaningless. The public has little means of assessing or appreciating the abstract artist's ability to capture a recognisable likeness, to portray with paint or pen, or in stone the textures, plasticity and colour

x

of real life as generally perceived. Art with little or no
content is difficult to relate to one's own world and only
a reaction or evaluation on an aesthetic level is possible.
Meaning becomes locked in the intrinsicality of the art-
work itself. A meaningful two-way communication
between the artist and the public is no longer actively
sought, the creative act becomes an end in itself. This is
compounded in the latter part of the twentieth century
where representation becomes a subject itself and a mix-
ing of the different systems of representation is increas-
ingly utilised. On the other hand it is abundantly clear
that art cannot stay still, it has to change and develop to
fulfil new social and individual needs. The conundrum
for contemporary artists is how to develop their art and
set a new course without losing sight of land.

In our own era, the rise to world dominance of the
mass media married to increasingly more sophisticated
technology, producing images of amazingly high quality
has confronted all artists with an existential dilemma: are
they, as free spirits, needed anymore? If so, where and

how? Wherein lies the "sense of art? How does artistic
activity differ from other human activities? Do we need
an art separate from its applied function in areas like
advertising or illustration?

With the sophistication of modern printing there is
now, for the untutored eye, little recognisable difference
between a good reproduction and an original, unless one
is told. The image has become democratised, but at the
same time devalued, because it is no longer an individ-
ual piece of work. Certainly the need to create is as strong
as ever – there is no lack of would-be artists, but there is
hardly a market any longer for original works. Many
artists can only make a living today by prostituting their
art in the form of a sales tool on behalf of corporate pay-
masters (only a handful can make a living selling art for
itself). How can real art communicate with or move peo-
ple in a way that differs from the 'art' produced by new
technology and the media, which use these self-same
artistic skills? In an ironic and perverse twist of history we
seem to be returning to a pre-Renaissance position where

the artists serve the dissemination of a central idea, that of "consumption", and have again lost control over their individual ideas and images. Pre-Renaissance art manipulated consciousness in a direct and unashamed way under an ecclesiastic directive, as mass advertising does today under the directive of the corporate boardrooms.

The new visual communications media affect the recipient in equal measure as they do the artist. We, in the highly industrialised countries, live in societies where there is not only a surfeit of consumer goods, but also of imagery. We are surrounded everywhere we go with hoardings, posters, photos and TV screens. This has led to a lower level of conscious perception – it jades the visual palate. How can a painter compete with the harsh and realistic images of the war photographer or the high-gloss quality of the fashion photographer? How can the painter's small canvas achieve recognition as something special alongside a digitally-enlarged image on a hoarding, or the sculptor's hewn stone compete with the sleek beauty and design of a Porsche or Jaguar car?

Artists have, today, been remorselessly absorbed into this media circus. The leading ones are treated like film stars, are idolised and expensive. Those not in this league become marginalised, remaining impoverished and eclipsed. It is an all-or-nothing situation which reflects the monopoly-capitalist era, where a few companies, or in this case a few individuals, rise to dominate the market at the expense of all others. We can see the same process in film, theatre and television.

Warhol once remarked perceptively: "You need a good gallery so the 'ruling class' will notice you and spread enough confidence in your future so collectors will buy you, whether for $500 or $50,000." And they do. A handful of such artists become millionaires at a tender age because the ruling classes delight in their work precisely because it doesn't challenge their life style and world view, but does create a social éclat. In fact the artists' works often make icons of the mass-produced source of their patrons' wealth, transforming their banal, avaricious, bourgeois way of life into high art. It is hardly surprising that these patrons are prepared to throw money at it in gratitude and purchase it as they do their stocks and shares, as an investment.

Thomas Mann saw the artist's role in a very different light: "The artist must insist on his outsider status so that his art does not devolve into a mere function of social need. The essence of art involves maintaining a certain oppositional position vis à vis reality, life, society." Theodor Adorno took up Mann's point and rephrased it dialectically. He maintained that art only becomes socialised through its opposition to society and that such a position can only be attained through autonomy. He goes on to say that the artist in bourgeois society suffers under the stigma of uselessness, he desires and simultaneously damns this autonomy. Both of these writers are suggesting that the artist needs to maintain a critical and oppositional stance to ruling class hegemony as well as challenging accepted norms.

At a period in history where the individual and society have been cut adrift from any anchorage points, recognition of whatever kind for artists is, understandably, felt by them to be a vindication of their worth. Our era is one in which idealism, in the form of either religion or a belief in social progress (or socialism) has been eclipsed by the brutality and cynicism of global capitalism, with its emphasis on rampant individualism and the cash nexus. It is little wonder that the art world reflects this process. The concept of creative integrity has been replaced by "getting to the top," genuine innovation replaced by fashion, chic and notoriety. The significance of the works themselves has also been largely eclipsed by their flamboyant creators; without the designer label clearly displayed on their works these become meaningless and worthless artifacts. For artists like Sprague, this climate is not conducive to an appreciation of their art. It contrasts significantly, for instance, with the sixties, where society was politically vibrant, particularly the student movement, but also wider sections of society. There was a palpable relief at the melting of the Cold War and a new sense of optimism imbued people's lives. Then almost every youngster had a political poster on their bedroom wall and most street corners were fly-posted or graffitied with political slogans and images.

It would be meaningless to pretend to arbitrate on what is true or great art – putting artists into hierarchies is a pointless task. However, for a socialist, someone who believes in an interventionist role for art, in the feasibility and urgent need for human progress, art will be perceived very much in terms of its contribution in that sense. In other words art which is seen to have a humanist content, which promotes progress or is critical of injustice and inequality, is socially relevant, which extols beauty and is uplifting and encourages humanity to have faith in itself will be seen as more relevant and significant; art which doesn't place humanity at its core, but rather aesthetic concepts devoid of any real connectedness to social processes will be seen as less relevant. It is not just socialists, though, who will view art in this way – many Christians, liberals, humanists will have a broadly similar standpoint. They, too, will see art as bearing witness to, or promoting, humanity's striving for perfection.

Even judgements based on such criteria, though, will

change with time and hindsight. Seldom, if ever, can contemporaries judge the art of their own period with any semblance of objectivity. Our own cultural, ideological and social context will colour our judgements. Only in the flow of different contexts and the passing of time will more lasting re-assessments be possible. In the past Marxists often judged a work of art on the basis of its theme or subject. They invariably confused subject matter with the artistic resolution of ideas. The value of a work of art does not lie in what it purports to portray, but in giving adequate or exemplary artistic expression to the chosen subject matter. Sprague's work has to be seen in this light too. We need to place it not only in its social context, but also in that of the art world itself. His work lies outside the so-called mainstream, i.e. that art which dominates the subject matter in art magazines, is exhibited in prestigious galleries and purchased by wealthy patrons.

For artists like Sprague art only has meaning in its relationship with, and its ability to interpret or comment on, reality. Many modernist artists are striving for a pure aestheticism as far removed from reality or reflection of it as possible. The former are not deemed fashionable, largely because they insist on imbuing their art with a content which they feel is essential for any meaningful communication of their individual sense of beauty, understanding of, or response to, the real world. They refuse to be dazzled by the alluring prospect of shows in West End galleries or the accolades of corporate patrons. It would, though, be simple to accuse artists like Sprague of expressing sour grapes simply because their work is not lauded, exhibited and bought by Charles Saatchi, but this would be missing the point completely. He does not seek that kind of recognition, but he nevertheless feels his work should be granted a validity alongside other movements and fashions. The reason this does not happen is because a few patrons and their protégés dominate the art world almost exclusively; also, because, in Britain, the

mix of art and politics is viewed as a fundamental sole-cism. These protégés are able to dominate precisely because they best represent the value systems of monop-oly capitalism and are, despite their iconoclastic claims, consciously or unconsciously, upholders of the system. Most of them would, however, no doubt see themselves as outsiders, dissidents and iconoclasts, but in fact they are very much insiders and conformists, reproducing the acceptable image of capitalism through a distorting (per-haps drugs induced) fairground mirror. They are the court jesters coddled by their paymasters, entertaining their public with barbless wit.

"Totalitarian states have an official art, a chosen aes-thetic that is authorised and promoted at the cost of the other, competing styles. In the Soviet Union, the official art was socialist realism. Working in any other mode was considered – and treated as – an act of subversion. We in Britain, too, have an official art – concept art – and it per-forms an equally valuable service. It is endorsed by Downing Street, sponsored by big business and selected and exhibited by cultural tsars such as the Tate's Nicholas Serota, who dominate the arts scene from their crystal Kremlins'. This was said, not by some bitter, rejected artist, but by Ivan Massow, the then chairman of the Institute of Contemporary Arts, one of the chief institutions for pro-moting avant garde art. He goes on to admit that, as chair-man of the ICA, an institute that "fervently champions concept art" he is a stakeholder in "the cartel that has organised this monopoly". He admits to have frequently "had a nagging voice in my head" telling him that it was all hype and no substance. Such apostasy cost him his head on the unforgiving art establishment's guillotine.

Damien Hirst, one of the foremost exponents of con-temporary Britart, was quoted in a *Guardian* series on the Britart phenomenon: "The art world's very shallow and very small and it's very easy to get to the top of it. And then you burst through and you've no idea where the fuck to go." This confusion is exemplified by his most recent work – a 20ft high, ten ton bronze replica of his son's Humbrol plastic toy anatomical figure, which cost £14.99. He calls his work "Hymn" and Charles Saatchi reputedly paid £1 million for it. Hirst says of it: "I might even get sued for it. I expect it. Because I copied it so directly." How disarmingly truthful. However, one has to be circumspect about such statements because artists are traditionally not the most articulate when it comes to explaining the meanings of their works. In fact he did have to pay the toy company a nominal sum for breach-ing its copyright.

The *Guardian* journalist explains Hirst's talent, in case you should doubt it: "He has always used drugs and drink as a way of isolating himself from banal experience and to bring him to something original and extraordinary..." A copy of a kid's cheap plastic toy is undoubtedly extraordi-narily original, especially with a price tag of £1 million. The article goes on to suggest that, "The fragility of exis-tence is Hirst's big theme...it's why he puts things behind glass and in formaldehyde in big steel and glass cases; to hold off inevitable decay and corruption; as part of a futile effort to preserve them." Museums do that too, but I was-n't aware that they were creating great art. "Even at his drunkest," the *Guardian* continues sycophantically and poker-faced, "you can sense him thinking."

Richard Smith rode to fame in the sixties but is now largely forgotten. His paintings are described in the *Guardian* series as "big and splashy and content-free." "He was a thinker," we are told, and "his work had a pronounced intellectual as well as a purely visceral dimension." It must certainly be intellectually demand-ing to produce "content-free" art and something "pure-ly visceral" and "intellectual" at the same time. Smith's subject, it is explained to us, "was to be surface appear-ances: the resounding shallows of consumer culture; the complex sheen of advertising and packaging." It appears that the critic is unable to recognise the sub-stantive difference between glorifying mass marketing and criticising it. Utilising mass advertising techniques and consumer packaging does not of itself imply a cri-tique. The German artist, Hans Haacke, did it more effectively. He used Leyland company adverts, but sub-verted their message by changing the copy, using quo-tations from the firm's executive directors justifying investment in South Africa. Art which subverts itself by attempting to imitate mass-produced items is the zenith of alienation and, ultimately, the death of art.

In his book, *The Conditions of Success*, the former director of The Tate, Sir Alan Bowness, says: "I do not believe that any great art has been produced in a non-competitive situation; on the contrary, it is the fiercely competitive environment in which the young artist finds himself that drives him to excel...Artists who emerge from such a situation do not have a consistency of style...but there is a consistency of purpose. They want to get to the top." Such a statement could have come straight from Margaret Thatcher or one of the Chicago monetarist gurus. It slots art comfortably into the mod-ern capitalist ethic. It does not mention aims other than "to get to the top", and, in its emphasis on competition, includes no acknowledgement of the co-operative endeavours of, for instance, communities of artists, teams of muralists, the co-operation between craftspeo-ple and artists, as well as artists and public. Such an atti-

tude is anathema to Sprague who is working to create an opposite form of society, precisely one of co-operation and in which the aim of the artist is not to "get to the top", but to get to the people.

To understand more fully the meaning and significance of a work of art, it has to be related back to the society in which it gestated. What does it signify in terms of its relationship to contemporary society or in terms of social or art history? Questions to which no one today can give very satisfactory or conclusive answers, but a cursory look at what contemporary critics and some of the leading artists themselves are saying does provide pointers. No work of art can be adequately explained simply in terms of itself, as most critics today, faute de mieux, try to do; this can only be done when art is seen as a refraction or mediation of specific social relationships.

Conceptual art has been fashionable for some time, and is symptomatic of much of what is amiss in the contemporary art scene, however definitions of what conceptual art actually is are difficult to come by. The aim of the conceptual art movement was to bring about a decisive break with the visual tradition of painting and sculpture and could be understood as either a critical continuation or a fundamental disruption of Modernism, depending on which version of Modernism one uses. Its dominance has also involved a complete demotion of craftsmanship, skill, technique and individuality. The ease of using new technologies like computers, video cameras and lasers has contributed considerably to this phenomenon.

There are still a small number of figurative artists, like Lucien Freud, who retain their place at court, but even these are invariably solipsistic and do not engage with social issues or pose a real challenge to the cultural hegemony.

From his review in *Art Monthly* of the book, *Rewriting Conceptual Art*, Jonathan Harris writes: "...nearly all contributors also admit tacitly or explicitly that the capaciousness of the term (conceptual art) tends to render it fairly intractable, though they go on to discuss work by an artist or group of artists for whom the label appears to have significant use-value. 'Conceptual Art' manages to pull off the intriguing feat

of being both terminally indefinable and yet specifically appropriate..."

Terry Eagleton sums up the situation when he says: "The terrors and allures of the signifier, its snares, seductions and subversions: all of this might figure at once as a bracingly modern form of politics and as a glamorous substitute for baulked political energies, an ersatz iconoclasm in a politically quiescent society." He goes on to suggest that post-modernists are seduced into finding revolutionary and radical activity in the deconstruction of art. Postmodernism avowedly aims to break down the differ-

ences between popular and high culture, but in so doing removes all meaning. Postmodern theory maintains that material reality is unknowable and fragmented. As individual subjects we are ourselves constructed by various texts and discourses through which subject positions are created for us. Hence material reality is not just unknowable but unchangeable by conscious intervention.

For some time now artists have suffered an ongoing crisis of legitimacy, a widespread feeling that they are not needed by a society which denies them a socially useful role. In a desperate search for an artistic validity one recent trend has been to utilise new technology or scientific paraphernalia to give works of art a pseudo-scientific credibility. Panamarenko is perhaps a good example of this. As art has apparently lost its ability to function as "art" in a meaningfully social way, this is an attempt to make it function as art-science. In effect the artists are using the paraphernalia of science and the magic of science, like electricity and light to create an artistic effect, but their art, despite protestations to the contrary, throws little light on scientific research. The increasing use of technology too is part of this same process – video, digital imaging, even using cameras attached to animals to free the images from human interference. All these are panic efforts to reverse the process of art's increasing irrelevancy in the modern world, but also genuine, if misguided, attempts to keep abreast of modern technological developments which impact on people's lives. But simply by grafting art onto the flamboyant glitz and glamour of technology and science will hardly reinvigorate it. Without something essential of social worth to communicate, such attempts will remain embarrassing and empty rhetoric.

In an *Art Monthly* review of a Panamarenko exhibition at the Hayward Gallery, where technology was central to the work on show, the reviewer says (apparently without tongue in cheek): "But while Panamarenko takes great care with the physical dangers his works may entail, he is not afraid of theoretical conflicts, and challenges the orthodoxies of modern scientific thought, such as Einstein's Theory of Relativity."

There have been a whole number of recent "art-science" exhibitions. Panamarenko's sculpture exhibition at the Hayward, in March 2000, was one, "Audible Light" at MoMA in Oxford was another, where the works had titles like "Domestic Audiction Suggesting a Constant Flux of Semi-Individuals to be Detected", or the multi-disciplinary venture "nOIse" at Kettle's Yard. Out of a review of the latter comes this gem: "One work which seemed to find its niche in the museum's anthropology section was Paul D Miller's large fabric wall hanging in garish colours

and patterns determined by amplification analysis. The resulting effect connects with the analysed tribal music samples which are its subject, partly because the patterns are unashamedly rhythmic, and because they pull towards what we might already describe as tribal pattern making. In this sense it used a standard anthropological analysis of the tribal rhythms to activate a sense of anthropology about ourselves." (*Art Monthly*) This is using the fig leaf of scientific relevance to mask a dearth of artistic ideas. It is symptomatic of a frenetic search for meaning or significance in a system with scant rationality or ethical foundation.

Mounting the challenge

Figurative and narrative art has been largely relegated to history by the art world élite. This is hardly surprising if one looks back at the long and fruitful tradition and at the more recent legacy of photography. Where else could figurative and narrative art go without repetition? The urge to push back frontiers and to be innovative has taken art away from realism to abstraction. This has progressed from the early Cubists, with their straightforward demontage and re-assemblage of elements, to the complexities (and banalities) of conceptual art which today utilise the paraphernalia of electronic technologies and science.

Art, however, if it is to retain any real social relevance, will always remain a form of expression with the aim of communicating, whether the artist's own inner psychological turmoil, obsessions, fantasies or his relationship with the wider social and political world. In this sense the figurative and narrative will always retain a central role as far as the wider public is concerned. Purely abstract art or idiosyncratic, self-referential art, however innovative, surprising, fascinating or shocking, does irresistibly lead up a cul-de-sac; and after entering it, at sometime, one has to re-emerge into the world at large.

The opening of the Bankside Tate Modern art gallery in May 2000 was a unique opportunity to reflect the breadth and richness of British contemporary art. It was accompanied by unprecedented publicity for contemporary art and witnessed a veritable galaxy of guests from the media, the arts and politics flocking through the gallery's portals.

But what contemporary art do we find in this glorious monument to a past industrial age? Madeleine Bunting in *the Guardian* found the pulse when she wrote: "At every step, one's visual sense – of colour, space, form – is delighted, challenged, subverted. There is plenty of humour, beauty and curiosity. But according to this cornucopia of modern art – the biggest in the world – at

WE'RE ONLY OBEYING
GOVERNMENT ORDERS

politics. It represents the new fragmentary nature of a society losing its coherence and the extreme individualisation of artistic responses to reality. There are one or two exceptions. It does have a small corner on the significance of Guernica and the artists who reacted to the bloody suppression of the Spanish Republic. It also has Richard Hamilton's triptych on the Northern Ireland conflict and Hans Haacke's poster series on British Leyland's co-operation with the South African apartheid system, but that is it. In a gallery of this size, that is certainly unrepresentative.

Sir Nicholas Serota, the Director of Tate Modern, began his career, significantly, as a trained economist and accountant. In his 2001 Richard Dimbleby lecture, he defended what he called "modern art" on the basis that it "shocks and shakes people's beliefs and values", as if realist art cannot. Serota's definition of modern art appears to be that which is uncritical of the social and economic system, outrageous only in its vulgarity, shakes people in the extremism of its form or materials, but rarely in terms of ideological content.

Artists like Ken Sprague, Peter Kennard, Desmond Rochfort, Paul Butler or Ray Walker to name but a few, with their "shocking" politics and positing of alternative social values, have no place in this new pantheon. This is not to suggest that all artists have to be or should be politically committed in their art, it is merely proposing that such artists have something socially and artistically valid to express and should have a key role in the artistic discourse. They are, though, being largely excluded – "proletarian art has been ousted by proprietarial art," to paraphrase Bernard Shaw. Of course their art is not proletarian in the sense of being produced by proletarians, but it identifies with working people, their oppression, exclusion and their aspirations. It also challenges the way society is structured – it is not consumer art to be marketed and privately owned.

The state clearly feels more comfortable subsidising a therapeutic rather than an interrogatory culture. There has been a large-scale shift of focus during the latter part of the twentieth century from the political to the personal and this has resulted in virtually drowning any political or intellectual debate in the arts. The demise of Communism with its promised realisation of a dream has undoubtedly contributed to this fatalistic introversion.

The Tate Modern curators, in their selection process, have, with a certain legitimacy, attempted to choose those works from the twentieth century which are symbolic of the most influential artistic trends or have been strongly innovative, and in this they have largely succeeded. What they have done, though, is to select within

some point in the twentieth century, it seems to me, western European art gave up trying to say much about how we organise ourselves politically and economically and largely retreated into individual experience."

This point was reiterated by David Rodway, one of the organisers of a small protest group (Action to Transform Art and Culture) at the opening: "Our protest is at the shallow and facile nature of contemporary art fashions, which, far from being cutting-edge, have overlooked key discoveries about perception and creativity, and mislead society by recycling in visual form the flawed assumptions and values of capitalism and commercialism." Madeleine Bunting characterises it as "therapeutic culture", "with its anxious preoccupation with self, sex and its tendency to voyeurism and romanticism..."

The Tate Modern collection reflects, in artistic terms, what we see happening in western society in general – a widespread political apathy and rejection of traditional

the self-referential confines of the art world itself and from within their own (rather élitist, upper-middle class and politically conservative) ideological and cultural parameters.

It was the Dadaists in Berlin in the twenties who mounted probably the first organised and politically-motivated attack on bourgeois art. A banner draped over the entrance to one of the first exhibitions stated: "The Dada movement calls for the abolition of the art trade."

In issue No.3 of *Dada*, a reviewer writes: "Dadaism has a programmatic character, which makes clear that Dadaism in Berlin is not and has no intention of being art or to represent a particular artistic direction; it is a politically-motivated rejection of art, especially expressionism, which the bourgeoisie, after initial resistance, had made acceptable. This rejection was mounted in an absurd, but hard-hitting and in a consciously offensive manner against the lovers of nebulous-mystical, sweet-romantic, as well as expressionist and abstract art." The difference between the Dadaists and today's organisers of the Sensation and Apocalypse exhibitions is that the Dadaists were deliberately shocking for a political and artistic purpose, not for its own sake. They made farcical use of ephemera, created minimalist works of art and jokes with a serious critical purpose.

There has been scarcely a murmur of challenge to the high priests of the art world. One recent one, though, has thrown down a gauntlet to the domination of the contemporary art scene by corporate sponsorship and is, in some ways, reminiscent of what the Dadaists tried. It has come from a small group of artists called CRASH (Creating Resistance to Society's Haemorrhoids), who held an exhibition at the ICA in November 1999. In their "mission statement" they declare that "traditionally the worlds of work and art have not had much to do with each other. Artists have been seen as separate from the rest of us; work in the 9-5 sense has not been a primary activity or subject for them... The irony is that an artist putting a farm animal in a tank of preservative earns more than the entire staff at your local Sainsbury's... 1990s corporate 'lifestyle' culture has spawned a useless generation of kitsch fetishists and facile careerists. Content has given way to irony, while the culture of the workplace...continues to erode the existence of our day to day lives." They see advertising as pilfering the art world and modern British artists as pilfering the marketing tools of business to promote their art. Their credo succinctly pinpoints the basic canker at the heart of contemporary British art.

Sprague has never deserted the world of work – those who earn their bread and butter in 9-5 jobs. Even in his Devon retreat he has taken up the cause of the local hill farmers and of the citizens of Lynton fighting the corporate planners, organised pensioners, worked with disabled children and been active in the local peace movement.

One can truly say that his art is rooted in the community. It may have suffered because of this commitment, in the sense of being less adventurous and experimental, and often being squeezed into a use-value or functional mode, but this price is perhaps, in his case, less significant than for those that have severed this link along with their integrity for the nebulous goals of success. He and others like him belong to a quasi-second culture, a sub-culture, marginalised by the cultural mandarins. But, like persistent and ineradicable weeds, they continue to flourish in the interstices between the West End galleries, the hegemony of wealthy patrons, the artist-jesters and the indifference of the political careerists who determine what passes for government arts policy.

Illustrations

Angelou, Maya: *Even the Stars Look Lonesome*, Virago Press 1998

Anti-Apartheid Movement: *Drawing the Line (cartoonists against apartheid)*, Anti-Apartheid Movement 1985

Benjamin, Walter: *Illuminations* (collection), Cape 1970

Berger, John: *Ernst Neizvestney and the role of the artist in the USSR*, Pelican 1969; *A Painter of our Time*, Penguin 1958

Ways of Seeing, Penguin 1972

Bunting, Madeleine: 'No politics, we're British' *The Guardian*, 15 May 2000

Burn, Gordon: 'Inside Britart', *The Guardian*, April 2000

Coomaraswamy, Ananda K.: *Why Exhibit Works of Art*, Dover Publications, New York 1956

Craig, David (linocuts by Ken Sprague): *Latest News*, Fireweed 1977

Croft Andy (Ed.): *A Weapon in the Struggle – the cultural history of the Communist Party in Britain*, Pluto Press 1998

Dada Issue No.3: Malik Publishers 1920

Dudintsev, Vladimir: *Not by Bread Alone*, Hutchinson 1957

Dutta, K. and Robinson A. (ed): *Rabindranath Tagore – an anthology*, Picador 1997

Eagleton, Terry: *The Illusions of Postmodernism* Blackwell 1996

Evans, Rob: 'Chemical warfare trials short of volunteers', *The Guardian* 10 March 2000

Fer, Briony, Batchelor, David and Wood, Paul: *Realism, Rationalism, Surrealism – art between the wars*, Open University Press 1993

Fischer, Ernst: *The Necessity of Art – a Marxist appraisal*, Pelican 1963

Foner, P and Schultz, R: *The Other America*, Journeyman Press 1985

Forrester, Viviane: *The Economic Horror*, Polity Press 1999

Gorman, John: *Banner Bright – Images of Labour*, Allen Lane 1973

Gray, Nigel and Sprague, Ken (illustrations): *Come Close*, Fireweed 1977

Gros, Bertram: *Friendly Fascism*, Black Rose Books 1963

Grosz, Georg: *A Small Yes and A Big No – The Autobiography of Georg Grosz*, Zenith 1982

Hain, Peter: *Political Strikes – the state and trade unionism in Britain*, Penguin/Viking 1986

Hall, Stuart and Whannel, A.D.: *The Popular Arts*, London 1964

Harris, Jonathan: 'No Beginning No End' (Review of *Rewriting Conceptual Art* eds Michael Newman and Jon Bird, Reaktion Press 1999) *Art Monthly* (March 2000)

Hauser, Arnold: *Social History of Art* Routledge 1999

Holroyd, Michael:*Bernard Shaw*, Vintage 1998

How M. (ed): *Is that damned Paper Still Coming Out – the very best of the Daily Worker Morning Star*, People's Press Printing Society 2001

Jones, Jack: *Union Man – an autobiography*, Collins 1986

Kalla, Gina: 'The Road to Jerusalem' (a review of Ken Sprague's print series: Jerusalem or Bust) *Artery Magazine* 1978

Karp, Marcia & Holmes, Paul (eds.), illustrations by Ken Sprague: *Psychodrama – inspiration and technique*, Routledge 1991

Karp, Marcia, Holmes, Paul & Watson (eds.), montage illustrations by Ken Sprague: *Psychodrama since Moreno*, Routledge 1994

Karp, Marcia, Holmes, Paul and Tauvon, Kate (eds.), illustrations by Ken Sprague: *Handbook of Psychodrama*, Routledge 1998

Klingender, Francis: *Art and the Industrial Revolution*, Augustus M Kelley 1968

Lindey, Christine: *Art in the Cold War*, The Herbert Press 1990

Moss, Baron: *The Big Wall*, Bachman & Turner 1979

Mace, Rodney: *British Trade Union Posters – an illustrated history*, Sutton Publishing 1999

Masereel, Frans: *Stories without Words*, Redstone Press 1986

Massow, Ivan: 'Why I hate official art', *New Statesman* 21 January 2002

Morris, William: *Three Works*, Seven Seas Books 1968

Moreno, Jacob: *Who shall survive?: foundations of sociometry, group psychotherapy, and sociodrama*, Beacon House 1977

Orwell, George: *Collected Essays*, Mercury Books 1961

Pacheco, Ana Maria: *Pacheco in the National Gallery*, National Gallery Publications 1999

Pevsner, Nikolaus: *The Englishness of English Art*, The Architectural Press 1956

Pollitt, Marjorie: *A Rebel Life*, Red Pen Publications 1989

Read, Herbert et al: *5 on Revolutionary Art*, Wishart 1935

Rickards, Maurice: *Posters of Protest and Revolution*, Adams and Dart 1970

Roberts, John (ed): *Art has no History – the making and unmaking of modern art*, Verso 1994

Rochfort, Desmond: *The Mexican Muralists*, Laurence King Publishing 1988

Ruskin, John: *Unto This Last*, Hendon Publishing 2000

Schultz, Deborah: 'Flights of Fancy' (review of Panamarenko exhibition), *Art Monthly*, March 2000

Siqueiros, Alfaro: *Art and Revolution*, Lawrence and Wishart 1975

Shahn, Ben: *The Shape of Content*, Harvard University Press 1967

Stonor Saunders Frances: *Who Paid the Piper – the CIA and the cultural cold war*, Granta Books 1999

Thompson, Edward: *William Morris-romantic to revolutionary*, Merlin Press 1955.

Uglow, Jenny: *Hogarth – a life and a world*, Faber and Faber 1997

Weale, Sally: 'System C.R.A.S.H!', *The Guardian* 17 November 1999

Wesker, Arnold: *As much as I dare – an autobiography*, Century 1994

Whitechapel Art Gallery: *Art for Society catalogue* 1978

Willet, John: *The New Sobriety – art and politics in the Weimar Period*, Thames & Hudson 1978

Other books from Hawthorn Press

Futures that work

Using Search Conferences to Revitalize Companies, Communities, and Organizations

Robert Rehm, Nancy Cebula, Fran Ryan and Martin Large

'This time-tested approach capitalizes on the tremendous power of the human spirit to create innovative plans. It is a treasure trove of practical experiences and easy to understand principles for planning success. I highly recommend this relevant book.'

Tom Devane, co-author with Peggy Holman of
The Change Handbook: Group Methods for Shaping the Future

Futures That Work is all about the search conference – a practical way to build communities of people who want to make positive change happen for their organization or community. The result is engagement, learning and energy for realizing sustainable solutions.

This practical guide for using search conferences represents the latest evolution of this successful method, including the process, the principles underlying the method, how to plan for a search conference, design tips and compelling stories from searches done around the world.

Robert Rehm and **Nancy Cebula** enable organizations and communities to become more effective through the participation of their people. They live in Boulder, Colorado. Robert is the author of People in Charge: Creating Self Managing Workplaces. **Fran Ryan** and **Martin Large**, from Britain, use search conferences for enabling change in the non-profit, government and private sectors.

'Futures that Work restores one's faith in the collective capacity of people – regardless of position, status, age, race, or gender – to come together and create positive futures for themselves and their systems. The

many cases reflect true democracy at work, and my fondest wish is that leaders of troubled organizations and nations will read and heed the lessons of this book.'

Barry Oshry, author, *Seeing Systems: Unlocking the Mysteries of Organizational Life*

'The search conference created a focused opportunity for our entire staff to rethink our purpose and place in the bigger scale of things. The process respected our history, appropriately challenged our present and allowed us to lay the groundwork for a future we could all embrace.'

Chris Dropinski, Principal, GreenPlay,former Director, Boulder Colorado Parks and Recreation Department

'The Search Conference allows for a thorough exchange of ideas that can truly lay the foundation for a collaborative working environment. What makes Search so memorable is the short period of time in which this "shift" occurs – it is nothing less than transformation in the course of two days!'

Nancy Intermill, Lincoln/Greater Nebraska Alzheimer's Association

224pp; 229 x 184mm; paperback; 1 903458 24 2

People in Charge
Creating self managing workplaces

Robert Rehm

A step-by-step guide to designing self managing workplaces.

'Frankly, I find most books on this subject useless. This one is different. It is filled with practical theories, and business related examples, that I can use on a daily basis.'

Kevin Purcell, Director of Organization
Consulting, Microsoft Corporation

Powerful and practical, Participative Design enables companies to create more productive workplaces and better results. Here are the tools for creating self managing workplaces using Participative Design. The concepts, do-it-yourself guide and helpful examples show how people can re-design their work. The result is a more productive workplace full of energy, learning, quality and pride. And people in charge of their work.

Participative Design is a powerful but simple way of creating the conditions for good work. You can analyse your workplace, asking; 'Is there elbow room for decisions? Learning? Mutual support and respect? Meaningfulness? A desirable future?' Then you can take stock of the current structure and workflow, re-designing these to be self managing. Finally, each team agrees goals, resources, ground rules, training needs, co-ordination and career paths – checking if their plan improves working conditions.

'Far and away the most readable and informative book on democracy and participation in the workplace. Rehm describes how to design processes based on actionable principles that can, in fact, transform a

system. People in Charge offers hope and possibility to anyone who seeks to fully utilise the creative potential of the people in an organisation. It's a gift.'

Sandra Janoff, PhD, Co-author, *Future Search*

Participative Design was devised by Fred Emery in the 1970's. Here, Robert Rehm shows how managers and workers can use Participative Design to do a better job.

And putting people in charge works. Examples include the US Federal Courts, a Prudential call centre, the South African Land Bank, retail stores, a wine company and the conductor-less Orpheus Orchestra of New York.

Contents:- The self managing workplace; the six criteria for productive work; origins of Participative Design; the workshop; a start up guide for self managing teams; case studies; resources.

Robert Rehm consults with communities and businesses seeking renewal through participation. With a background in organisation development, socio-technical systems and fast cycle re-design, he specialises in participative planning, design and learning.

288pp; 243 x 189mm; paperback; 1 869 890 87 6

New Eyes for Plants

A workbook for observing and drawing plants

Margaret Colquhoun and **Axel Ewald**

Simple observation exercises interwoven with inspiring illustrations to take you on a vivid journey through the seasons with a fresh pair of eyes. Using the holistic approach of Goethe, this book opens a door 'onto a new way of practising Science as an Art'.

208pp; 270 x 210mm; paperback; 1 869 890 85 X

Colour Dynamics Workbook

Step by step guide to water colour painting and colour theory

Angela Patten

'Excellent for beginners and professionals alike. The clear, well explained text leads you through a series of exercises and techniques. The beginner will enjoy the discovery of colour. Teachers and therapists will value this resource with its sparkling insights.'

Pat Hubbard, Arts Foundation Course Tutor

The creative, healing power of colour affects us profoundly. Painting with water colour helps you experience the essence of each colour, renewing your ability to see the world afresh. You can then feel with Paul Klee who said, 'Colour has me... I and colour are one. I am a painter.'

Angela Patten invites you on an inspiring journey of discovery into the world of colour. This will enrich your painting by deepening your intuitive grasp of colour with:

- Useful tips on materials and painting methods for developing your painting skills.

- Painting exercises for deepening your colour experience

 Popular themes for painting exercises in your personal workbook, including rainbows, trees, flowers, landscapes and the seasons

- Stimulating experiments and painting tips using after images, complementary colours, colour circles, colour enhancement and perspective for creating visual impact.

Colour Dynamics is informed by Goethe and Rudolf Steiner's research, whilst inviting readers to deepen their *own* colour insights. This is a useful resource for beginners, art students, painters, teachers, art therapists, architects and interior designers. It offers a lively approach to colour theory that will revitalise the way you see, experience and paint from the heart of each colour.

Angela Patten is a painter, interior colour designer, muralist and art therapist. She has taught in state, Steiner schools and with adults. She studied at Gerard Wagner's Painting School, Dornach, Switzerland and has held many exhibitions in Britain, Switzerland and New Zealand.

192pp; 297 x 210mm; hardback; 1 903458 32 3

We would be delighted to hear your feedback on our books, how they can be improved, and what your needs are. Visit our website for details of forthcoming books and events: ***www.hawthornpress.com***

Ordering Books

If you have difficulties ordering Hawthorn Press books from a bookshop, you can order direct from:

Getting in touch with Hawthorn Press

United Kingdom

Booksource
32 Finlas Street
Glasgow
G22 5DU

Tel: (0141) 558 1366
Fax: (0141) 557 0189
E-mail:
orders@booksource.net
Website:
www.booksource.net

North America

Anthroposophic Press
C/o Books International
PO Box 960
Herndon
VA 201 72-0960

Toll free order line:
800 856 8664
Toll free fax line:
800 277 9747

Australia

Astam Books Pty Ltd
57-61 John Street
Leichhardt
NSW 2040

Tel:(02) 9566 4400
Fax: (02) 9566 4411
E-mail:-
sales@astambooks.com.au
Website:
www.astambooks.com.au